Gender and Development in the Middle East and North Africa

Gender and Development in the Middle East and North Africa

Women in the Public Sphere

THE WORLD BANK
Washington, D.C.

Contents

Foreword ... **xiii**

Acknowledgments .. **xv**

Glossary of Terms ... **xvii**

Acronyms and Abbreviations .. **xix**

Overview .. **1**
The Gender Paradox ... 1
The Costs of Low Participation of Women in the
Economy and the Political Sphere Are High 1
. . . But the Benefits of Enhanced Participation of
Women Are Positive ... 4
Factors That Have Empowered Women in Other Parts
of the World Have Been Less Effective in MENA 4
Achievements in Women's Education and Health 5
. . . Are Not Matched by Gains in Women's
Participation in the Labor Force 6
What Has Slowed Women's Entry into the Labor Force? 7
Even If Demand Factors Play a Role 7
. . . Standard Labor Market Discrimination Does Not
Explain Low Participation 9
. . . But the Combination of Social and Economic
Factors Does ... 10
A New Agenda about Gender .. 12
What Needs to Be Done 12
. . . And Who Needs to Do It .. 14

1. Why Does Gender Inequality Matter in MENA? **17**
A Historical Perspective on Gender Equality in MENA 19
Outline of the Report ... 21
Notes ... 22

2. Closing the Gender Gap in Education and Health 25

Increasing the Achievements in Women's Education 27
 Dramatic Increase in Years of Schooling and Literacy 29
 Progress in Reducing Gender Gaps in School Enrollment 30
 Completion Rates That Reflect Continued
 Discouragement for Girls 32
Educating Women for Empowerment 35
 Greater Emphasis Needed to Create Demand
 for Schooling 38
 Enrollment of Girls from Remote and Poor Families 43
Making Progress in Health and Fertility 43
 Life Expectancy That Has Increased 43
 Infant and Maternal Mortality Rates That Have Fallen 44
 Fertility That Has Fallen Dramatically 46
Challenging the Health Sector: Social Health and
 Second-Generation Issues 49
 Reduction in Early Pregnancies 50
 Increase in Reproductive Health Knowledge 51
 Improvement in Women's Access to Health Services 51
Notes 53

3. Women in the Economy 55

Women's Participation in Economic Activity Has
 Increased at an Accelerating Rate . . . 57
. . . But Participation of Women in the Labor
 Force Remains Low 61
Economic Impact of Low Participation by Women in the
 Labor Force 64
 The Burden of High Economic Dependency 65
 Forgone Return on Investments in Girls' Education 67
 High Costs for Households Headed by Women 69
 The Costs of Low Female Participation Compared
 with Family and National Income 69
Unemployment and Female Participation in the
 Labor Force 74
 Women Face Higher Unemployment than Men Do . . . 75
 . . . But Higher Female Labor Force Participation
 Is Not Associated with Higher Unemployment 77
Mixed Effect on Female Employment from Old
 Patterns of Growth 79
 Women Have Tended to Work More in the Public Sector 79
 Women and Men Are in Informal and Unregulated
 Categories of Work 81
 Women Remain in Agriculture Longer than Men Do 83

The Challenge of Inclusion in the Private Sector 84
Appendix: Labor Force Participation Rates That Vary
 with the Data Source 86
Notes 89

4. Constraints on Women's Work 93

The Traditional Gender Paradigm in MENA 94
 Key Elements of the Traditional Gender Paradigm 94
 Traditional Norms That Affect Labor Market Behavior 98
Discrimination in Wages, Benefits, and Job Segregation 100
 Gender Gaps in Wages 101
 Family Benefits and Other Nonwage Compensation
 That Favor Men 104
 Gender-Based Job Segregation That Reduces
 Economic Efficiency 108
Restrictions on Women's Flexibility as Workers 111
 Constraints on Women Originating from
 the "Code of Modesty" 111
 Other Factors Limiting Women's Work 116
Combining Work and Family Responsibilities 118
 Government-Mandated Maternity Leave Policies 118
 Support for Working Mothers 120
Notes 124

5. The Gender Policy Agenda to Meet
Demographic and Economic Needs 129

A Definition of the Agenda for Change 131
 Harmonizing Legal Structures 132
 Building an Infrastructure to Support Women
 and the Family 134
 Providing Skills for the Labor Market 134
 Reforming Labor Market Policies 135
A Rallying Agent for Change 135
 Inclusion: More Participation by Women in
 Political Life 136
 Accountability: State Leadership Still Matters Greatly 141
Notes 145

Appendix: Legal and Statistical Background 149

Bibliography 165

Index 193

Boxes

2.1 Educating Girls Means Smaller, Healthier
Families 28
2.2 Approaches to Literacy Training for Women:
Examples from the Republic of Yemen and
the Islamic Republic of Iran 31
2.3 Raising Girls' Primary Enrollment in Egypt:
Working on the Supply and Demand Sides 38
2.4 Typical Socialization of Boys and Girls 39
2.5 Two Awareness Campaigns in Jordan 40
2.6 Effects of Gender Discrimination That Begin
Early in Life 46
2.7 Successful Family Planning Programs in Tunisia
and the Islamic Republic of Iran 48
2.8 Falling Fertility in Oman and the Republic of
Yemen—A Tale of Two Countries 50
2.9 Disadvantages of Early Marriage 51
2.10 HIV/AIDS 52
3.1 Definitions and Available Data Affect How We
View Female Participation in the Labor Force 56
3.2 Explaining Changes in Female Participation
in the Labor Force in MENA 60
3.3 Effects of Women's Earnings on Expenditure
Patterns 74
4.1 A Typical Dilemma 96
4.2 Clashes between Public and Private
Empowerment 97
4.3 Trends in Egyptian Wage Differentials 105
4.4 Female Income Earners as Main Providers of the
Household: Gender-Related Cases in
the United States 107
4.5 Garment Workers in Morocco: Daughters
but Not Wives 112
4.6 Night Taxis in the Islamic Republic of Iran 114
4.7 Protection of Women's Safety 116
4.8 Gender Distinctions That Hinder Business
Development 117
4.9 Models for Funding Maternity Benefits 120
4.10 Mothers in Germany: Briefcase or Baby Carriage? 122
4.11 Jobs, Jobs, and More Jobs . . . from Dutch
Disease to the Dutch Miracle 123
5.1 Women in Politics in the Islamic Republic of Iran 138
5.2 Women in the Judiciary 143
5.3 Convention on the Elimination of All Forms
of Discrimination against Women 144

Figures

O.1 Progress in Empowering Women in MENA and
Other Developing Regions, 2000 — 2

O.2 Ratio of Nonworking to Working People in MENA
and Other Developing Regions, 2000 — 3

O.3 Male and Female Labor Force Participation,
by Region, 2000 — 6

O.4 Female Labor Force Participation and
Unemployment in MENA and OECD
Countries, 2000 — 8

O.5 Female Labor Force Participation Rates, by Age
and Region, 2000 — 9

O.6 Policy Framework for a Comprehensive Gender
Policy in Support of MENA's New
Development Model — 13

2.1 Progress in Female and Male Education and
Life Expectancy in the MENA Region, 1970–2000 — 26

2.2 Average Years of Schooling for Women in MENA
Countries, 1960 and 1999 — 29

2.3 Rising Female and Male Literacy Rates in the
MENA Region, 1970–2000 — 30

2.4 Declining Gender Gap in Primary Gross
Enrollment in MENA Countries and
World Regions, 1980–2000 — 32

2.5 Declining Gender Gap in Secondary Gross
Enrollment in MENA Countries and
World Regions, 1980–2000 — 33

2.6 Gender Gaps in Tertiary Gross Enrollment in
MENA Countries, 2000 — 34

2.7 Primary School Completion Rates in MENA
Countries, 2000 — 35

2.8 Secondary School Completion Rates in MENA
Countries, 1990 and 2000 — 36

2.9 Tertiary Completion Rates in MENA Countries,
1990 and 2000 — 36

2.10 Rising Gender Gap in Completion Rates from
Primary to Tertiary Education in MENA
Countries, 2000 — 37

2.11 Gaps between Female and Male Life Expectancy
at Birth in MENA Countries Compared with
Middle-Income Average, 1970 and 2000 — 44

2.12 Infant Mortality per 1,000 Live Births in MENA
Countries, 1980 and 2001 — 45

2.13 Decline in Total Fertility Rates in MENA
Countries, 1980 and 2002 — 47

2.14 Contraceptive Prevalence in MENA Countries,
 2003 or Most Recent Year 49
3.1 Actual and Projected Growth in Female Participation
 in the Labor Force in MENA, 1950–2010 58
3.2 Male and Female Participation in the Labor Force
 in World Regions, 2000 or Latest Year Available 61
3.3 Ratio of Actual to Predicted Female Participation
 in the Labor Force in MENA and Selected
 Countries and Regions, 1980 and 2000 62
3.4 Variations in Female Rates of Labor Force
 Participation in Country Groups within
 MENA, 2000 63
3.5 Ratio of Nonworking to Working People in
 Developing Regions, 2003 65
3.6 Female Education and Labor Force Participation
 in MENA and EAP, 1970–2000 67
3.7 Sources of Income for Female- and Male-Headed
 Households in MENA Countries, Various Years 70
3.8 Potential Increases in Average Household Income If . . . 71
3.9 Male and Female Unemployment Rates in MENA
 Countries and World Regions, Most Recent Year 75
3.10 Female Unemployment Rates by Educational
 Level in MENA Countries, Various Years 76
3.11 Female Labor Force Participation and
 Unemployment in MENA and OECD
 Countries, 2000 78
3.12 Female Employment in the Public Sector in
 MENA Countries, Various Years 80
3.13 Public Sector Employment as a Percentage of
 Women's and Men's Jobs, Various Years 80
3.14 Informal Employment as a Percentage of Total
 Nonagricultural Employment, 1994–2000 82
3.15 Informal Sector Work as a Percentage of Labor Force
 Participation in MENA Countries, Various Years 82
3.16 Women Are Not Leaving Agriculture as Quickly
 as Are Men in MENA Countries, 1970–2000 83
3.17 Paid Private Sector Employment as a Percentage of
 the Labor Force, Men and Women in
 MENA Countries, Various Years 85
3A.1 Labor Force Participation Rates, by Data Source 87
4.1 Age-Specific Female Participation Rates in MENA
 and World Regions, 2000 99
4.2 Participation Rates for Married and Unmarried
 Women in MENA Countries, 1990s 100
5.1 Policy Framework for a Comprehensive Gender Policy
 in Support of MENA's New Development Model 131

Tables

2.1 Public Spending on Education and Health in
 MENA Countries and World Regions, 2000 27
2.2 Decline in Total Fertility Rates in World
 Regions, 1980 and 2002 46
3.1 Trends in Female Participation in the Labor Force in
 MENA Countries and World Regions, 1960–2000 59
3.2 Rates of Return to Schooling, by Gender and
 Sector, in MENA Countries, 1988–99 68
4.1 Selected Obedience Clauses in Family Laws in
 MENA Countries 98
4.2 Wages and Discrimination in MENA Countries
 and World Regions, 2000 or Most Recent Year 102
4.3 Average Years of Education: Men and Women in
 the Labor Force in MENA Countries, 1989–99 103
4.4 Wages and Discrimination, Public and
 Private Sectors in MENA Countries, 2000 or
 Most Recent Year 103
4.5 Laws on Employee Pensions for Men and Women
 in MENA Countries as of 2002 106
4.6 Occupational Segregation in MENA and
 World Regions, 2000 or Most Recent Year 110
4.7 Trends in Occupational and Industrial Segregation
 in MENA Countries, 1988–2000 111
4.8 Legal Restrictions on Women's Work and Mobility
 in MENA, 2003 113
4.9 Maternity Leave Laws in MENA Countries 119
5.1 Equal Rights under the Constitution 133
5.2 Political Participation in MENA Countries 137
5.3 Women in Parliament in World Regions, 2003 139

Appendix Tables

A.1 Strategic Opportunity, Legal Equality, Work, Benefits,
 and Pension 150
A.2 Pension and Benefits Regulations in Comparable
 Countries in Various Regions 151
A.3 Equal Constitutional Rights, Freedom of Movement,
 and Marriage 152
A.4(a) Women's Right to Work: Constitutions or Country
 Laws That Specifically Mention the Right of
 Women to Work with No Discrimination in
 Their Employment and Opportunities 153
A.4(b) Women's Right to Work: Constitutions or Country
 Laws That Specify the Right of "All Citizens" to
 Work but Include Provisions That Either Directly
 Restrict Women's Options or Allow the Possibility

	for Regulating, Restricting, or Terminating a Woman's Economic Activity	154
A.5	Status of Ratification of the U.N. Convention on the Elimination of All Forms of Discrimination against Women (CEDAW)	155
A.6	Primary, Secondary, and Tertiary School Gross Enrollment Ratio, by Country and by Region, 1980–2000	157
A.7(a)	Male and Female Literacy and Average Years of Schooling for People Age 15 and Older, by Country, 1970–2002	159
A.7(b)	Male and Female Literacy and Average Years of Schooling for People Age 15 and Older, by Region, 1970–2002	160
A.8(a)	Health Sector Data: Infant Mortality Rates and Maternal Mortality Rates, 1980–2001	161
A.8(b)	Health Sector Data: Total Fertility Rates, by Country and by Region, 1980–2001	162
A.8(c)	Health Sector Data: Life Expectancy at Birth, by Country and by Region, 1970–2002	163
A.8(d)	Health Sector Data: Contraceptive Prevalence Rates among Married Women, 2002	164

Foreword

Today, the Middle East and North Africa (MENA) region is contemplating a new development model that will stimulate economic growth and provide adequate jobs for its growing and increasingly better educated labor force. This model rests on finding new sources of competitiveness to fuel a diversified, export-oriented, and private sector–driven economy. To continue, this growth must rely on human resources rather than on the natural resources relied on in the past. Women remain a huge, untapped reservoir of human potential for countries in the region.

Throughout the business world, companies are finding that having a diverse work force pays off in tangible ways—from bringing new perspectives on products to helping companies open markets that would otherwise have remained unexploited. Having a diverse workplace helps companies produce products that meet new and different market niches throughout the world. Diversity is no longer just a matter of good corporate citizenship. It is becoming a key driver of financial survival and competitiveness. Thus, women are becoming increasingly powerful players in their roles as producers, investors, and even consumers who are driving companies to become more gender intelligent and gender inclusive.

A striking fact that emerges in case after case of successful exporting countries is that women have played a pivotal role in emerging industries. This pattern emerged in industrial countries a century ago—to some degree because men were already fully engaged in other sectors. Women's involvement was also a critical ingredient as newly industrializing countries developed industries that capitalize on gender-linked characteristics and needs. For instance, this involvement was most visible in the textiles and electronics industries in East Asia and has been one of the factors leading to the success of the Asian Tigers.

In a global economy that values mental power over physical might, MENA's new comparative advantage could well be its large and educated

work force and, increasingly, its female work force. Until recently, gender issues have been seen as a peripheral concern that was mainly within the realm of the social sectors. Yet gender is ultimately also an economic issue. Women's relatively low participation in the economy has had huge costs that are felt throughout society and the economy. Above all, the lack of adequate women's involvement in the economy has reduced the potential welfare of families.

Today, one of every three inhabitants of the MENA region is a woman below the age of 30. She is likely to be healthier and more educated than her mother, having benefited from massive investments in education and health sectors during recent decades. She is also likely to fare well compared with her peers in other regions. Yet she is likely to face greater obstacles in finding a job and playing an active public role in her society than her contemporaries face elsewhere. In many parts of MENA, she already demands—and will do so increasingly in the future—equal access to opportunity and security, as she sees herself more and more on a par with the men of her generation.

The report recognizes the complexity of gender issues, which cut across many disciplines and have deep historical roots. In nearly every country around the world, gender issues are one of the most debated topics in national dialogues. And in every country, gender and family values are likely to be treated as the ultimate test of cultural authenticity. Yet people and institutions adapt and adjust to economic realities and can, in themselves, become an engine for growth. The welfare of the family remains an overriding goal—but solutions vary over time.

Tackling the gender agenda effectively and in a lasting way is important for economic and social development of the MENA region. Approaches will differ from country to country, and bringing about sustainable change will take political vision and stamina.

JEAN-LOUIS SARBIB
VICE PRESIDENT
MIDDLE EAST AND NORTH AFRICA REGION
THE WORLD BANK

Acknowledgments

The MENA Development Reports are coordinated by the Office of the Chief Economist of the Middle East and North Africa Region of the World Bank, which is led by Mustapha Kamel Nabli.

The book was prepared under the guidance of Jean-Louis Sarbib and, later, Christiaan J. Poortman. The main authors were Mustapha Kamel Nabli and Nadereh Chamlou. The core team was led by Nadereh Chamlou and included Susan R. Razzaz (who carried out a large part of the economic analysis), Randa Akeel (who worked on the legal sections), Marion Recktenwald (who worked on the social section), and Maliheh Paryavi (who was the research assistant). The book benefited greatly from the insight, input, and guidance of Shirin Ebadi. The peer reviewers were Habib Fetini, Elizabeth King, and Karen Mason. Hamid Alavi, Elizabeth Ruppert Bulmer, and Tarik Yousef also contributed to the book. The book incorporates background materials prepared by Ragui Assaad, Heba El-Shazli, Camillia Fawzi El-Solh, Simel Esim, Caren Grown, Nadia Hijab, Stephan Klasen, Francesca Lamanna, Djavad Salehi-Isfahani, and Mona Yacoubian.

The book was reviewed by Mona Chemali Khalaf and Golnar Mehran, who are members of the World Bank's Consultative Council for Gender (CCG). In addition, valuable comments were received from Suheir Azzouni, Shahida El-Baz, Asma Khader, and Rabea Naciri, who are also members of the World Bank's CCG. The book received comments from Mohammed Abu-Ali, Jamal Al-Kibbi, Zoubida Allaoua, Mahmood A. Ayub, Ferid Belhaj, Regina Maria Bendokat, Najy Benhassine, Mark Blackden, Sukeina Bouraoui, Meskerem Brhane, Marcos Ghattas, Gita Gopal, Sherif Omar Hassan, Imane Hayef, Heidi Hennrich-Hanson, Robert Holzmann, Farrukh Iqbal, Magdi Iskander, Omer M. Karasapan, Jennifer Keller, Carmen Niethammer, Letitia A. Obeng, Ngozi Okonjo-Iweala, Jack P. Roepers, George Schieber, Kutlu Somel, David Steel, Bachir Souhlal, Hasan A. Tuluy, Zafiris Tzannatos, Ayesha Vawdaand, and Leila Zlaoui.

The book was edited by Rachel Weaving and Communications Development International and by Publications Professionals LLC. The World Bank's Office of the Publisher managed editorial and print production, including book design. Additional statistical assistance was provided by Paul Dyer, Manuel Felix, Marenglen Marku, Yu Pingkang, Michael Robbins, Jessica Soto, Giovanni Vecchi, Theodora Xenogiani, Zheng Yi, and Sami Zouari. Krisztina Mazo and Brigitte Wiss were the team assistants. The team would like to thank all of those who contributed to the various stages of production of this book, including those who may have been inadvertently omitted.

Glossary of Terms

The Middle East and North Africa (MENA). This report covers the following 19 countries and territories of the Middle East and North Africa: Algeria, Bahrain, Djibouti, the Arab Republic of Egypt, the Islamic Republic of Iran, Iraq, Jordan, Kuwait, Lebanon, Libya, Morocco, Oman, the Palestinian Territories, Qatar, Saudi Arabia, the Syrian Arab Republic, Tunisia, the United Arab Emirates, and the Republic of Yemen. The region has a rich historical and cultural heritage, and it is the birthplace of some of the oldest civilizations and empires. About three-quarters of the region's 325 million people share the same language (Arabic)—the remainder speak Farsi—and the majority are Muslim. A great number of minority ethnic and religious groups inhabit the region. The region has established urban centers, yet the geography also includes large, relatively isolated regions with large rural populations. Some 40 percent of the population lives in nonurban areas, and some areas have extensive nomadic groups.

Gender. The term *gender* refers to socially constructed and socially learned behaviors and expectations associated with females and males. All cultures interpret and elaborate the biological differences between women and men into a set of social expectations about what behaviors and activities are appropriate and what rights, resources, and power women and men possess. Like race, ethnicity, and class, gender is a social category that largely establishes one's life chances. It shapes one's participation in society and in the economy. Some societies do not experience racial or ethnic divides, but all societies experience gender asymmetries—differences and disparities—to varying degrees. Often those asymmetries take time to change, but they are far from static and can, at times, change quite rapidly in response to policy and shifting socioeconomic conditions. While the term gender refers to men and women, for

the purposes of this report, *gender* refers to the condition of women in the MENA societies.

Gender equality. This report defines *gender equality* in terms of equality under the law, equality of opportunity (including equality of rewards for work and equality in access to human capital and other productive resources that enable opportunity), and equality of voice (the ability to influence and contribute to the development process). For two reasons, it stops short of defining *gender equality* as equality of outcomes. First, different cultures and societies can follow different paths in their pursuit of gender equality. Second, attaining gender equality demands a recognition that current social, economic, cultural, and political systems are gendered; that women's differential status is pervasive, therefore limiting both men's and women's flexibility to choose; that this pattern is further affected by race, ethnicity, and disability; and that it is necessary to incorporate women's specificity, priorities, and values into all major social institutions.

Empowerment. The term *empowerment* refers to the expansion of assets and capabilities of individuals to participate in, negotiate with, influence, control, and hold accountable the institutions that affect their lives.

Acronyms and Abbreviations

AFR	Africa
CAWTAR	Center of Arab Women for Training and Research
CCG	Consultative Council for Gender
CEDAW	Convention on the Elimination of All Forms of Discrimination against Women
CEO	Chief executive officer
CREDIF	Centre de Recherches d'Etudes de Documentation et d'Information sur la Femme
EAP	East Asia and the Pacific
ECA	Europe and Central Asia
EEP	Education Enhancement Program
GDP	Gross domestic product
ICT	Information and communication technology
IDEA	International Institute for Democracy and Electoral Assistance
ILO	International Labour Organisation
IMF	International Monetary Fund
INJAZ	Save the Children's Economic Opportunities for Jordanian Youth
LAC	Latin America and the Caribbean
MENA	Middle East and North Africa
NGO	Nongovernmental organization
OECD	Organisation for Economic Co-operation and Development
UNAIDS	Joint United Nations Programme on HIV/AIDS
UNDP	United Nations Development Programme
UNESCO	United Nations Educational, Scientific, and Cultural Organization

UNICEF	United Nations Children's Fund
UNIFEM	United Nations Development Fund for Women
UN-HABITAT	United Nations Human Settlements Program
USAID	United States Agency for International Development
WHO	World Health Organization
WIDTECH	Women in Development Technical Assistance

Overview

Gender inequality—the differential access to opportunity and security for women and girls—has become an important and visible issue for the economies of the Middle East and North Africa (MENA). Gender equality issues in MENA are usually approached from a social, anthropological, or political angle. But the costs of inequality are also borne at the economic level. This book seeks to advance the gender equality discussion in the region by framing the issues in terms of economic necessity. It analyzes the potential for women's greater economic contribution to the region's new development model, which is further discussed in three parallel books on trade, employment, and governance. It identifies key economic and sociopolitical impediments to women's increased labor force participation and empowerment, and it suggests a way forward in developing an agenda for change.

The Gender Paradox

MENA's achievements in many areas of women's well-being compare favorably with those of other regions. Indicators such as female education, fertility, and life expectancy show that MENA's progress in those areas in recent decades has been substantial. Where MENA falls considerably short is on indicators of women's economic participation and political empowerment (figure O.1).

MENA's rate of female labor force participation is significantly lower than rates in the rest of the world, and it is lower than would be expected when considering the region's fertility rates, its educational levels, and the age structure of the female population.

The Costs of Low Participation of Women in the Economy and the Political Sphere Are High . . .

The effects and costs of this gender paradox are felt throughout society in many ways. Gender inequality holds back a country's economic

FIGURE O.1

Progress in Empowering Women in MENA and Other Developing Regions, 2000

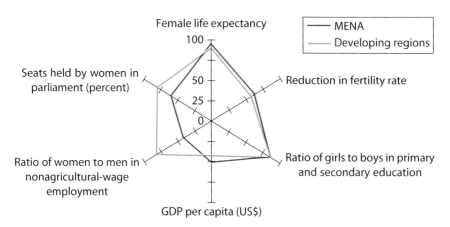

Note: These are normalized indicators; the aim is to show comparison.
Sources: World Bank 2003j and World Bank staff estimates.

performance. Barriers that reduce open competition impede a country's ability to draw on its best talents, and they ultimately undermine economic growth and productivity. The MENA economies, which are no longer able to rely on oil, remittances, and the public sector to drive growth, must look to new models of growth and development that rely more heavily on exports and private investment and that make more productive use of nonoil resources, especially human capital. Women remain a largely untapped resource in the region; they make up 49 percent of the population and, in some countries, as much as 63 percent of university students. However, they represent only 28 percent of the labor force.

The economic well-being of a population—including consumption of food, housing, health care, and other market-based goods and services—is determined not only by how much each working person earns, but also by what proportion of the population works. In MENA, each employed person supports more than two nonworking dependents—a burden that is more than double that of workers in East Asia (figure O.2). High unemployment, high proportions of people too young or too old to work, and low participation of women in the labor force all make MENA's economic dependency ratio the highest in the world. Real wages have stagnated or declined since the mid-1980s, and unemployment rates have increased, thereby making it increasingly difficult even for men with jobs to continue to raise living standards for their families.

Bringing unemployment rates down is crucial but will not be sufficient to bring MENA's economic dependency ratio into a sustainable

FIGURE O.2

Ratio of Nonworking to Working People in MENA and Other Developing Regions, 2000

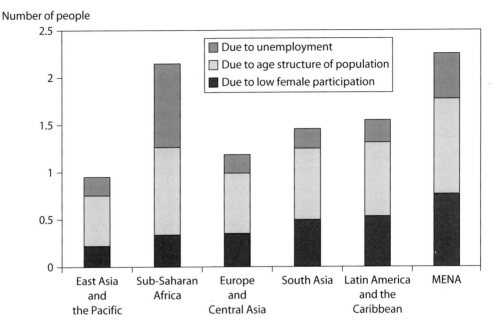

Source: Staff estimates based on ILO LABORSTA Database 2003a.

range. Bringing down that ratio will require a rise in the rate at which women participate in the labor force.

Discrimination against segments of a population on the basis of race, gender, ethnicity, or religious background influences a country's larger social climate and reduces development prospects, good governance, and the effectiveness of society's institutions. Studies show that inclusiveness and diversity of perspectives improve decisionmaking about resource allocation. Women tend to have perspectives different from men about issues in the public domain and about decisionmaking in political bureaucracies. Women's presence in the political arenas and their influence on public policy are more limited in MENA than in any other region.

With significant investment in women's education, MENA has increased each woman's productive potential and her capacity to earn. But the very low levels of female participation in the labor force mean that the region is not capturing a large part of the return on its investment. Add to that the observed higher rates of return for educating women than for educating men (explained in chapter 3), and it becomes clear that increased participation of women in the labor force would raise the returns from investing in education throughout the economy.

. . . But the Benefits of Enhanced Participation of Women Are Positive

The low participation of women in the labor force has a high cost to the economy and a high cost to the family. Simulations using household survey data show that if rates of female participation in the labor force increased from their actual levels to predicted levels (which are based on the existing levels of female education, fertility, and age structure), average household earnings would increase by as much as 25 percent. For many families, these increased earnings are the ticket to the middle class. Analyses based on cross-country data suggest that countries achieve higher levels of per capita income through increased participation by women in the labor force, which can contribute to faster economic growth. If female participation rates had been at predicted levels, per capita gross domestic product (GDP) growth rates might have been 0.7 percent higher per year during the 1990s. This lost potential is significant when compared with an average per capita income growth of 1.9 percent for the decade. The question is whether the region can afford such a loss in the future caused by gender inequality.

Factors That Have Empowered Women in Other Parts of the World Have Been Less Effective in MENA

The practices of previous decades continue to influence behavior within the current economic context of the region. Reforms from the 1950s through the 1970s did much to address issues of women's rights and status within society. Women made significant inroads in the labor market and in decisionmaking positions. During the oil boom years of the 1970s, rapidly increasing real wages allowed a small number of working people to support a large number of nonworking dependents. Families did not need two incomes to raise their living standards. This slowed down the progress of previous decades. Then, with the economic slowdown in the 1980s, the popular view emerged that men should receive preference for the shrinking supply of jobs, because they had families to support. Several countries took explicit actions against women's participation in the labor force, while popular movements and the media strongly emphasized the importance of women's domestic roles and contributions as mothers.

Developments in the 1990s have raised the profile of the gender debate and have given a new impetus to resolving "the woman question." First, the old male-breadwinner model is out of date. Today's economic pressures leave many households without a choice: women now need to

work outside the home to help support their families. A second factor is the high expectations of the region's now predominantly youthful population (6 in 10 people in the region are below the age of 25). Successful education policies have created a generation of young women who are increasingly on a par with their male counterparts and who want the same opportunities and rewards.

The demand for female labor is tied more to the level and nature of growth than is the demand for male labor. Past policies of capital-intensive, import-substituting, and state-driven investment and growth strategies left fewer opportunities for women outside of female-intensive public sector jobs in education and health. As the region adopts a new development model that is export centered, private sector driven, and labor intensive, the demand dynamics for female labor will change significantly. Those topics are discussed in detail in the parallel books on trade and employment. This book focuses mainly on the constraints on female labor force supply. The book seeks to address inefficiencies and distortions that impede women's entry into the labor force.

Achievements in Women's Education and Health . . .

Most countries in the region have dedicated significant resources to women's education and health, with impressive results. Over the past decade, MENA governments spent an average of 5.3 percent of GDP on education—the highest in the world—and 2.9 percent on health care. This investment has significantly changed the supply, quality, and profile of the labor force, especially for women.

The average number of years of schooling for women increased from 0.5 in 1960 to 4.5 in 1999, and the average literacy rate of women rose from 16.6 percent in 1970 to 52.5 percent in 2000. By 2000, in primary schools across the region, 9 girls were enrolled for every 10 boys. At the secondary level, the enrollment gap is even smaller: 74 percent of girls and 77 percent of boys are enrolled. Female gross enrollment as a percentage of male enrollment has increased from 75 percent to 90 percent between 1980 and 2000. On average, MENA seems to be on track for eliminating gender disparity in primary and secondary education by 2005. This elimination is the first-order indicator for the third Millennium Development Goal, which promotes gender equality and empowerment of women and to which all members of the United Nations agreed. Girls are also staying in school longer. Across the region, an enrollment of more than one in four girls exists in tertiary education, and women outnumber men in colleges and universities in several countries of the region. Girls who stay in school tend to outperform boys. But data on school completion show much higher dropout rates for girls,

particularly at higher levels of education, predominantly because of early marriage.

Women in MENA are also living longer and healthier lives. Since 1980, their life expectancy has increased by some 10 years, mainly because of improved health care and reduced maternal mortality. Above all, the region has experienced spectacular declines in the fertility rate—from 6.2 to 3.3 children per woman since 1980. Part of the reason for the drop is the expansion in women's education; educated women tend to marry later and are more likely to use contraceptives. Government population policies have also played a vital role in promoting the need for smaller family sizes.

. . . Are Not Matched by Gains in Women's Participation in the Labor Force

Starting from a low level, female participation in the labor force in MENA has grown by 50 percent since 1960. Despite this significant growth and despite the high potential for women to participate in the labor force, actual rates of participation remain among the lowest in the world (figure O.3).

FIGURE O.3

Male and Female Labor Force Participation, by Region, 2000

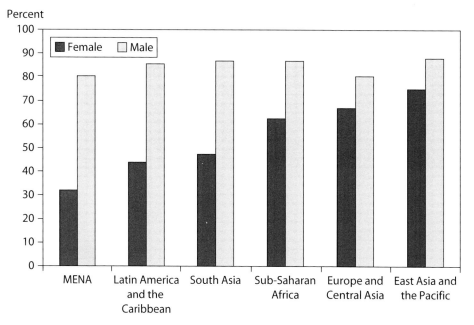

Source: ILO 1996; United Nations 2002.

What Has Slowed Women's Entry into the Labor Force?

The economic legacy of the past, which continues to suppress female participation in the labor force, includes many supply and demand factors that reinforce each other in a vicious circle and that vary across countries.

The labor-abundant, resource-rich countries (Algeria, the Islamic Republic of Iran, Iraq, the Syrian Arab Republic, and the Republic of Yemen) tend to have slightly lower rates of female participation in the labor force than do the labor-abundant, resource-poor economies (the Arab Republic of Egypt, Lebanon, Morocco, and Tunisia), though Jordan and the West Bank and Gaza are exceptions. Higher levels of unearned income, such as natural resource rents, reduce the need for earned income and promote capital-intensive investments, therefore, lowering the supply of and demand for female labor. Moreover, because relatively high incomes and redistributive social contracts supported investments in girls' education, those countries tend to have actual rates of female participation in the labor force that fall well below their potential. The resource-poor economies have had to rely more heavily on labor-intensive development and thus have depended more on women's economic participation, with rates of female participation in the labor force closer to their potential.

Even If Demand Factors Play a Role . . .

Although demand factors that can affect female participation in the labor force in various ways are addressed in the companion books, two factors deserve special attention here. The most important is unemployment. The weak growth performance of MENA in the 1990s has led to poor labor market outcomes, which have prevented absorption of the large increases in the labor supply. Employers prefer to hire men. This preference is based on the belief that men's income is more important to their families. Women, realizing their decreased likelihood of being hired, drop out of the labor force. Thus, creating more jobs is a necessary precondition to further increases in women's participation in the labor force. However, as explained later in the book, so is dispelling the fear that women's increased participation would raise aggregate unemployment.

Data from member countries of the Organisation for Economic Co-operation and Development (OECD) show a weak negative correlation between unemployment and female participation in the labor force, whereas data from MENA countries show a somewhat stronger negative correlation (figure O.4). This indicates that in the long run, a healthy economy that is more inclusive of women in the labor force is also more

FIGURE O.4

Female Labor Force Participation and Unemployment in MENA and OECD Countries, 2000
(percent)

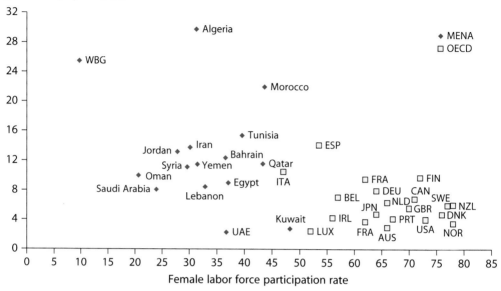

Note: AUS = Australia, AUT = Austria, BEL = Belgium, CAN = Canada, DEU = Germany, DNK = Denmark, ESP = Spain, FIN = Finland, FRA = France, GBR = Great Britain, IRL = Ireland, ITA = Italy, JPN = Japan, LUX = Luxembourg, NLD = Netherlands, NOR = Norway, NZL = New Zealand, OECD = Organisation for Economic Co-operation and Development, PRT = Portugal, SWE = Sweden, UAE = United Arab Emirates, USA = United States of America, and WBG = West Bank and Gaza.
Source: Scarpetta forthcoming; World Bank 2004.

likely to enjoy lower unemployment. In this context, the challenge for MENA is the overall expansion of opportunities for both men and women, building on their specific skills and talents, rather than the creation of opportunities for one group at the expense of the other.

The second important demand factor relates to the dominant pattern of economic growth in MENA, which relies on a large proportion of public sector jobs, extensive government controls, inward-looking trade policies, and a weak investment climate. In most of the region, women have tended to participate heavily in public sector employment. Reasons include (a) the perception that public sector professions such as teaching and nursing are appropriate for women; (b) the public sector's egalitarian and affirmative action practices in hiring and wage setting; and (c) the favorable conditions of work in the public sector, including generous maternity leave benefits. With the share of public sector employment shrinking in many countries, the public sector will no longer remain an important source of jobs for women in the future.

In the private sector, by contrast, women have faced significant disadvantages and fewer job opportunities. Often they work with lower wages and with little potential for growth. There are exceptions, however,

including Morocco and Tunisia, which have been able to expand manu-
facturing exports, notably in textiles and garment manufacturing, and
have had some success in increasing women's participation in the paid
private sector. Most other MENA countries, however, have been less
successful as a result of their more inward-looking trade policies.

. . . Standard Labor Market Discrimination Does Not Explain Low Participation . . .

Analysis of standard measures of labor market discrimination, such as
wage gaps and job segregation, points to differential treatment of women.
However, this differential treatment is by and large in line with the expe-
rience of other regions, which have significantly higher rates of female
participation in the labor force. Nor do wage discrimination and job seg-
regation explain the difference in the age distribution of the female labor
force when compared with that of other regions. Household survey data
for MENA countries show that women are much less likely to work if
they are married, especially if they have children. In other regions, the
likelihood that women will work increases if they are married and have
children (figure O.5). Hence, by themselves, the standard factors of labor
market discrimination cannot provide an adequate explanation.

FIGURE O.5

Female Labor Force Participation Rates, by Age and Region, 2000

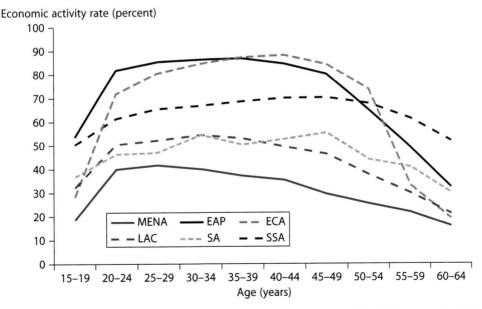

Note: EAP = East Asia and the Pacific, ECA = Europe and Central Asia, LAC = Latin America and the Caribbean, SA = South Asia, and SSA = Sub-Saharan Africa.
Source: World Bank 2003j.

. . . But the Combination of Social and Economic Factors Does

Rates of female participation in the labor force are indicative of a host of formal labor market laws and regulations, as well as social norms and attitudes, that put a low value on women's work outside the home and that create barriers to having women join the labor force. Understanding how these factors interact and influence female labor force supply requires examining how gender roles and economic and noneconomic incentives and constraints play out in decisionmaking within households.

In MENA, gender roles and dynamics within the household are shaped by a traditional gender paradigm, with four elements:

1. The centrality of the family, rather than the individual, as the main unit of society. This emphasis on the family is seen as justification for equivalent, rather than equal, rights, in which men and women are presumed to play complementary roles. Both men and women view the family as important and as a cultural asset.

2. The assumption that the man is the sole breadwinner of the family.

3. A "code of modesty," in which family honor and dignity rest on the reputation of the woman. This code imposes restrictions on interaction between men and women.

4. An unequal balance of power in the private sphere that affects women's access to the public sphere. This power difference is anchored in family laws.

This paradigm presumes that a woman will marry (early), that her most important contribution to the family and society will be as a homemaker and mother, that the household will be headed by a man who has a job that will allow him to provide for his family, that the woman will depend on the man for support, and that the man's responsibility for supporting and protecting his wife and family justifies his authority regarding and control over his wife's interactions in the public sphere.

In most MENA countries, labor laws alone do not discriminate explicitly against women. Indeed, they stipulate that women should receive equal compensation for equal work, they offer generous maternity leave benefits, and they protect women against job termination in case of marriage and pregnancy. But the benefits granted by those laws tend to remain unattainable, because they are weakly enforced and because the potential beneficiaries lack recourse. In addition, some labor regulations, as a measure to support and underscore the traditional paradigm, end up indirectly discriminating against women—and subsequently their families—through a host of conditions on nonwage employment benefits.

For example, tax- and employment-related benefits to families are channeled only through men. A woman can receive such benefits only if she is officially the head of the household (if she is widowed or proves that her husband is old or incapacitated). This differential treatment effectively reduces a woman's compensation even when she holds the same kind of job as a man. With the feminization of the public sector, which normally provides such nonwage benefits, and with men being employed more in the private sector, where nonwage benefits are scarcer, the rigidity of channeling benefits only through the man reduces rather than enhances the protection of families. This fact is particularly important at a time when the region will undergo significant economic changes that will impose uncertainties and costs on families.

Further, a range of gender-based regulations—including, in many countries, restrictions on the type and hours of work and requirements for the husband's permission to work and travel—make women less flexible as workers. Those regulations may discourage employers from hiring women and may limit women's ability to compete for jobs. This scenario may reduce a country's ability to compete in international markets, especially in such new sectors as the information and communication technology (ICT) or service industries, which rely on a round-the-clock work force.

Ultimately, differential treatment of men and women under family law further curtails women's participation in the labor force. A husband's unilateral right of divorce and a wife's legal obligation to obey her husband may create an additional barrier to women's entry into the labor force. A wife's disobedience can technically result in loss of support from her husband and a justification for divorce, with potential loss of custody of her children, which is normally given to the father once children are beyond infancy. Hence, interacting with the outside world without her husband's consent may involve substantial risk for a woman. Morocco, for instance, has set out to reform its family laws—the *Moudawana*—as a critical step toward promoting greater gender equality.

Naturally, most of these laws were put in place to protect families by assigning clear responsibilities of support. But the husband's responsibility to provide for the family confers rights and authority on him—reinforced through a host of policies and institutions—that he retains even if he does not or cannot provide fully for his family and even if the woman contributes a significant portion to the family income. As a result, women are seen as, and become, financially, legally, and socially dependent on men, or they enjoy little recognition and legal protection for their contribution to the family.

Today, the economic reality is that it is increasingly difficult for a family to be supported by one breadwinner. This situation puts in question

the economic and noneconomic factors that affect women's ability to join the labor force. In adhering to the traditional paradigm, laws and regulations that support the male breadwinner model fail to recognize that women need greater flexibility to play multiple roles—as mothers, wives, workers, and citizens—to maximize family welfare.

A New Agenda about Gender

A large proportion of young women and men of the current generation are different from their parents. They have been raised in smaller, nuclear families, where gender disparities are likely to have been less pronounced. This generation is likely to push for different rules of the game and for equality in the private and public spheres.

The demographic change in MENA will be no different from that experienced in much of the Western world with the baby boom generation. In the West, what changed the rights of women, the male breadwinner model, and the prevailing and accepted wage and job discrimination was the wave of women (as well as men) who were determined to challenge both women's unequal standing (as well as that of other disadvantaged groups) in society and the institutions that supported such discrimination. It is important to note that the campaign for gender equality would not have gone as far without the active support and advocacy of men as well.

What Needs to Be Done . . .

Within the domain of the region's new model economic policy for development, a new agenda covering gender is necessary to achieve greater efficiency and equity within society and the economy. The goal of this agenda would be to enable women to have greater access to opportunity and economic security (figure O.6). Within this framework, gender equality can be advanced by supporting the two critical pillars of good governance: (a) greater *inclusiveness* of women in decisionmaking, which will create a more gender-egalitarian environment in the economic and social spheres, and (b) greater *accountability* of institutions to advance fairness and equality. Gender equality is an integral part of good governance—respecting everyone's rights and taking everyone's needs into account.

The new gender agenda could consist of four broad policy areas for addressing gender disparities:

1. Review of the legislative environment to provide consistency between women's constitutional rights and ordinary legislation. Currently, a

FIGURE O.6

Policy Framework for a Comprehensive Gender Policy in Support of MENA's New Development Model

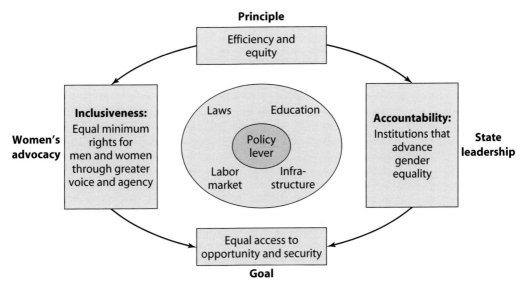

Source: Authors.

number of legal provisions fail to recognize women's equal rights under the constitution in most countries—for instance, their equality as citizens and the right to work.

2. A supportive infrastructure that will facilitate women's participation in the public sphere. Women are more constrained by their immediate physical environment than are men. Investments in standard infrastructure—such as better transport, water, and telecommunications—can vastly expand a woman's horizon, free up her time, as can expansion in market services that cater to women's needs—such as a well-functioning childcare market—which allow them to combine work and family responsibilities.

3. Continued attention to education, particularly in areas that provide women with better market skills. Although men in the region face a similar problem, women face additional challenges because of early marriage and childbearing, which interrupt their schooling and work and then outdate their skills. These issues could be addressed by providing vocational and lifelong learning opportunities.

4. Reform of labor laws and regulations that need to be realigned with the region's new development model so that they create better

incentive for job creation in the private sector. A number of labor market regulations raise the costs of women's labor relative to that of men and serve as disincentives to private employers.

. . . And Who Needs to Do It

The public sphere is the sphere of power, influence, and patronage and, as such, has been traditionally reserved for men. A call for gender equality is effectively a "transgression" of women into this space and a claim to share power and control. Gender equality can easily be seen as a threat to the social order and an erosion of the established power structure. Yet it is important for improving economic growth, creating productive employment, and reducing poverty.

Change will need to be led from the top *and* to be supported by the grassroots. The two main agents for change will be women's advocacy groups and the state. Gender equality will remain an abstraction unless a substantial number of women believe that they must do something to exercise their rights and governance, and unless they realize that they must play an active role in promoting gender equality.

Women need to be more active in political life. Greater participation of women in the political process will be key to achieving change. The traditional gender paradigm makes itself felt not only in important aspects of law, but also in women's low representation in political life and at all levels of public decisionmaking. Although many countries accord women equal rights as citizens and voters through their national constitutions and laws, women's participation in politics and governance is far from widespread.

Numerous measures are effective in stimulating women's political voice and agency, including the establishment of quotas (for example, reserving a specific number or share of positions for women in political parties or local and national assemblies). Quotas provoke both vehement opposition and impassioned support. Supporters argue that quotas compensate for real impediments that bar women from their fair share of political seats and that some positive discrimination is not a luxury but a necessity. Opposition to quotas can be addressed by ensuring that the positions are filled through a competitive and participatory process, rather than through direct appointment. Women's greater participation can also be furthered through civil society, grassroots actions, decentralization, leadership training, and the media.

State leadership still matters greatly. Women's participation in the political process for change is crucial, but its growth is likely to be gradual. In MENA's political setting, the bottom-up approach will not succeed unless it is matched by the government's leadership and commitment to a more gender-egalitarian environment.

The role of the state has been critical in affording women greater rights. Unlike the past, when state policies to advance the interests of women could be mandated from above, the reforms needed today may oppose some vested interests in order to provide greater benefit to all. Thus, the leadership role of the executive will need to shift away from decreeing change and move toward generating broad-based political will and building broad-based coalitions for reform. Unless this approach is taken, ownership of reforms will be weak and success will be short-lived.

Reaching out in partnership and dialogue with other domestic centers of power and authority—including religious authorities and their deliberative bodies, plus civil society organizations—will strengthen the legitimacy and popularity of any new policy proposal. Publicly deliberating and generating publicity about new initiatives, as well as vetting new programs in front of both supportive and critical audiences, will prepare the public for unfamiliar change. Such change will not be possible without investing in and strengthening institutions that formulate the gender agenda, through collection of gender-specific data, informed research, and effective dissemination.

The gender horizon in the MENA region is becoming much brighter. Investments in education and health are beginning to have their effect in empowering women. In the next decade, as these investments mature, their effect will be magnified. But more still needs to be done. As MENA reconsiders its development policies to create better opportunities for its youths, it needs to view gender issues as part of the solution for the future. Tackling these issues effectively and in a sustainable manner will take considerable political will and stamina. A long road is ahead, but the journey must begin today if the families of the region are to benefit from all available resources—human and other—for economic growth.

Why Does Gender Inequality Matter in MENA?

Addressing gender issues is increasingly important for the Middle East and North Africa (MENA), where sizable gender inequality remains and undermines development potential (UNDP and Arab Fund for Economic and Social Development 2002).[1] The costs of the differential treatment of women and girls in the region are felt throughout society. Despite the pervasiveness of the inequities, gender issues remain one of the least-understood and least-studied fields in development. Policymakers treat such gender issues as peripheral concerns. But the demographics of MENA today, combined with the fundamental economic changes the region needs to undergo to become globally competitive, no longer allow policymakers the luxury of ignoring gender issues. Gender equality must become an integral and explicit part of short- and medium-term development policy and practice in MENA.

Gender equality has been advocated mainly from social, anthropological, or political perspectives. This report seeks to advance the debate by analyzing the effect of gender discrimination on economic growth, income, and productivity in the region when viewed in terms of equity and efficiency. The report analyzes the determinants of women's participation in the economies of MENA and sheds light on the dynamics that are within households and communities and that underpin broader processes of social and macroeconomic change. It recommends change at these levels and within the realm of broader policymaking and state intervention.

This report defines *gender equality* in terms of (a) equality under the law; (b) equality of opportunity, including equal rewards for work and equal access to productive resources; and (c) equality of voice, including the ability to influence and contribute to the development process. It stops short of defining gender equality as equality of outcomes.[2]

Although gender inequality is widespread and costly throughout the region, there is great diversity among MENA countries in women's status and in the obstacles to their inclusion in public life. The specific problems differ from country to country, from urban to rural areas, and,

to some extent, by family income level. So do the solutions. Thus, although this report provides a broadly applicable interpretation of the problems and broad recommendations for achieving change, solutions will need to be tailored to local conditions and development goals.

The report does not address certain topics of immense importance to women's role in the economy. First among those topics is women's economic contribution at the household level, that is, their production of goods and services that in advanced economies are instead purchased in the market. The growing literature and debate on this topic deserve a separate discussion. Second, women in the region have traditionally controlled their own assets and incomes and are increasingly becoming producers, investors, and entrepreneurs. Their potential for growth in such roles deserves a separate discussion.

Gender inequality undermines equity and impedes economic efficiency in two broad areas:

1. Discrimination against segments of a population influences a country's social climate to the detriment of development prospects. It works against good governance and compromises the effectiveness of societal institutions. Studies show that the inclusion of diverse perspectives in government yields better decisions about resource allocation. Keeping women out of government limits the effectiveness of a state and its policies. Currently, women's presence in the political arena and their influence on public policy are more limited in MENA than in any other region of the world.

2. Gender inequality, like other barriers that impede open competition, depresses a country's macroeconomic performance and the welfare of all its people (Becker 1993).[3] Today this cost is one that the region can ill afford. The economic slowdown has forced growing numbers of people into unemployment. Countries in MENA need to adopt a new development model that entails three fundamental shifts in their sources of growth: (a) from oil to nonoil sectors, (b) from domination by the public sector to activities driven by the private sector, and (c) from protected import substitution to a competitive export orientation (World Bank 2003i). To succeed in opening their economies, the countries will need to make more flexible and productive use of all their resources and, most important, their human capital.

Women's situation in MENA is paradoxical. Several decades of major investment in the social sectors have greatly improved women's levels of education and health and have lowered their rates of fertility. But these dramatic improvements have not yet produced the expected payoff in higher employment and economic growth, as has been experienced in

countries in other regions that have similar education and fertility variables. Less than a third of women in MENA participate in the labor force. Although this rate has been growing, at 32 percent it remains the lowest in the world and is much below the level that would be expected given the profile of the region's female population in terms of education, fertility, and age distribution.[4] Furthermore, women workers in MENA tend to leave the labor force when they marry and have children to a much greater extent than do women in other developing regions.

Having such a small proportion of women working is costly. Failure to make more productive use of the region's increasingly educated women holds down overall prosperity and limits the ability of regional producers to compete against countries that make full use of all their human capital.

The countries of MENA have shown their commitment to gender equality by signing the Millennium Declaration, and they are making efforts to achieve the U.N. Millennium Development Goals, the third of which is to "promote gender equality and empower women." A large number of these countries have also ratified the U.N. Convention on the Elimination of All Forms of Discrimination against Women (CEDAW).[5] Nonetheless, much work remains to be done to make commitments such as CEDAW felt in daily life.

This report argues that women have key roles to play in supporting family income and contributing to the region's development. It explores why factors that have led to women's greater empowerment in other parts of the world have, thus far, proved to be less effective in MENA. It identifies levers for change that would empower women and allow them the flexibility to contribute more to their families, their societies, and their economies.

A Historical Perspective on Gender Equality in MENA

Gender issues have been at the forefront of the development debate in the region since the mid-19th century. The debate at that time focused mainly on emancipating women as part of the overall modernization of the state and the economy. In essence, the issues have changed little since then.

From the 1950s through the 1970s, governments made a deliberate push toward gender equity in what came to be called "state feminism." This was a period of decolonization in some countries, of nation building and state modernization in others, and—across the board—of forging new national identities. Against this background, states undertook progressive actions to promote health, education, employment, and greater political rights for women. Almost throughout the region, government policies

identified women's emancipation and equality as an integral part of national development. Women from all social strata were encouraged to participate in the economy. Modern labor laws were adopted to provide women with protection and benefits such as maternity leave and childcare. Two-income families advanced out of poverty into the middle class, helping attain the goals of state development planners. Family laws were revised—within the framework of religious laws—to address some basic injustices, and ministries and organizations for women's affairs were set up to mainstream women's issues into the overall development process. During this period, most women in MENA received the right to vote.

The reforms of those three decades did much to address women's strategic needs within society. However, like other reform measures, those that advanced women's interests were also generally introduced from the top down, rather than as the result of a process of consensus building to gain the broad ownership of the population. More than any other measures (such as changing social and economic structures), gender-related reforms were seen as elite driven and met resistance at the grassroots and from groups who felt left out of the process. Gender issues thus became an important symbol of resistance to modernization—and westernization— and a lightning rod for opposition to a host of government policies. The coded language of a crisis of the family, motherhood, and national honor united diverse groups and politicized gender issues. Even so, as long as growth was steady—as it was until the mid-1970s—the need for women's participation in the economy, particularly in the health and education sectors, grew steadily as well and many of the reforms took root.

With the oil boom in the mid-1970s, rapidly increasing real wages made it possible for a small number of workers to support nonworking dependents. Family living standards increased rapidly, most often supported by only one breadwinner. In a number of countries, mainly oil exporters, this trend proceeded in line with development policies that were public sector driven and were geared toward infrastructure and construction. Because those sectors tend to be more male dominated, the development models in such countries provided fewer opportunities for women to enter the labor market in the private sector and in fields other than education and health. In contrast, the development models pursued by countries such as Tunisia and Morocco focused on developing more labor-intensive and export-oriented industries, such as textiles, in which women had a greater comparative advantage.

In the 1980s, the region's economic slowdown called women's participation in the labor force further into question. The popular view was that men should receive preference for the limited supply of jobs because they had families to support. Several countries took explicit action to reduce women's participation in the labor force, including

offering early retirement to women and giving preference to male job applicants. Popular movements and the media emphasized the importance of women's domestic roles and their contributions as mothers. Aside from education and health policies, which focused on gender issues, broader economic policies were approached from a "gender neutral" perspective that did not serve women's strategic needs or advance their status within society.

Developments in the 1990s have raised the profile of the gender debate and have given a new significance to resolving "the woman question."[6] First, the old male-breadwinner model is out of date. Today's economic pressures leave many households without a choice. More and more women now need to work outside the home to help support their families. For poor households, having two incomes is again the ticket to the middle class. A second factor is the high expectations of the region's now predominantly youthful population, of which nearly two-thirds is younger than 25. Successful government policies have created a generation of young educated women who are increasingly on a par with their male counterparts and want the same opportunities and rewards.

Outline of the Report

Chapter 2 describes the significant progress the region has made in improving women's health and education. This starting point is critical, because these achievements are central to a discussion of the role of women in the economy. The payoffs of these improvements include lower illiteracy and fertility rates, longer life expectancy, and lower maternal and infant mortality. Challenges remain, however, particularly in closing gender gaps in literacy and educational opportunities and in better preparing girls for the working world.

Chapter 3 addresses the important role of women in the economy. It shows that, driven by the impressive achievements in women's education and health, the participation of women in the labor force has increased significantly over the past two decades. However, such achievements have not been fully translated into more market-driven work, and the rate of women's participation in the labor force in MENA remains the lowest in the world. This low rate of participation imposes costs on the region's economies and families. Chapter 3 then explores some of the reasons for women's low participation in the economy, reasons that originate in attributes of the demand for labor and the growth experience in MENA. It addresses in particular the fear that greater labor force participation by women will be at the cost of jobs for men; on the basis of the relationship between aggregate unemployment and women's

participation in the labor force, the chapter concludes that such fears are largely unfounded.

Chapter 4 explores the constraints on women's entry into the labor force and the factors that make them leave work for marriage and children to a greater extent than do women in other regions. These constraints include wage and nonwage discrimination and job segregation, as well as a series of factors that affect the flexibility of women as workers and their ability to combine work and family responsibilities. The chapter argues that the lack of flexibility in the policies and regulations that support the traditional gender paradigm actually contributes to the prevalence and persistence of such constraints.

Chapter 5 proposes a framework for planning efforts to achieve gender equality. It highlights the significance of inclusiveness and of greater participation by women—a basic feature of better governance. It suggests a tentative agenda for change, as well as the levers to be used to achieve such change.

It must be emphasized that gender-disaggregated data and research in MENA are scarce and often hard to compare consistently across countries or over time. The analysis here has certainly been limited by such constraints. Nonetheless, an effort has been made to bring together household and labor force survey data and to put those data on a comparable basis across countries. Analyses of surveys from nine countries were specially commissioned for the report.[7] Other specially commissioned studies underlying the report are a review of the laws affecting women in the 19 countries of the region (Hijab, El-Solh, and Ebadi 2003), and a cross-regional study of the links between economic growth and gender inequality in education and employment (Klasen and Lamanna 2003). The report also relies heavily on secondary sources, as well as on the three companion reports on the region (World Bank 2003e, 2003g, 2003i).

The report should be of interest to (a) policymakers, whose understanding of the important linkages among gender equality, growth, and welfare is critical to the content, direction, and process of change, and (b) proponents of gender equality, whose advocacy would be strengthened by the analysis of how women's access to opportunities can improve the well-being of women and that of their families.

Notes

1. *Arab Human Development Report 2002: Creating Opportunities for Future Generations* (UNDP and Arab Fund for Economic and Social Development 2002) identifies women's empowerment as one of the three

key deficits impeding development in MENA. UNDP and Arab Fund for Economic and Social Development

2. These definitions follow those used in World Bank (2001).

3. The literature on discrimination points to the fact that when the group that is being discriminated against "is a sizable fraction of the total, discrimination by members of the majority injures them [the majority] as well" (Becker 1993). For instance, significant literature exists about the cost of apartheid to the white population in South Africa.

4. This number includes formal and informal work in nonagricultural sectors. It may overestimate the actual participation of women from the region because it includes female expatriate workers, who are counted in labor force statistics. In some countries, including Gulf countries, expatriates make up a sizable proportion of the female participants in the labor force of the formal sector.

5. Ratifying countries are Algeria, Bahrain, Djibouti, the Arab Republic of Egypt, Iraq, Jordan, Kuwait, Lebanon, Libya, Morocco, Saudi Arabia, Tunisia, and the Republic of Yemen. The Syrian Arab Republic has recently signed but not yet ratified CEDAW. Countries that ratify CEDAW commit themselves legally to put its provisions into practice and to report regularly on its implementation.

6. After the 1970s and 1980s, gender issues have sometimes been referred to as "the woman question."

7. Those nine are Djibouti, Egypt, the Islamic Republic of Iran, Jordan, Lebanon, Morocco, Tunisia, the West Bank and Gaza, and the Republic of Yemen.

Closing the Gender Gap in Education and Health

The Middle East and North Africa (MENA) is often seen as a region where development has bypassed women. However, this omission is not the case in either education or health—two crucial determinants of women's economic participation and empowerment. This chapter describes the progress made in gender-specific social indicators that affect women's participation in the labor force. It offers recommendations to further enhance the education and health conditions of women. The three main messages are as follows:

1. Over the past three to four decades, MENA countries have achieved tremendous progress in increasing levels of schooling attained and in reducing illiteracy rates among women. The average years of schooling for women increased from 0.5 year in 1960 to 4.5 years in 1999. The literacy rate for women rose from 16.6 percent in 1970 to 52.5 percent in 2000. As a result of sustained political commitment and significant public investment, the gender gaps in enrollment and the provision of services have narrowed at all levels of education.

2. The region is on its way to meeting the education requirements of the third U.N. Millennium Development Goal, which is to "promote gender equality and empower women." All MENA countries seem likely to eliminate gender gaps in primary and secondary education by 2005. Achieving those goals and strengthening the educational performance of women require more emphasis on measures to increase demand for girls' education, as well as on the quality of education offered.

3. Women in MENA are living longer and healthier lives. Fertility rates in the region have decreased overall from 6.2 births per woman in 1980 to 3.2 in 2002. They are even close to replacement levels in some countries, though they are still high in others. Maternal and infant mortality rates are still high. The region is also beginning to face a set of second-generation issues in health and reproductive health (such as early pregnancy), women's access to health services, and

FIGURE 2.1

Progress in Female and Male Education and Life Expectancy in the MENA Region, 1970–2000

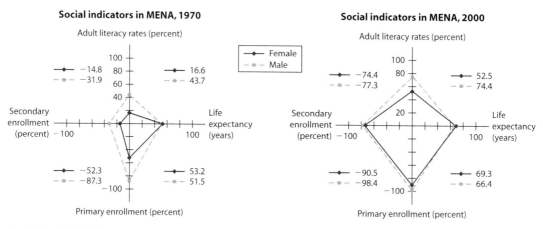

Source: World Bank 2003f.

reproductive health knowledge—issues whose solutions will require policymakers to address more deeply rooted issues and social practices.

Several decades of government commitment, with successful strategies made possible by major investments, have enabled the MENA countries to make impressive strides in women's education and health and to achieve broad parity with education and health conditions in other developing regions (figure 2.1).

Over the past decade, governments in the region spent an average of 5.3 percent of gross domestic product (GDP) on education—the highest in the world—and an average of 2.9 percent of GDP on health (table 2.1). Public spending on education ranges from 11 percent of the government budget in Lebanon, where private spending on education has traditionally been high, to 26 percent in Morocco (UNDP 2002). Public spending has been sustained at relatively high rates despite the fiscal difficulties that many countries have experienced since the mid-1980s.

Gender budgeting is an effective means to further address existing gender disparities in health and education. As in any other sector, gender-sensitive budgeting offers a practical means to make gender concerns explicit in policy development and implementation. The goal here is not to budget separately for men and women but to redefine priorities and to reallocate relevant resources that respond to the needs of the entire population, taking explicit account of women's less-advantaged position.

TABLE 2.1

Public Spending on Education and Health in MENA Countries and World Regions, 2000

(percentage of GDP)

Country or region	Education	Health
Algeria	4.8[a]	3.0
Bahrain	3.0	2.8
Djibouti	3.5[a]	4.2[b]
Egypt, Arab Rep. of	4.7[a]	1.8
Iran, Islamic Rep. of	4.4	2.5
Iraq	—	2.2
Jordan	5.0[a]	4.2
Kuwait	6.1[a]	2.6
Lebanon	3.0	2.5[b]
Libya	—	1.6
Morocco	5.5	1.3
Oman	3.9[a]	2.3
Qatar	3.6[a]	2.5
Saudi Arabia	9.5[a]	4.2
Syrian Arab Rep.	4.1	1.6
Tunisia	6.8	2.9[b]
United Arab Emirates	1.9[a]	2.5
West Bank and Gaza	—	—
Yemen, Rep. of	10.0	2.1[b]
East Asia and the Pacific	2.3	1.8
Europe and Central Asia	4.4[a]	4.0
Latin America and the Caribbean	4.4	3.3
MENA	**5.3[a]**	**2.9**
South Asia	2.5	1.0
Sub-Saharan Africa	3.4[a]	2.5

— Not available.
a. Data from most recent year available during 1995–2000.
b. 1998 data.
Source: World Bank 2003j.

Morocco thus far is the only country in MENA that has taken substantial steps to integrate the gender analysis of budgets into its policy processes, with the participation of nongovernmental organizations (NGOs), parliament, government, and donor agencies.

Increasing the Achievements in Women's Education

The provision of public education has long been part of the social contract in every MENA country (World Bank 2003e). The need to establish political legitimacy, further driven by rapidly expanding populations of young people, pushed many of the region's governments to make

BOX 2.1

Educating Girls Means Smaller, Healthier Families

Empirical studies from a diverse group of countries show that the education of mothers improves the education, nutrition, and health of their children. Women who have a primary education marry later than those who have no education, resulting in a tendency for smaller and healthier families. One additional year of education has been shown to reduce a woman's fertility rate by 5–10 percent. Women who have a primary education are 1.5–2 times more likely to practice family planning. The results include improved birth spacing, lower infant and child mortality and morbidity, and enhanced educational attainment of children.

Sources: Shafik 2001; World Bank 1999.

education a fundamental right of citizenship and to gain popular support in the process (World Bank 1999). In almost all MENA countries, constitutions have clauses guaranteeing at least free primary education for all. Most states have enforced compulsory education policies, many with attendance requirements that extend years beyond the primary level (Hijab, El-Solh, and Ebadi 2003).

For women, education has been seen primarily as a means to create healthier and better-educated families and, to a certain extent, as a means to empower women outside the home. Against the background of increased conservatism in the region, education has been a widely accepted and uncontroversial area of gender inequality for governments to address (box 2.1).

Although gender gaps remain, girls' school enrollment rates and literacy rates have risen dramatically over the past decade. Starting from low levels of enrollment three decades ago, girls and women in MENA have either surpassed their counterparts in other regions or narrowed the differences between MENA and other regions (World Bank 1999). Today in MENA, for every 10 women and girls who have primary or no education, 5 have secondary and higher education. Country-level disparities do remain. In some countries, such as Djibouti, gender gaps in education are low, but the overall proportion of children attending school is also low. In other countries, such as the Arab Republic of Egypt or Morocco, gender gaps are larger.

Women's education has shown clear payoffs in lower fertility rates, better family health, and increasing enrollment rates for children in primary education. MENA has succeeded in getting an increasing proportion of its girls into school. But the region has had less success in

keeping girls in school until graduation, in preparing them for the labor market, in reaping economic returns on education through paid employment, and in empowering women to make their voices heard in public policymaking. The reasons lie both within and outside the education sector.

Dramatic Increase in Years of Schooling and Literacy

Among the total population in MENA over the age of 15, the average years of schooling rose from less than a year in 1960 to 5.3 years in 1999—the largest gain of any region in the world. For women, the increase was more dramatic: from 0.5 to 4.5 years. This increase is large in all countries for which data are available (figure 2.2). Nonetheless, a gender gap remains, with average years of schooling in 1999 of 6.2 years for men compared with 4.5 years for women.

Over the past three decades, MENA has achieved impressive increases in the literacy rates of both women and men (figure 2.3). Fewer than one in three adults could read and write in 1970; two out of three can now.

FIGURE 2.2

Average Years of Schooling for Women in MENA Countries, 1960 and 1999

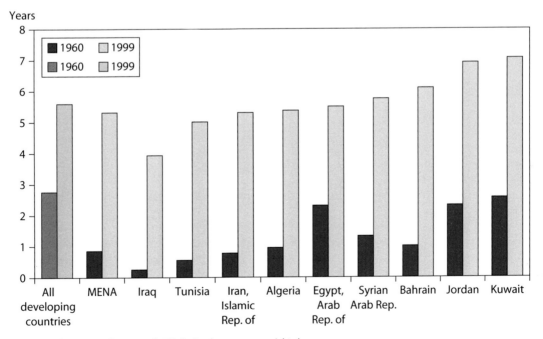

Note: Figures for Egypt are for 1980 and 1999. Regional averages are weighted.
Source: Barro and Lee 2000.

FIGURE 2.3

Rising Female and Male Literacy Rates in the MENA Region, 1970–2000

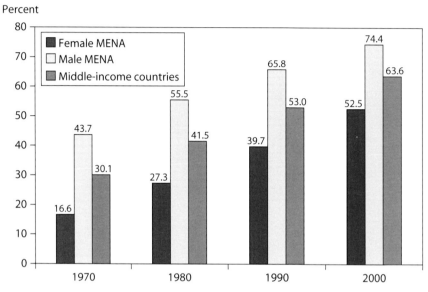

Percent

Legend:
- ■ Female MENA
- □ Male MENA
- ▣ Middle-income countries

Data values:

1970: Female MENA 16.6, Male MENA 43.7, Middle-income countries 30.1

1980: Female MENA 27.3, Male MENA 55.5, Middle-income countries 41.5

1990: Female MENA 39.7, Male MENA 65.8, Middle-income countries 53.0

2000: Female MENA 52.5, Male MENA 74.4, Middle-income countries 63.6

Source: World Bank 2003f.

Women, particularly, have benefited. In 1970, women made up only 16.4 percent of literate adults. By the year 2000, they accounted for more than 50 percent.

Yet, a large gender gap in literacy remains. Men are still 40 percent more likely to be literate than women. And illiteracy among rural women remains a persistent challenge. In Morocco, only 1 in 10 rural women can read and write, and in the Republic of Yemen only 1 in 9 can. But the region's progress to date has been strong. Box 2.2 describes some innovative approaches to literacy training for women in the Republic of Yemen and the Islamic Republic of Iran.

Progress in Reducing Gender Gaps in School Enrollment

School enrollment numbers are important indicators of disparities in access to education. In primary education, MENA is on its way to closing gender gaps in enrollment (figure 2.4). Across the region, enrollment rates for girls are virtually as high as those for boys. At the secondary level, many MENA countries appear to have closed the gender gap. Indeed, in 6 of the 15 countries with data for 2000, girls had higher gross secondary enrollment rates than did boys (figure 2.5). However, several countries still had low secondary enrollment rates for girls in 2000:

BOX 2.2

Approaches to Literacy Training for Women: Examples from the Republic of Yemen and the Islamic Republic of Iran

Yemeni Women Discover Literacy through Poetry

"Wealth does not come to the one who sits, except for those who own shops or who studied in schools," recites a Yemeni woman in an innovative pilot project, which draws upon Yemen's rich oral traditions to teach literacy. Only 25 percent of Yemen's adult females are literate, which makes a challenge of narrowing the gender gap in education and achieving the Millennium Development Goal of promoting gender equality by 2015. In partnership with Yemen's Ministry of Education, this World Bank–funded project, which is a pilot in Culture and Poverty, responds to the needs of women who want to learn to read and write simple letters and documents, short Qu'ranic verses, road signs, and instructions on food and pesticide containers. Early in the project about 100 rural women learned to read by creating and sharing poetry with other women in their communities. The project has since attracted interest from other development assistance agencies and is receiving support through Yemen's Social Fund for Development.

Targeting Adult Women in the Islamic Republic of Iran

Several literacy programs of the Islamic Republic of Iran's Bureau of Continuing Education are tailored to the needs of adult women. One popular program encourages neo-literates and members of their families to borrow a book of their choice on a weekly basis to read and discuss together. The program has been popular with mothers who are learning to read. Other measures include publication (since 1989) of a weekly page for neoliterates in a widely distributed daily newspaper and (since 1994) a national radio program for adult learners whose contests and other features encourage reading and writing skills.

Source: World Bank 2003k.

Morocco (35 percent), Syrian Arab Republic (41 percent), and the Republic of Yemen (25 percent).

Enrollment in tertiary education has risen for both women and men. The data suggest some gains for women over the 1990s, even relative to men. In looking at these data, however, one has to keep in mind that a larger proportion of the region's male students study abroad, and countries mostly provide enrollment data only for their local institutions. This underreporting is likely to produce a slightly underestimated gender gap in higher education (UNESCO 2002, p. 48). Tertiary enrollment

FIGURE 2.4

Declining Gender Gap in Primary Gross Enrollment in MENA Countries and World Regions, 1980–2000

(female enrollment as a percentage of male enrollment)

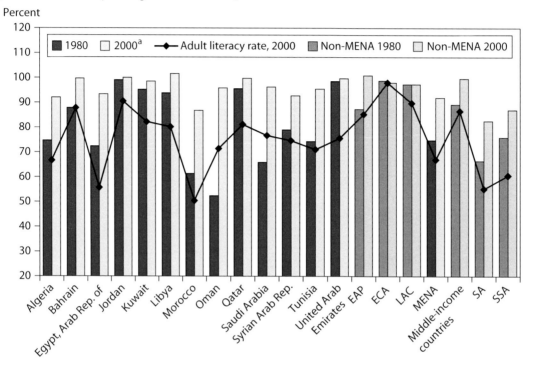

Note: EAP = East Asia and the Pacific, ECA = Europe and Central Asia, LAC = Latin America and the Caribbean, SA = South Asia, and SSA = Sub-Saharan Africa.
a. Data are for 2000 or most recent year available. Gross enrollment ratio is the ratio of total enrollment, regardless of age, to the population of the age group that officially corresponds to the level of education shown.
Source: World Bank 2003f.

rates for women rose from around 9 percent in 1990 to almost 14 percent in 1997, while overall rates rose from 12 percent to 17 percent. And by 2000, women outnumbered men entering local colleges and universities in many MENA countries, including Lebanon, Oman, and Qatar (figure 2.6).

Completion Rates That Reflect Continued Discouragement for Girls

While school enrollment has steadily increased and enrollment gaps have been reduced for girls in the region, narrowing the gender gap in school completion rates has remained a more difficult challenge, particularly at higher levels of education.

FIGURE 2.5

Declining Gender Gap in Secondary Gross Enrollment in MENA Countries and World Regions, 1980–2000
(female enrollment as a percentage of male enrollment)

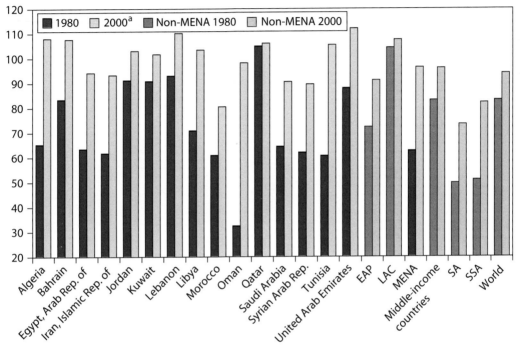

Note: EAP = East Asia and the Pacific, LAC = Latin America and the Caribbean, SA = South Asia, and SSA = Sub-Saharan Africa.
a. Data are for 2000 or most recent year available. Data for Morocco are for 1999, and data for the Republic of Yemen are for 1998.
Source: World Bank 2003f.

At the primary level, the region has made considerable progress in raising girls' completion rates to match those of boys (figure 2.7). At the secondary and tertiary levels, however, girls are far less likely than boys to complete school, and much less progress has been made in reducing this gender gap over the past decade. At the secondary level (figure 2.8), fewer than one-third of the girls who enroll actually complete school. At the tertiary level, more than two-fifths of women students drop out before graduating (figure 2.9). Throughout the region, the higher the level of education, the greater the gender gap in completion between women and men (figure 2.10).

Various factors play roles in reducing the completion rates of girls, relative to boys, and many apply at all levels of schooling. Girls in poor families, for whom child schooling may entail genuine costs to family income or livelihood, are often at a distinct disadvantage to boys (World Bank

FIGURE 2.6

Gender Gaps in Tertiary Gross Enrollment in MENA Countries, 2000

(female enrollment as a percentage of male enrollment)

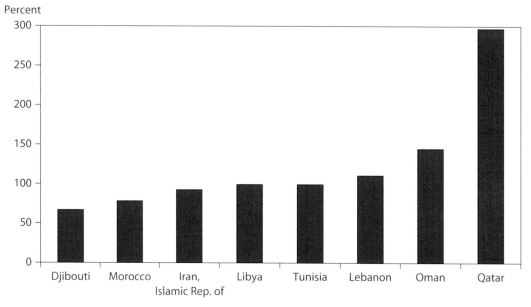

Source: World Bank 2003f.

2003c). Factors that raise the opportunity cost of schooling in general—such as lack of transport or responsibility for household chores (World Bank 2003k)—as well as factors that lower the potential gains from schooling in general—such as poor school facilities or inadequate teacher training (V. Moghadam 1998)[1] have a disproportionate effect on girls' completion rates. At the higher levels of education, early marriage and childbearing also play roles, with social norms requiring women to prefer domestic duties over schooling. Many other factors, such as the quality and relevance of education, gender norms, and concerns for girls' safety, have also worked to the detriment of girls' school completion rates.

All school dropouts represent an economic loss. But the loss is more disquieting if the students who drop out are potentially high academic performers. Throughout the 1990s, girls in Egypt achieved higher final examination scores than boys at both the primary and secondary school levels (Arab Republic of Egypt, Central Agency for Public Mobilization and Statistics 2001),[2] and the pass rates of girls between the 5th primary and 1st secondary were considerably higher than pass rates for boys. In Iran in 2002, for the fourth year in a row, the percentage of girls passing the rigorous university entrance exam exceeded the percentage of boys

FIGURE 2.7

Primary School Completion Rates in MENA Countries, 2000

(female completion rate as a percentage of male completion rate)

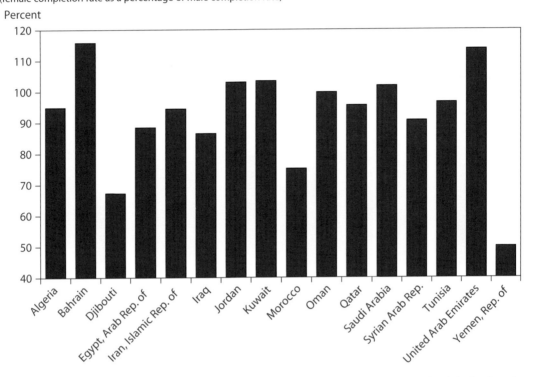

Note: School completion rates show what percentage of students who enroll in a given level of school actually complete their education at that level. Data are for 2000 or most recent year available.
Source: World Bank 2003f.

passing. Throughout the region, as girls strengthen their academic performance, a challenge remains to better encourage them to complete school.

Educating Women for Empowerment

In all, MENA's educational advancements of the past decades have been impressive, and the particular focus on girls' education has yielded strong results. In education, the region is well on the way to meeting the third U.N. Millennium Development Goal, agreed to by all member countries of the United Nations, "to promote gender equality and empower women." The goal calls for eliminating gender disparities in primary and secondary education, preferably by 2005, and in all levels of education by

FIGURE 2.8

Secondary School Completion Rates in MENA Countries, 1990 and 2000

(female completion rate as a percentage of male completion rate)

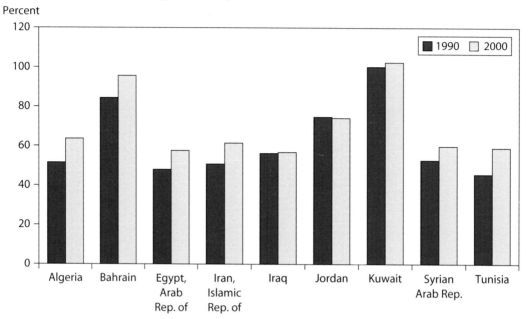

Source: Barro and Lee 2000.

FIGURE 2.9

Tertiary Completion Rates in MENA Countries, 1990 and 2000

(female completion rate as a percentage of male completion rate)

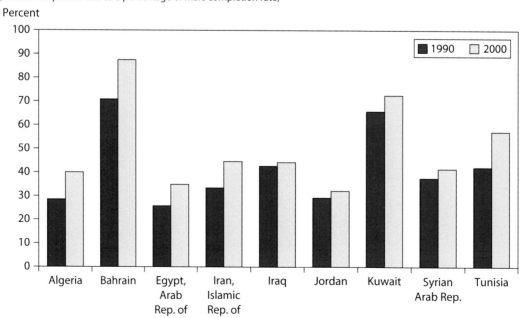

Source: Barro and Lee 2000.

FIGURE 2.10

Rising Gender Gap in Completion Rates from Primary to Tertiary Education in MENA Countries, 2000

(female completion rate as a percentage of male completion rate)

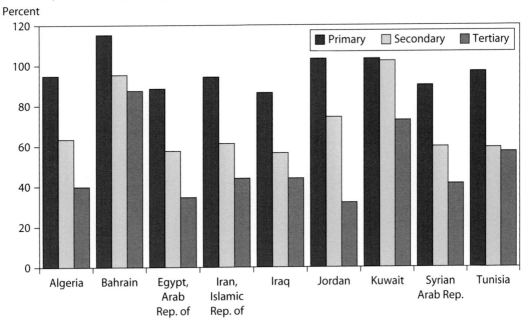

Source: Primary completion rates compiled from World Bank 2003f (2000 or most recent year available); secondary and tertiary data from Barro and Lee 2000.

2015. The gender gaps in primary and secondary education are likely to be eliminated as early as 2005 in all MENA countries.

Closing those gaps, however, will be more difficult than it has been in the past. Against the background of decreasing public sector budgets—coupled with continuing growth in the school-age population and in rural and nomadic populations, who are harder to reach—that closure will require efficiency gains, as well as educational strategies that include new priorities and approaches. Continued, if not greater, government commitment will be needed on the supply side, along with a new emphasis on demand-side interventions (box 2.3).

In regard to the other areas addressed by the third Millennium Development Goal—improvements in the shares of women working in paid nonagricultural jobs and holding seats in national parliaments—women in the region have made less progress. Although other factors are also at work, the quality of education has a role to play in empowering women to obtain roles in the public sphere. Here too, some new priorities and approaches will be needed in educational policies and practices, thereby targeting the particular needs of girls.

BOX 2.3

Raising Girls' Primary Enrollment in Egypt: Working on the Supply and Demand Sides

The results of Egypt's Education Enhancement Program (EEP) show the effectiveness of a focused, targeted program to improve girls' access to primary education by addressing issues on both the supply and the demand sides. Since the mid-1990s, new schools have been built in areas targeted for their low rates of enrollment of girls, while efforts have been made to increase demand for schooling through community awareness and support to disadvantaged children. In a break with traditional planning approaches, EEP relies heavily on community participation: the communities define the school sites and donate land to the government.

Building community awareness and support has functioned well at different levels. Local education officials made valuable contacts in the communities; those officials have become part of the local network and have been able to understand what barriers women face and what measures to take to overcome the constraints so that the overall education goals for the community can be reached. Local community leaders who were brought into the awareness campaigns have played a pivotal role in achieving project aims through their ability to identify poor families and girls and help them enter the system; by disseminating information on the importance of primary education for girls and on subsidies for those in need; and, later, by taking on management responsibilities for school improvement through parent–teacher associations and local committees. As a result of the awareness campaigns, school administrators learned that a major barrier to enrolling children in school stemmed from the economic difficulty associated with obtaining the required birth certificates. Various efforts helped reduce the cost of obtaining a birth certificate by a factor of 10.

Source: World Bank 2003f.

Greater Emphasis Needed to Create Demand for Schooling

Thus far, much of the focus has been on *supplying* education for girls. Public expenditures have focused on building schools, for example, and on providing more teachers and textbooks. Clearly, such efforts to enhance girls' access to schooling need to continue. But, as many governments in the region acknowledge, an important next step is to increase girls' *demand* for education. Programs need to be based on an understanding of the determinants of enrollment, including the incentives perceived by girls and their families that determine their commitment to

BOX 2.4

Typical Socialization of Boys and Girls

A large body of international literature shows that parents the world over expect different things from boys and girls.

Not just in MENA, child-rearing activities are known to emphasize assertive and more aggressive behavior in boys, whereas a girl is typically expected to be timid, to play indoors, to undertake household chores, and to become a wife and mother. Findings from a study of disadvantaged and vulnerable children in MENA show that most girls are expected to work longer hours than their brothers, sometimes up to 14 hours a day. Boys are reared with the expectation that they will enter paid jobs. Girls who face discrimination from an early age are likely to have less education and poorer health as they grow up, with adverse consequences for their empowerment.

Source: World Bank 2002c.

education. This understanding is particularly important in poor and rural areas, where all members of the family need to work and where girls contribute significantly to household activities.

The demand for girls' schooling, compared with the demand for boys' schooling, is more affected by the perceived value of education. In some quarters, such as cosmopolitan Beirut, Cairo, Rabat, Tunis, or Tehran, demand for girls' education is as high as in any other major city of the world. But among some rural and poor urban families, school is seen as an unwarranted and costly distraction from the work girls are expected to do for their families. This perception is especially prevalent where girls are supposed to prepare themselves for marriage, not jobs (box 2.4). Studies have shown that many families believe a boy has a right to education, which he should exercise even if the available education is poor, but that the same families need to be convinced that education is worthwhile for girls.

Visible returns to schooling are important in convincing families of the value of education. Awareness campaigns—to highlight job opportunities for girls and the returns that can be gained from a girl's education— can have positive results (box 2.5).

Quality of education. As one considers educational policy interventions to improve the quality of education, it is important to consider both material inputs and qualitative aspects of the school and classroom environment.

BOX 2.5

Two Awareness Campaigns in Jordan

In the 1970s when extensive male labor migration to the Gulf caused labor shortages at home, Jordan already had a pool of educated women on which to draw. The government actively promoted women's participation in the modern work force through consciousness-raising seminars and through legislation. Such a campaign, highlighting both the need to have women in the work force and the benefits that women derive from working, can be instrumental in raising demand for girls' education. Today Jordan has the highest female literacy rate and gender parity in the region. However, this campaign—while effective in pushing women to work—was discontinued when a large proportion of the Jordanian male workers returned from the Gulf.

 Today, through a national initiative organized by Save the Children's Economic Opportunities for Jordanian Youth (INJAZ), Jordan plans to enhance the technical vocational capacities and to foster the entrepreneurial talents of high school girls and boys. In cooperation with local public schools and volunteers from the private sector, students are taught the realities of today's business challenges and the technical, marketing, and managerial skills needed to succeed. INJAZ targeted an extensive media campaign at the private sector to encourage people to get involved with what it is trying to achieve. INJAZ students themselves participate in exhibits to showcase their projects.

Source: Hijab 1996b; INJAZ Web site(http://www.injaz.org.jo/); and "INJAZ Students" 2002.

Material inputs include variables such as quantity and quality of teachers, books, and equipment, plus supporting infrastructure such as paved roads. Within education, measures specifically designed to increase girls' demand for schooling play an important role. These measures require welfare-sensitive planning with a view to prevailing social norms. They should include, where affordable, the elimination of long travel distances to school that could jeopardize a girl's safety, the provision of greater numbers of women teachers, the provision of boundary walls in schools, and the provision of girls' bathrooms (a detail that is often overlooked). Measures to reduce the costs of girls' schooling to families include offering flexible school hours so that girls can continue carrying out their home or farm work as well as their school work. Provision of affordable childcare assistance or daycare centers can also increase girls' attendance.[3]

 Girls, particularly in rural schools or in disadvantaged neighborhoods, tend to have fewer and less-adequate facilities, fewer supplies, and

less-competent teachers than boys.[4] The quality of teaching and the relevance of education's content have a significant effect on students' enrollment and retention. Given the impediments to women's travel (discussed in chapter 4), female teachers may not have the same access to in-service training as do male teachers.

Qualitative aspects of the school and classroom environment, in addition to the design and structure of the curricula, include other important factors such as teacher and student attitudes, school policies toward girls' education, teachers' treatment of students, and gender messages embedded in the school curricula and textbooks. Experience suggests that girls have particular needs in many of these areas. Thus, promoting gender equality in demand for education requires further affirmative action to provide girls with schooling of equivalent quality to that of boys.[5]

Curricula and guidance. Unemployment rates among secondary school graduates—both boys and girls—partly reflect a mismatch between what students learn in school and what competencies they need in the workplace. For women this mismatch is particularly jarring, reflecting the typical orientation of women's education to roles in the home and family, rather than to the skills needed in the workplace.

Girls and boys typically do not receive the same training courses. Curricula for girls are often geared toward domestic subjects and may have the levels of difficulty adjusted downward. In many countries, young women who show academic promise and continue to higher education may still be channeled mainly to subjects in the humanities and social sciences—fields in which market opportunities are limited.

Role models and other factors that shape women's academic choices. Another factor that guides girls' academic choices is the lack of readily visible role models in a range of professions. Young women may shape their academic decisions according to the likely ease of obtaining a future husband's permission to work (this permission would be easier to obtain in female-dominated professions). Another consideration is whether they will be able to reconcile work with family obligations, which may channel them into professions, such as teaching, that more commonly offer part-time work. Recently in some countries, more women have been entering the sciences, engineering, medicine, and law, but their numbers remain much lower than those of men.[6] More curriculum reform is needed in MENA's education systems if the funds spent on education and vocational training, particularly for women, are to support more efficient and effective economic participations of graduates.

Provision of early-childhood education. Early-childhood education programs are a good way for governments to achieve equitable education goals while making it possible for women to work or pursue an education. With regard to school attendance, experience has shown that such programs have a broad range of benefits: (a) they raise the return on education in general because they prepare children to learn better throughout their subsequent school years; (b) by eliminating the need for older children to stay at home and care for their younger siblings, the programs help families keep children in school; and (c) they are important generators of employment for women, who in practice make up the majority of caregivers and the majority of early-childhood educators.

In 1999/2000, 16 percent of children in MENA were enrolled in pre-primary education.[7] Enrollment rates vary among the countries, but the low rates in Algeria, Egypt, Oman, Saudi Arabia, and the Republic of Yemen contribute to the low average in the region (UNESCO 2002). Available research points out that children at an early age learn best from their peers and that socialization is an important factor in their development. With smaller and increasingly nuclear families, children may not get the stimulus in a home setting that they may have received in the more extended and larger families of the past. In addition, universal early-childhood education is becoming the norm in industrial economies around the world. In MENA, it is available only to the elite and some segments of the middle class. Because early education is not available to all, children from a working class family could thus fall behind their peers during their first years of life.

Vocational training. Vocational training systems in the region have many shortcomings. Those systems are outdated, and there does not exist a strong relationship between education and vocational training and labor market needs (Kirchberger 2002). In many countries, fewer than half as many women as men are enrolled in technical and vocational training (UNESCO 2002). In some cases, women face fewer choices and opportunities to acquire technical training that prepares them for the working world. Solutions will require care to avoid investing in outdated models and to revamp the curricula while lowering barriers to women's entry.

For the many women who leave school early to marry and have children, few opportunities are available for lifelong learning or re-schooling.[8] Although reducing illiteracy is of key importance, providing lifelong learning opportunities in a whole range of fields can be a vital means of empowering women through both better knowledge and an ability to earn a living.

Enrollment of Girls from Remote and Poor Families

Reaching the remaining illiterate women and girls will take a relatively greater effort and additional resources, because they are generally located in poor rural and remote areas. Some are from minority groups, and some are nomadic.[9]

Rural poverty poses a major challenge to efforts for providing universal access to education.[10] In many MENA countries, poor rural children—both boys and girls—make up a disproportionate share of the out-of-school children. Not only are services difficult to provide in remote rural areas, but also traditional activities and values that limit families' demand for education tend to be stronger in rural areas. Egypt, Morocco, and the Republic of Yemen, in particular, face the challenge of extensive rural populations. Only 6 percent of rural people have access to paved roads, and poverty among such populations is significant. In many rural areas, social norms prevent girls from going to school unless female teachers will teach them. Women educators make a crucial contribution to girls' schooling, but in many areas they are hard to recruit and retain if they are not recruited locally.

Making Progress in Health and Fertility

Women in MENA are living longer and healthier lives.[11] Fertility rates have decreased overall, although they are still high in some countries. Maternal mortality rates have decreased and contraceptive use has increased.

That said, maternal and infant mortality rates are still high in MENA, and only Sub-Saharan Africa has a lower percentage of medically supervised births. Moreover, while national-level trends mostly bode well for women's empowerment, the conditions of women differ widely by geography and by income level within many countries. Furthermore, the region still has to deal with second-generation issues in health and reproductive health (such as early pregnancies), the solutions to which will require addressing deeply rooted traditions.

Life Expectancy That Has Increased

Women's life expectancy rose in all MENA countries between 1970 and 2000.[12] On average, women in MENA can now expect to live for 69 years, but in Djibouti and the Republic of Yemen, their life expectancy is well below this average, at 47 and 57 years, respectively.

Biologically, women have an advantage over men with regard to life
expectancy. Where health conditions are good, women can expect to
live roughly 5 years longer than men. Where female life expectancy
does not exceed that of males, this anomaly points to the possibility of
women having less access than men to nutritious food and adequate
medical care. The difference between male and female life expectancy
for the MENA region as a whole has improved; however, it varies
among countries. In some MENA countries, the female life expectancy
advantage has reached levels similar to the average in middle-income
countries of 4.7 years, but in others the advantage remains considerably
smaller (figure 2.11).

Infant and Maternal Mortality Rates That Have Fallen

A large part of the gains in life expectancy in general and female life
expectancy in particular reflects a lowering of infant and maternal

FIGURE 2.11

Gaps between Female and Male Life Expectancy at Birth in MENA Countries Compared with Middle-Income Average, 1970 and 2000

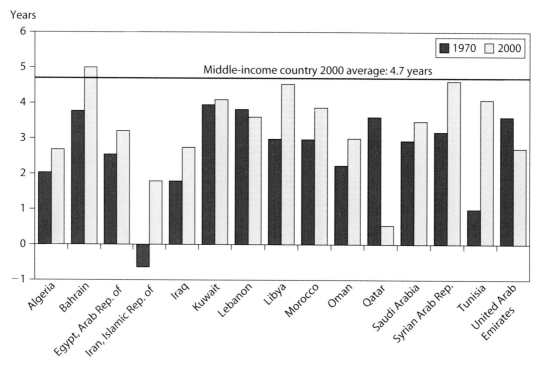

Note: Female advantage is the difference between female and male life expectancies at birth.
a. Qatar and the United Arab Emirates already have high female life expectancies of ages 75 and 76.7, respectively, compared with male life
expectancies of ages 74.4 and 74, respectively.
Source: World Bank 2003f.

mortality, which in turn reflects better prenatal care and the growing proportion of births attended by skilled personnel.

Infant mortality today (at 44 per 1,000 live births) is now one-fourth what it was in 1960 (164 per 1,000). The reductions have been dramatic, particularly in Egypt, the Islamic Republic of Iran, Algeria, and Morocco (figure 2.12). Libya and Tunisia have now achieved some of the lowest infant mortality rates among all middle-income countries. Among children 5 years of age and younger, however, rates of survival are lower for girls than for boys (box 2.6).

MENA's maternal mortality rates remain high compared with those of other middle-income regions. Roughly 13,000 women in the region die each year of complications related to pregnancy and childbirth (Roudi-Fahimi 2003).[13] It comes as no surprise that maternal mortality rates are lowest in countries with the highest levels of health expenditure per capita and the smallest gender gaps in education.

FIGURE 2.12

Infant Mortality per 1,000 Live Births in MENA Countries, 1980 and 2001

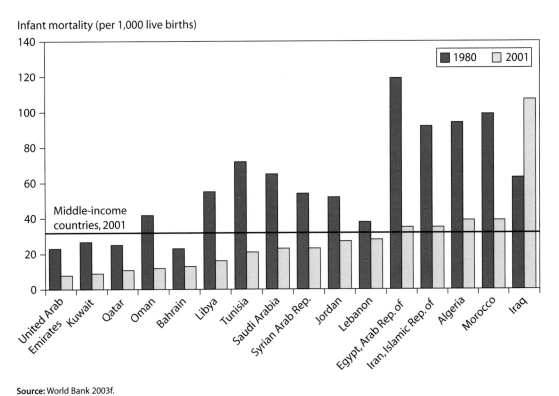

Infant mortality (per 1,000 live births)

Source: World Bank 2003f.

BOX 2.6

Effects of Gender Discrimination That Begin Early in Life

In certain socioeconomic groups, gender bias influences the survival rate of females. Among newborn babies, whose survival chances depend heavily on maternal health and prenatal care, MENA's mortality rates reflect the expected biological advantage of females, that is, more girls survive. But among infants and children who are under age 5 and whose survival depends heavily on nutritional, environmental, and child management factors, girls experience higher mortality rates. In Egypt, for example, girls born in rural areas to mothers who have little or no education are especially at risk. For girls whose mothers have less than a primary education, the mortality rate among infants and children under age 5 is almost twice the rate for boys. In comparison, the rate for girls of mothers who have a secondary or higher level of education is 80 percent of the rate of boys.

Source: World Bank 2002.

Fertility That Has Fallen Dramatically

MENA still has one of the highest fertility rates in the world, but over the past two decades it has achieved a striking drop in fertility, from 6.2 births per woman to 3.2 (table 2.2 and figure 2.13).

Part of the reason for the drop is the expansion in women's education; educated women tend to marry later and are more likely to use contraceptives. But government population policies, which are increasingly a feature of overall development policies in the region, have

TABLE 2.2

Decline in Total Fertility Rates in World Regions, 1980 and 2002

Region	1980	2002
East Asia and the Pacific	3.1	2.1
Europe and Central Asia	2.5	1.6
Latin America and the Caribbean	4.1	2.5
MENA	**6.2**	**3.2**
South Asia	5.3	3.1
Sub-Saharan Africa	6.6	5.0
World	3.7	2.6

Note: The total fertility rate represents the number of children who would be born to a woman if she were to live to the end of her childbearing years and bear children in accordance with prevailing age-specific fertility rates.
Source: World Bank 2003j.

FIGURE 2.13

Decline in Total Fertility Rates in MENA Countries, 1980 and 2002

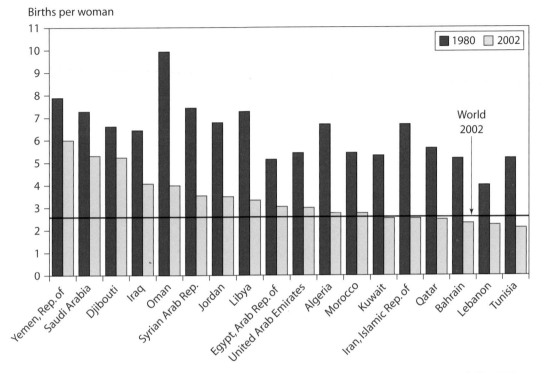

Note: The total fertility rate represents the number of children who would be born to a woman if she were to live to the end of her childbearing years and bear children in accordance with prevailing age-specific fertility rates.
Source: World Bank 2003f.

also played a role (box 2.7). Bahrain, Jordan, the Islamic Republic of Iran, Lebanon, Qatar, and Tunisia have managed to achieve fertility rates comparable to those of industrial countries, but fertility rates remain relatively high in Djibouti, the Republic of Yemen, and Saudi Arabia.

The region's rate of contraceptive prevalence coexists with a fertility rate that is still high by world standards. Fertility rates reflect people's deliberate choices, conditioned by social structures and economic perceptions, rather than just the availability or lack of contraceptives.[14] MENA statistics suggest that women's traditional roles as mothers and homemakers still dominate and that women still derive respect and security from having many children, especially sons. In many MENA countries, children contribute directly or indirectly to the family's subsistence and to caring for their elderly parents. Where child mortality is high, families choose to have many children, in case some do not survive. Women who lack adequate access to social welfare systems

BOX 2.7

Successful Family Planning Programs in Tunisia and the Islamic Republic of Iran

Tunisia and the Islamic Republic of Iran show that increased demand for family planning, together with the appropriate government population policies and the supply of family planning services, can lower the fertility rate.

Tunisia has achieved a sharp decline in birth rates as a result of assertive family planning policies. Millions of Tunisian women have been persuaded by family planning campaigners to have fewer children than their parents and grandparents did, and the improvements in living standards for the country's 10 million citizens are more pronounced than in most developing countries. The fertility rate has plunged from 7.2 in the 1960s to 2.1 today, and it is now the lowest in MENA.

The Islamic Republic of Iran's total fertility rate dropped from 6.7 to 2.6 between 1980 and 2001, as the result of a highly successful family planning program. The country has changed its official position on family planning twice since the 1960s. In 1966, it was one of the first countries in the developing world to establish a national family planning program. By the mid-1970s, 37 percent of married women were practicing family planning, with 24 percent using modern methods.

Soon after the 1979 Islamic revolution, the new government replaced the previous regime's population program with pro-fertility policies. At the end of the Iran–Iraq war in 1988, rapid population growth of more than 3 percent a year (one of the highest rates in the world) was seen as a major obstacle to economic reconstruction and development.

In response to the growing demand from an increasingly educated population, the government used the media to help revitalize its family planning program and to promote the message that the population growth rate was too high and, left unchecked, could have negative effects on the national economy and the population's welfare. The level and rate of decline in fertility have surpassed expectations. The official government target in its first 5-year development plan was to reduce the total fertility rate to 4.0 births per woman by 2011. By 2000, the rate was already down to half the stated goal, at 2.0 births per woman.

Sources: Tunisia: Naik 2003; Iran: Roudi-Fahimi 2003; and Population Reference Bureau Web site (http://www.prb.org/).

also look to children, particularly sons, to support them in case of need, for example, if they become widowed or divorced (Jabbra and Jabbra 1992).

Contraception offers women the benefits of healthier spacing of pregnancies and increased ability to plan their number of children. Contraceptive use can also be an indicator of women's empowerment at the family level; if a woman cannot decide with her husband when and

FIGURE 2.14

Contraceptive Prevalence in MENA Countries, 2003 or Most Recent Year

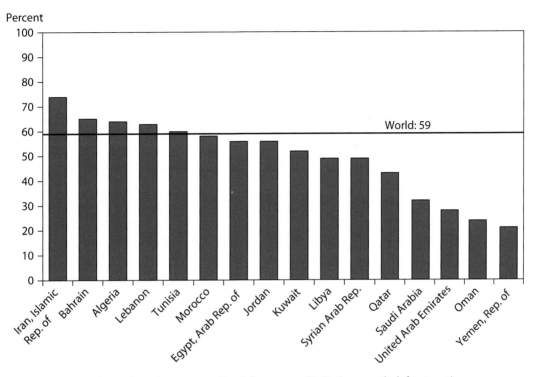

Note: Contraceptive prevalence refers to the percentage of married women ages 15–49 using any method of contraception.
Source: Population Reference Bureau 2003.

how many children she wants to have, she is unlikely to have much decisionmaking power in other spheres of her life.

The prevalence of contraceptives has increased significantly in MENA countries; and in more than half it is now quite close to the world average (figure 2.14). However, some countries—Oman, Saudi Arabia, and the Republic of Yemen—still have contraceptive prevalence rates of less than 30 percent. In the Republic of Yemen, contraceptive prevalence among women who have a primary education is three times that among women who have no education (box 2.8) (Shafik 2001).

Challenging the Health Sector: Social Health and Second-Generation Issues

Now that much is being accomplished in the basic areas of women's life expectancy and fertility, the region needs to contend with several second-generation issues in women's reproductive health, which have

BOX 2.8

Falling Fertility in Oman and the Republic of Yemen—A Tale of Two Countries

Oman and the Republic of Yemen are neighbors occupying the southern part of the Arabian peninsula. Both still have some of the lowest contraceptive use rates in MENA, but unlike its neighbor, Oman has been able to reduce its fertility considerably. From the 1980s to 2001, Oman's total fertility rate declined by 5.8 live births, to 4.1 live births. Important causes were a trend toward later marriage for women and a rise in the proportion of married women practicing modern contraception. Underlying these changes were the contextual factors of political stability and economic development; the expansion of educational opportunities, especially for girls; a decline in child mortality; and population policy measures.

Total fertility rates in both countries were associated with changes in the age distribution of fertility. Over the 1980s and 1990s, all Omani women experienced a decline in fertility, but the greatest decline took place among women ages 15–29. The difference mainly reflects a delay in marriage and a rise in celibacy.

In the Republic of Yemen, by contrast, the largest decline was among women ages 35 and older. More than three-fourths of Omani married women practiced modern methods (mostly injectables, female sterilization, and oral contraceptives), whereas fewer than half of Yemeni women practiced modern methods (mostly oral contraceptives and intrauterine devices).

In politically stable Oman, living standards, in general, have greatly improved since the mid-1970s. The Republic of Yemen has had a turbulent political history, making it difficult to address longer-term development questions such as lowering fertility.

Source: Eltigani 2001. This study uses data on contraceptive practices from a 2000 survey in Oman.

implications for women's economic opportunities and productivity. Here, the actions that are needed entail challenges to established beliefs about sexuality and traditional practices, including those of women themselves.

Reduction in Early Pregnancies

The average age at first marriage has increased significantly in the region, and recent data suggest that only 4 percent of women now ages 20–24 were married by the age of 15, compared with 17 percent of women now ages 45–49, a generation ago. However, it is still common for women in some social groups to marry before age 20, and as many as 20 percent of women now ages 20–24 were married by age 18. Several countries maintain low official marriage ages for girls. The Islamic

BOX 2.9

Disadvantages of Early Marriage

Early marriage is an important reason that girls do not enroll in secondary and tertiary education and that many drop out before graduating. Studies show that adolescent marriages do not confer social seniority or increased rights and access to resources. Married adolescents report a lack of freedom, more domestic work, and domination by their husbands. They have fewer social contacts, are less likely to know about contraceptive methods and sexually transmitted diseases, and are less likely to discuss sexual issues with their peers. Married adolescent girls have higher levels of sexual activity, perceive themselves as being at low risk of sexually transmitted diseases, often cannot seek health information or care without permission from others, and do not have independent incomes to pay for health services.

The treacherous synergies among poverty, lack of education, and early childbearing increase the risks of infant and maternal mortality and morbidity. They greatly constrain women's self-esteem and confidence and their abilities to build personal assets and to have command over resources.

Source: Bruce 2001.

Republic of Iran's is the lowest in the region at age 13, having been raised from 9. (Few, however, marry at such an early age.) Thus, early pregnancy, the result of girls' early marriage while their bodies are still maturing, remains a reproductive health concern in a number of MENA countries (box 2.9).

Increase in Reproductive Health Knowledge

Young people between the ages of 10 and 24 make up close to one-third of the region's population, but social and health care services in MENA countries are ill-equipped to address young people's reproductive health needs. Questions on sexual health and sexuality have not been adequately addressed in most of the region and are still considered taboo (box 2.10).[15]

Improvement in Women's Access to Health Services

Several factors limit women's access to health services and facilities. They include social structure, taboos, perceptions of women's roles, geographic isolation, and socioeconomic group. As might be expected, rural people in most countries have less access to health services than their

BOX 2.10

HIV/AIDS

Despite traditional values that condemn sex outside of marriage, high-risk sexual behavior does occur in MENA. About 550,000 people in the region are now living with HIV (UNAIDS and WHO 2002). Even if the overall rate of prevalence among adults remains low, one must not ignore the fact that the total number of AIDS deaths in the region has increased almost sixfold since the early 1990s (UNAIDS, WHO, and World Bank 2002). A low prevalence rate does not mean low risk, and many of the factors that make a society vulnerable to AIDS exist in MENA: economic difficulties, poor surveillance systems, stigma, and fear.

Waiting to intervene could be socially and economically devastating. Because AIDS kills people in the prime of their working life, an epidemic has a debilitating effect on human capital; it can increasingly weaken the social fabric and thereby blunt the productivity growth on which economies depend. A recent report shows that losses across the region for the period 2000–25 could amount to 35 percent of GDP (UNAIDS, WHO, and World Bank 2002). This loss does not include the social costs and the increased vulnerability of young people, who are one of the most vulnerable groups.

The public in MENA is generally unaware of the extent of HIV prevalence and high-risk behavior, both of which remain taboo subjects. Lingering fear and denial, not only among the general public but also among social and political organizations, provide an ideal environment for the continued spread of the disease.

When a country adopts a gender-based strategy about HIV/AIDS, the most successful time for confronting the epidemic is when it is still at a low prevalence. Men who are away from their families, such as migrant workers, are most likely to put themselves at risk. The culture of silence around this topic is of dominant concern for efforts to implement effective preventive measures. Experts claim that the spread of HIV/AIDS in Africa could have been slowed significantly if health authorities had been alarmed by—rather than ignored—the vast numbers of female victims.

urban counterparts. But rural women have even greater access problems because of factors such as undeveloped roads, distance, few female medical practitioners, and lack of privacy in facility design. The last two are important elements in the more tradition-bound rural societies.

Lack of gender-specific information in the health sector makes it difficult for policymakers and analysts to develop accurate assessments of women's and children's health needs or of the services they are receiving. Governments have recently started collecting disaggregated data about women's and men's health, but the records are not always reliable (UNIFEM 2001).

Notes

1. This study found that rural parents value schooling for girls as a means to attract better-educated and financially successful husbands.

2. Data for 1998/99.

3. In the Islamic Republic of Iran and in Morocco, the presence of younger siblings has a negative effect on girls' enrollment rates, reflecting parents' reliance on their daughters to care for younger siblings. In Morocco and Djibouti, girls' enrollment rates increased with the presence of additional adult women in the household.

4. Further progress in these realms is sometimes related to conditions in other sectors. For instance, in the Republic of Yemen a key barrier to education—especially for rural girls—is the geography or mountainous terrain, which, when combined with the scarcity of water and the lack of roads, requires many girls to walk long distances to fetch water rather than attend school.

5. "Affirmative action" refers to "a coherent packet of measures, of a temporary character, aimed specifically at correcting the position of members of a target group in one or more aspects of their social life, in order to attain effective equality" (United Nations Economic and Social Council 2002).

6. In Morocco, since changes were introduced in 1996, it is no longer compulsory for girls to study family instruction and for boys to study technology; students are now allowed to choose subjects freely. The Islamic Republic of Iran, too, has opened all fields of study to women. Even when women enter scientific fields, however, they tend to concentrate on the lower end of the spectrum (for instance, within medicine, they enter fields such as dermatology, child dentistry, pediatrics, or gynecology, and within the sciences, they enter chemistry teaching rather than chemical engineering).

7. The gross enrollment ratio for boys was 17 percent and for girls, 14 percent.

8. In some countries—for example, Algeria and Morocco—opportunities for lifelong learning are minimal or nonexistent for both men and women.

9. Virtual classrooms that are provided through distance learning in countries with dispersed populations (for example, Australia) can provide good models for increasing literacy in rural areas.

10. In 1994, for example, net primary enrollments were 58 percent in Moroccan rural areas and 85 percent in urban areas, and secondary enrollments in Tunisian rural governorates were as low as 19 percent while in Tunis itself they were 78 percent (World Bank 1999).

11. The discussion in this chapter focuses largely on aspects of health that have implications for women's economic status and political empowerment. It does not, for example, look in detail at reproductive health or examine issues such as aging or nutritional and epidemiological transitions.

12. Life expectancy projections are based on mortality rates and reflect general health conditions, including public sanitation, nutrition, and the availability of medical care.

13. Three out of five maternal deaths in the region occur in only four countries: Egypt, Iraq, Morocco, and the Republic of Yemen.

14. Econometric work by Pritchett (1994) indicates that 90 percent of differences in fertility levels across countries can be explained by differences in desired fertility (that is, demand factors) rather than the supply of contraceptives. If one is to understand the effect of family planning, it is essential to analyze which age group is using contraception, which method is being used, and what context provides the incentive.

15. This knowledge is particularly important if myths about male and female sexuality are to be addressed, myths of the type that perpetuate female genital mutilation in Djibouti, Egypt, and the Republic of Yemen.

Women in the Economy

As described in chapter 2, the Middle East and North Africa (MENA) has made significant progress in improving women's health and education. Women's education has had large payoffs in lower fertility, in better family health status, and in more education for children. Despite the benefits in those crucial aspects of well-being, investments in girls' education have not achieved full payoffs in terms of the *economic* well-being of women, their families, and the economy as a whole.

Driven by achievements in education and health, the participation of women in the formal labor force has increased noticeably over the past two decades (box 3.1). However, the rate remains low in MENA compared to that in other regions. Maintaining low rates of female participation into the future would come at a high opportunity cost for families and societies at large. If MENA can instead meet the challenge of incorporating women into the economy, the benefits to household and national incomes could be significant.

The low level of participation of women in economic activity is the result of factors affecting both the supply of and the demand for female labor. This chapter explores how macroeconomic factors and the development model pursued by the countries of the region have affected the demand for labor. Supply factors behind the low rate of female participation in the labor force in MENA are explored in chapter 4.

This chapter has four main messages:

1. Despite regional success in closing gender gaps in education and health, and despite significant increases in female participation rates in MENA over the past few decades, the rates of female participation in the labor force remain by far the lowest in the world, and lower than would be expected on the basis of lower fertility, higher education, and age distribution of the female population.

2. With the highest economic dependency ratios in the world and evidence of higher rates of return on education for women than for men, MENA is clearly missing opportunities to improve the welfare of families and society. Higher participation by women—in line with

BOX 3.1

Definitions and Available Data Affect How We View Female Participation in the Labor Force

The precise ways that *work* and *unemployment* are defined affect the numbers given for labor force participation. Consider the following two examples. First, if the definition of work were narrowed to include only work for wages, female participation in the labor force in the Republic of Yemen would be only 4 percent, rather than the 31 percent referred to in this report. Second, even more significantly, ILO's and other commonly used definitions of *work* exclude services provided to one's own family, such as caring for children, cooking, and cleaning. If such family responsibilities were included in the definition, nearly all women would be included in the labor force.[1]

In the experience of many individuals, there is no clear boundary between work and other activities. Sometimes there is also no clear boundary between working part time or seasonally and working on a more regular basis. Any definition of labor force participation is bound to include an element of arbitrariness.

According to the ILO definition, which is used throughout this report, the term *labor force participation* includes both those individuals who are working and those who are actively looking for work but have been unable to find jobs—the unemployed. The term *work* refers to work for wages and salaries as well as unpaid work on family farms and in informal sector commercial activities, but does not refer to services provided to one's own family.

In addition to ILO data, the report draws on information from nine nationally representative household and labor force surveys[2] (see the appendix to this chapter).

Although this book has used all available data, it should be said at the outset that data on women's work in MENA are very limited and that this limitation constrains the understanding of the nature of women's participation in the labor force, the tradeoff that the region makes for maintaining low rates of female participation, and the reasons women choose to participate or not participate in the labor force.

[1]It is important to recognize the inherent value of services provided within families: without those services, society could not function. Nevertheless, the special attention given to production of goods and services that are exchangeable in the market—that is, work that yields a cash income—is not wholly misplaced. Families must devote a significant portion of their work effort to income-generating activities in order to raise their living standards. Moreover, cash income often brings with it a greater degree of control over household decisions and can be an important part of empowerment.

[2]For Djibouti, the Arab Republic of Egypt, the Islamic Republic of Iran, Jordan, Lebanon, Morocco, Tunisia, the West Bank and Gaza, and the Republic of Yemen. The appendix to this chapter describes the data sources used and how they affect the estimates of female participation in the labor force in the region.

predicted rates (when factoring for the current levels of female education, fertility, and age distribution)—could allow family income to increase by as much as 25 percent in countries for which data are available. In addition, those higher rates of participation could increase the annual growth of gross domestic product (GDP) per capita by an average of 0.7 percentage point. The gains could be higher for countries that have lower levels of participation by women in economic activity.

3. The fear that increased female participation would lead to higher unemployment is unfounded. The region's high levels of unemployment may discourage women from entering the labor force. But international experience shows that, in the long run, greater labor force participation by women is not associated with higher total unemployment rates. On the contrary, on the basis of both MENA and Organisation for Economic Co-operation and Development (OECD) experiences, it can be argued that an economy that is more inclusive of women in the labor force is likely to enjoy lower unemployment.

4. Development policies pursued in the MENA region have had a mixed effect on female employment. On the one hand, the policies have expanded opportunities in the public sector. On the other hand, they have created mainly low-productivity jobs for women in the private sector. The projected surge of more (and increasingly well-educated) women into the labor force (probably at a rate no higher than 5 percent a year during this decade) creates a need for better job opportunities in a more dynamic and productive private sector.

Women's Participation in Economic Activity Has Increased at an Accelerating Rate . . .

Throughout the world, a general pattern is seen in which increases in female education and decreases in fertility rates coincide with increases in the proportion of women in the labor force. Several mechanisms are at work here, often simultaneously. Lower fertility rates mean that women spend less time caring for children and have more time for income-generating activities. Education increases women's potential earnings, making work more desirable relative to other uses of time. And more-educated women tend to have fewer children.[1]

In MENA, changes in education and fertility, which are rooted in past investments in human capital, have created an enormous potential for

increased participation in the labor force. A generation ago, the average woman in the region expected to raise more than six children. The average woman today will raise only half as many—and the number is even smaller for the cohort of women who are now in their early twenties. The changes over the past generation are even more dramatic with respect to women's educational status.

At the same time, as the potential for female participation in the labor force was increasing, the need for it was rising as well. Real wages have stagnated or declined, and as unemployment rates have increased, it has become more and more difficult for the relatively small number of working people to continue to provide increasing standards of living for their families.

To what extent has the potential increase in female participation in the labor force, which results from changes in education and fertility, been realized?

Starting from a low level, female participation in the labor force in MENA has grown by 50 percent since 1960 (figure 3.1). The growth rate

FIGURE 3.1

Actual and Projected Growth in Female Participation in the Labor Force in MENA, 1950–2010

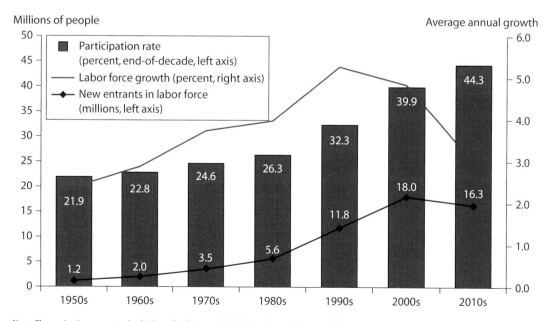

Note: The projections use standard ILO methodology, which is based on projections of changes in age structure and past trends of growth of female labor participation by age group, but does not account for changes in education levels, fertility, or economic conditions beyond what is implicit in past trends. Those estimates are, therefore, probably a lower bound of future growth of female participation in the labor force.
Source: ILO 1996; United Nations 2002.

TABLE 3.1

Trends in Female Participation in the Labor Force in MENA Countries and World Regions, 1960–2000

Country or region	1960	1970	1980	1990	2000	Percentage of change, 1960–2000
Algeria	16.9	17.6	19.1	20.1	31.2	85
Bahrain	4.8	5.7	18.2	29.8	36.5	668
Egypt, Arab Rep. of	25.9	27.4	29.2	31.5	37.0	43
Iran, Islamic Rep. of	19.8	19.8	20.6	22.2	30.1	52
Iraq	16.4	16.3	16.2	15.1	19.4	18
Jordan	13.6	14.4	14.6	17.8	27.8	104
Kuwait	8.2	12.1	21.1	38.8	48.2	486
Lebanon	12.5	18.1	21.4	26.2	32.3	158
Libya	20.5	19.0	23.4	21.3	26.1	28
Morocco	32.6	34.3	38.1	40.5	43.6	34
Oman	4.4	5.9	7.6	13.5	20.6	366
Qatar	5.5	8.3	14.4	34.0	43.3	691
Saudi Arabia	3.4	5.0	9.6	16.5	23.9	604
Syrian Arab Rep.	23.1	23.3	23.5	24.6	29.9	29
Tunisia	22.1	25.2	34.5	34.5	39.5	79
United Arab Emirates	5.7	8.9	16.3	30.6	36.7	548
West Bank and Gaza	6.3	6.4	6.4	6.6	9.7	55
Yemen, Rep. of	27.4	28.0	28.5	29.5	31.4	15
MENA	**21.9**	**22.8**	**24.7**	**26.4**	**32.2**	**47**
Sub-Saharan Africa	65.5	64.7	63.3	62.5	62.5	−5
South Asia	50.3	49.1	47.9	43.9	46.5	−7
East Asia and the Pacific	64.9	66.7	70.3	74.3	74.9	15
Eastern Europe and Central Asia	62.7	67.4	69.5	65.6	66.8	7
Latin America and the Caribbean	22.9	26.2	32.4	40.5	44.2	93

Notes: Labor participation is the ratio of the labor force to the total working-age population. It indicates the proportion of the available working-age population that is willing and able to work, and it includes people who are both employed and unemployed actively seeking work. Sub-Saharan Africa does not include Djibouti.
Source: Calculated using labor data estimates from the ILO (1996) and the United Nations (2002).

accelerated over the most recent two decades, reaching a dramatic 5.3 percent a year during the 1990s. The growth was also very rapid when compared to that in most developing regions, although considerably slower than that of Latin America and the Caribbean (table 3.1).[2]

Not surprisingly, a substantial part of the increase in female participation in the labor force in MENA has been due to the increased education and decreased fertility of working-age women (box 3.2). The increase also reflects the changing age profile of the region's adult women. For instance, 60 percent of women are now younger than 30, and this age cohort normally constitutes a higher proportion of the labor force.

BOX 3.2

Explaining Changes in Female Participation in the Labor Force in MENA

Education, fertility, and the age distribution of the population are important determinants of female participation in the labor force. Using panel regression analysis for 108 countries and three points in time (1980, 1990, and 2000), we carried out a decomposition of the change in female participation in the labor force in MENA. The results indicate that of the increase in participation rates between 1980 and 2000, nearly 21 percent was due to greater educational attainment by women and more than 37 percent was associated with the declines in the total fertility rate. The net effect of the changing age distribution of MENA's population accounted for nearly 15 percent of the increase in female participation. Almost 18 percent of the increase is unaccounted for by education, fertility, or age effects.

Explaining Changes in Female Labor Force Participation, MENA, 1980–2000

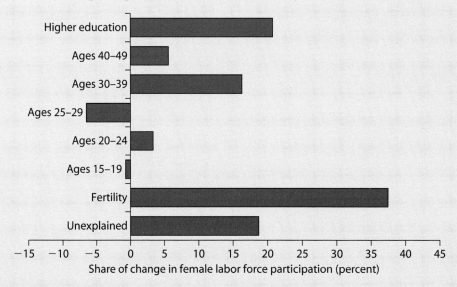

Source: World Bank staff estimates.

Specific age cohorts, however, displayed different patterns. The increase in the share of the population ages 15–19 explains the −0.7 percent of the change in female participation, given that increasing numbers of this age group are remaining in school and outside the labor force. A similar negative effect on female participation is associated with the 25–29 age group (−6.4 percent), reflecting the exit of women from the labor force at marriage or during child rearing. The combined effect of the ages 20–24, 30–39, and 40–49 accounts for 25.1 percent of the increase in female participation. For the 20–24 age group, this increase is due to this group's initial entry into the labor market, whereas for those ages 30–39 and 40–49, the positive effect reflects delayed marriage, the return of women to the labor market after child rearing, and delayed exit from the labor force.

... But Participation of Women in the Labor Force Remains Low

Despite the significant growth of female participation in the labor force and despite the high potential in MENA for women to participate in the labor force, actual rates remain among the lowest in the world. Figures 3.2 and 3.3 show that the current rates for women of working age are lower than in any other region of the world.

To avoid inappropriate comparisons between the countries of MENA and those of other regions that have different levels of fertility and female education, we calculate the rates of labor force participation that would be expected on the basis of characteristics of each country's female population (levels of fertility, female education, and female population age profile), given world patterns. More precisely, we use panel regression analysis to estimate the effects of education, fertility, and age distribution on female participation (box 3.2). If the general pattern to determine the supply of female labor found throughout the world applies to MENA, the ratios of actual to predicted rates for countries of the region would be about one.

FIGURE 3.2

Male and Female Participation in the Labor Force in World Regions, 2000 or Latest Year Available

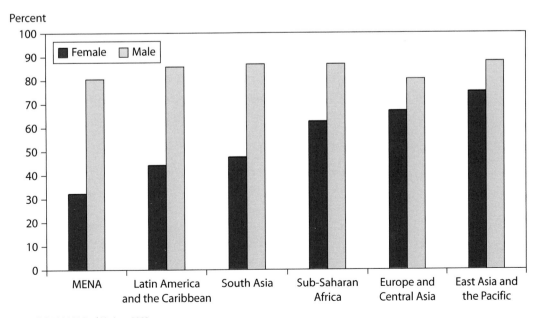

Source: ILO 1996; United Nations 2002.

FIGURE 3.3

Ratio of Actual to Predicted Female Participation in the Labor Force in MENA and Selected Countries and Regions, 1980 and 2000

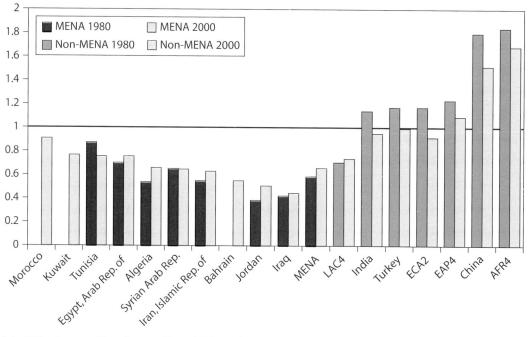

Actual: predicted ratio

Note: AFR4 = Cameroon, Ghana, Kenya, and Senegal; EAP4 = Indonesia, Malaysia, the Philippines, and Thailand; ECA2 = Hungary and Poland; and LAC4 = Argentina, Brazil, Chile, and Mexico. Bahrain and Kuwait estimates are based on total female participation in the labor force (which includes foreign workers).
Source: World Bank staff estimates.

Figure 3.3 shows that for all MENA countries, the observed rates of female participation in the labor force are lower—often by substantial margins—than would be expected from the other characteristics of the female working-age population. This observation indicates that the potential to integrate women into the regional economy, determined by past investment in female education and recent fertility trends, has not been realized. In countries for which comparisons over time can be made, the ratios have improved between 1980 and 2000 in all except Tunisia, but they always remain lower than one. This improvement shows that many MENA countries are including their women in the labor force at a faster rate than they are improving women's educational attainment and reducing fertility. As education increases and fertility decreases, the "expected" rate of female labor force participation increases. If the ratio of observed to expected rates of female labor force participation improves over time, it means that the observed rate is growing faster than the rate that would be expected (on the basis of higher education

FIGURE 3.4

Variations in Female Rates of Labor Force Participation in Country Groups within MENA, 2000

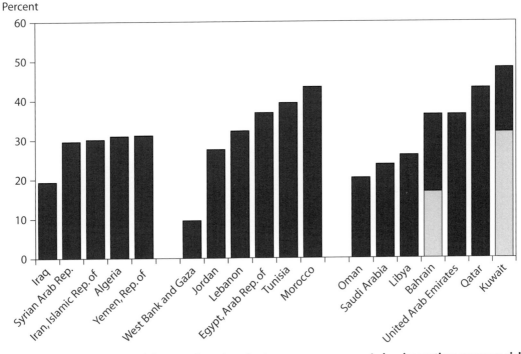

Percent

Labor abundant, resource rich Labor abundant, resource poor Labor importing, resource rich

Note: The lower bars for Bahrain and Kuwait include nationals only.
Source: ILO 1996; United Nations 2002.

and lower fertility). This progress is still relatively slow when compared to other regions, but it can be increased.

Female participation rates vary within the region. The economies of MENA fall generally into three categories, related to their labor and natural resource endowments: labor-abundant and natural resource–rich category, labor-abundant and natural resource–poor category, and labor-importing and natural resource–rich category (figure 3.4).

The labor-abundant, natural resource–rich countries (Algeria, the Islamic Republic of Iran, Iraq, Syrian Arab Republic, and the Republic of Yemen) tend to have slightly lower average rates of female participation in the labor force than do the labor-abundant, natural resource–poor economies (Arab Republic of Egypt, Lebanon, Morocco, and Tunisia), although Jordan and the West Bank and Gaza are exceptions. This inverse relationship between natural resource–based income and women's participation in the labor force is to be expected: higher levels

of unearned income, such as natural resource rents, reduce the need for earned income and promote investments in more capital-intensive industries; the former lowers the supply of and the latter reduces the demand for female labor. Moreover, because their relatively high incomes and redistributive social contracts supported investments in girls' education, those countries tend to have potential rates of female participation that are much higher than their actual rates.

The natural resource–poor economies have had to rely more heavily on labor-intensive development through agriculture or through manufacturing. For this reason, they have depended more heavily on women's economic participation, and they tend to have rates of participation closer to, but still below, their potential.

In countries in the third category—the labor-importing, natural resource–rich countries of the Gulf Cooperation Council—reported rates of female participation in the labor force seem to be driven by their foreign female work forces. Within this group, the three countries with the highest rates of participation—Kuwait, Qatar, and the United Arab Emirates—all have work forces made up of more than 80 percent foreigners. Because foreign workers are counted as part of the labor force, the participation rates of nationals are overestimated and are likely to be considerably lower than those shown in the figures. Available data for two countries—Bahrain and Kuwait—provide disaggregated data for female national and female foreign workers. In Bahrain, participation of female nationals in 2000 was 18.49 percent (versus 34.1 percent for all female workers), and in Kuwait the rate was 31.3 percent (versus 37.8 percent for all female workers). Hence, predicted rates of participation could be calculated only for Bahrain and Kuwait. Even though the calculation used total female participation (including foreign workers), the ratio of actual to predicted female labor is still low in both countries, particularly in Bahrain, where actual rates are one-third of predicted rates.

Economic Impact of Low Participation by Women in the Labor Force

Whatever the cause of the low participation of women in the labor force in MENA, it is costly to women, their families, and communities. This section describes two pieces of evidence that provide some indication of the presence and significance of these costs. The first relates to the resulting high economic dependency and the second to the different rates of return on education for men and women. This section goes on to provide some estimates of the costs that families and societies incur because of the lower participation of women in economic activity.

The Burden of High Economic Dependency

The well-being of the population—including consumption of food, housing, health care, and other market-based goods and services—is determined not only by how much each working person earns but also, crucially, by the portion of the population that works.

During the 1970s and early 1980s, rapidly increasing real wages made it possible for a small number of working individuals to support a large number of nonworking dependents and simultaneously to enjoy rising living standards. Since the mid-1980s, as real wages have stagnated or declined and as unemployment rates have increased, it has become increasingly difficult for the relatively small number of working people to continue to provide increasing standards of living for their families.

Despite the declining ability of workers to maintain living standards for their families, the number of nonworking dependents per worker continues to be higher in MENA than in all other regions. Only Sub-Saharan Africa comes close to (but still remains below) the same ratio. In MENA, each working person supports more than two nonworking dependents, compared with fewer than one in East Asia and the Pacific (figure 3.5).

FIGURE 3.5

Ratio of Nonworking to Working People in Developing Regions, 2003

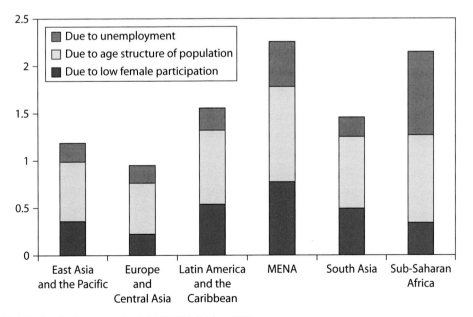

Source: World Bank staff estimates based on ILO LABORSTA Database 2003a.

International variations in this ratio—referred to as the economic dependency ratio[3]—are largely determined by three factors: the unemployment rates, the age profile of the population, and the amount of female participation in the labor force.[4]

Unemployment is a major concern in MENA and contributes substantially to the economic dependency ratio.[5] The portion of the economic dependency ratio caused by unemployment (figure 3.5) has been determined by calculating what the ratio would be if all those who are unemployed were to find jobs. The results show that bringing the economic dependency ratio into a sustainable range requires a reduction in unemployment, but that even if MENA were to resolve the unemployment problem, the region would still have nearly two nonworking dependents per worker (see figure 3.5).

The age profile of the population provides another part of the reason that MENA has the highest economic dependency ratio in the world. In 1950, MENA had the highest fertility rate in the world at 7.0 children per woman, a position that the region maintained through 1970. Fertility has since declined, slowly at first but more rapidly since 1985, and the gap between MENA and other developing regions has narrowed. The portion of the economic dependency ratio resulting from the age profile of the region's population is large. However, it is shrinking as the bulge in the child population attains working age. It will continue to shrink until 2020 as the region moves into the stage of "demographic gift"— when the growth of the working-age population will exceed the growth of the population under age 15 by a much bigger margin than in any other region in the world. So, although MENA's age structure is still relevant to its high economic dependency ratio, that effect will become smaller over time. By 2025, the proportions of the populations of working age in MENA, East Asia, and Latin America will be nearly equal.[6]

The third main factor determining the economic dependency ratio is the rate of women's participation in the labor force. Even if MENA were able to eliminate unemployment completely, and even controlling for differences in age distribution, each income would need to support 0.75 individual in MENA—three times as high as the comparable number in East Asia and the Pacific. Because men's participation rates vary little from one region to another, this remaining share of the economic dependency ratio is due almost entirely to differences in the women's participation rates.

As is clear from figure 3.5, all three factors—unemployment, the age profile of the population, and the rate of women's participation—play important roles in making MENA's economic dependency ratio the highest in the world. Although the momentum of past fertility and mortality changes implies that the age profile of the population will decline

in importance over time, the other two factors will not change automatically. Bringing unemployment rates down is crucial but not sufficient to bring MENA's economic dependency ratio into a sustainable range. So long as women's participation in regional labor forces remains low, the economic dependency ratio is likely to remain the highest in the world.

Forgone Return on Investments in Girls' Education

Because so few of MENA's women work, the region is forgoing much of the potential return on its investments in women's education. Figure 3.6 shows the gradual increase over time in female participation rates in the context of the increase in female education. This figure uses female secondary enrollments as a proxy for average years of schooling. Although the average education of the adult population is only imperfectly captured by female enrollment and is felt only with a lag, clearly the potential returns on the region's massive investment in female education will not be achieved so long as female participation in the labor force continues on its current path.

In contrast, in regions where female participation is high, investments in female education are more fully used. In East Asia and the Pacific, for example, most women work (figure 3.6), which implies that most of those

FIGURE 3.6

Female Education and Labor Force Participation in MENA and EAP, 1970–2000

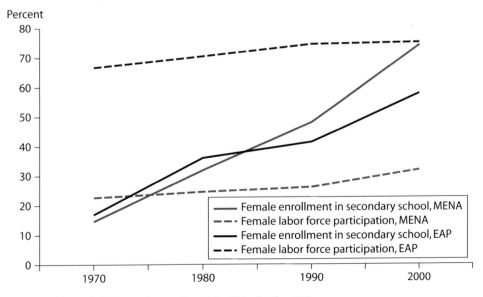

Note: In East Asia and the Pacific (EAP), secondary enrollment is for 1999 rather than 2000.
Sources: ILO 1996; World Bank 2003d, 2003j.

girls who receive an education will use that investment in their productive potential (as well as use the other benefits of education).

Another aspect of the return on female education is to consider rates of return on schooling for men and women according to the wage structure. Table 3.2 provides estimated rates of return on schooling for selected MENA countries by gender and sector. The reported results are for rates of return per year of education. The estimates for higher levels of education are cumulative rather than incremental, so that a return of 9.6 percent per year of vocational schooling in the upper secondary level is the average return for each of the 11 or 12 years of schooling that lead to this certificate, rather than the incremental return for the past 3 years of secondary schooling.

TABLE 3.2

Rates of Return to Schooling, by Gender and Sector, in MENA Countries, 1988–99

(percentage per year)

Indicator	Egypt, Arab Rep.		Morocco		Jordan	Yemen, Rep of
	1988	1998	1991	1999	1997	1997
Male public						
Primary	8.2	6.4	12.4	6.1	3.5	2.7
Lower secondary	7.0	4.9	10.7	8.2	2.9	2.7
Upper secondary, general	8.6	8.8	10.6	8.8	2.8	2.2
Upper secondary, vocational	9.6	7.2	8.4	6.8	3.8	3.3
University	10.1	8.8	10.8	8.9	4.6	3.8
Male private						
Primary	2.3	3.6	3.0	3.4	2.0	2.7
Lower secondary	2.5	4.4	6.4	6.3	5.5	2.7
Upper secondary, general	6.3	7.3	10.4	7.7	6.0	2.2
Upper secondary, vocational	5.3	5.0	6.9	5.8	3.2	3.3
University	8.5	7.3	12.5	9.5	10.2	5.2
Female public						
Primary	1.9	5.3	28.2	10.5	−3.9	5.1
Lower secondary	7.7	8.2	22.3	13.4	5.2	3.7
Upper secondary, general	8.6	9.7	18.1	12.1	4.6	3.9
Upper secondary, vocational	7.9	9.6	16.5	11.9	4.3	4.3
University	8.9	10.7	15.0	12.8	6.8	4.4
Female private						
Primary	0.9	7.2	8.5	9.4	14.7	8.0
Lower secondary	3.2	−11.2	13.9	10.0	9.8	7.4
Upper secondary, general	3.8	−1.5	16.4	11.0	10.4	12.1
Upper secondary, vocational	4.4	4.9	11.1	11.3	8.6	10.7
University	9.1	10.9	15.2	9.3	12.9	6.8

Note: Derived from regression that controls for potential experience and potential experience squared, urban and rural location, and part-time and casual work status in the private sector. The Republic of Yemen regressions control for age and age squared instead of potential experience and potential experience squared. All regressions control for sample selection using the Heckman procedure, except for the Morocco regressions.
Source: World Bank staff estimates.

These estimates show that, with the possible exception of Egypt, the rates of return on education in the private sector are higher for women than for men. This fact means that the gender gap in wages declines with education, but not that educated women are doing better or have a higher participation than educated men in this sector. Wage setting in the private sector emphasizes educational differences to the extent that they result in productivity differences. In contrast, in the public sector, wage-setting rules place stronger emphasis on formal education and seniority. In the case of women, wage inequality and wage barriers along with other dimensions that do not consider their economic productivity (such as social norms and lack of flexibility and resources to help them maintain their family responsibilities) may work to discourage women from the private sector—contributing to a forgone return on their education. Given the increasing participation of women in the labor force and a new development model that emphasizes an expanded role for the private sector, women's educational investment may not be fully recouped unless these noneconomic issues are addressed.

High Costs for Households Headed by Women

Another area where the cost of low female participation manifests itself is in the support provided by female-headed households. For households headed and financially supported by women, work outside the house is often an inescapable need. Female-headed households are a smaller proportion of the total in MENA than in other regions—ranging from 5 percent in Kuwait to 17 percent in Morocco.[7] This proportion appears to be growing (El-Kholy 1996a, 1996b), because of rising rates of divorce and increasing life expectancy (implying an increase in the number of years a woman can expect to live as a widow). Women in female-headed households are more likely to participate in the labor force than women in male-headed households, even after controlling for education and other factors.[8] Despite their greater likelihood of working, females who head households receive only a small portion of their income from earnings—36 percent on average, as opposed to 71 percent in male-headed households—and they depend heavily on transfers from friends and family (figure 3.7).

The Costs of Low Female Participation Compared with Family and National Income

How large are the potential long-term benefits of higher participation of females in the labor force? To explore this question, we have performed two types of simulations. In the first, we use household survey data to estimate the increase in the earned income of the average family. In the second, we use cross-country regressions to estimate the effect of female

FIGURE 3.7

Sources of Income for Female- and Male-Headed Households in MENA Countries, Various Years

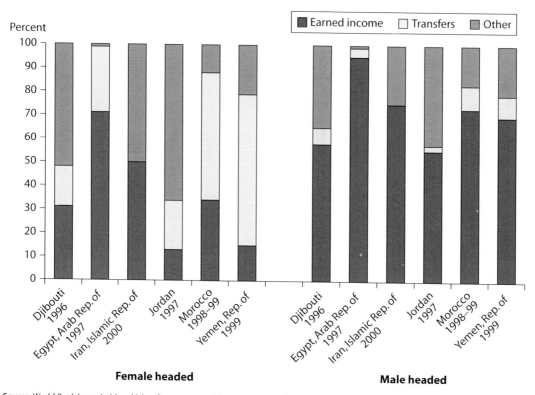

Source: World Bank household and labor force surveys of the most recent official date for each country.

participation on the growth rate of per capita income (gross domestic product per capita).

Effects on the average level of household income. Consider first the effect of female participation on the earned income of the average family. We include all countries for which background data from household surveys are available (Egypt, Jordan, Morocco, Tunisia, the Islamic Republic of Iran, and the Republic of Yemen).[9] In this simulation, we calculate how the earnings of the average household would change if female participation in the labor force increased from its actual rate to the rate predicted using the country's levels of female education and fertility, and its age profile.

This change in household income occurs simply because a larger number of household members are working. The analysis does not assume any change in women's income-earning potential, but does assume that women would continue to earn less than men for two reasons: (a) the women who would enter the labor force would be typical

of women in the population as a whole, which implies that they have less education and experience than male workers,[10] and (b) the current level of wage discrimination would continue.[11] We do assume that the women who enter the labor force are able to find jobs or can create income-generating opportunities for themselves. The assumption that increases in female participation will be met by a comparable increase in employment, rather than an increase in unemployment, is valid for our current purposes because we are examining the potential benefits over the long term. The relationship between female participation and unemployment is discussed more fully in a later section.

The simulation shows that in most countries household incomes would increase substantially if women participated in the labor force at predicted rates (when accounting for the characteristics of female education, age profile, and fertility). (See figure 3.8.) In Egypt, for example, household income could increase by more than 25 percent. The one country for which estimated income growth is less than 10 percent is the Republic of Yemen—where estimated growth is small for two reasons. First, because actual rates of female participation are relatively close to their potential, the actual participation rate is 31 percent and the predicted rate is 38 percent. This near parity occurs because in the Republic of Yemen

FIGURE 3.8

Potential Increases in Average Household Income If . . .

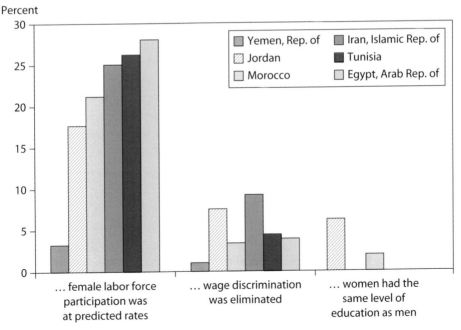

Source: World Bank staff calculations based on World Bank household and labor force surveys.

the level of female education is low and fertility is high; thus these factors would not affect the predicted rate significantly. The second, related reason is that women's wages are so much lower than men's wages and therefore make only a modest contribution to household incomes.

To put the potential benefits from increased female participation into perspective, we have broken down the effect of other changes related to working women: (a) the potential effect of bringing women's education up to the level of men and (b) the potential effect of eliminating wage discrimination. In some cases, the effect of those changes on the women who are already in the labor force is significant. In the cases of Jordan and the Islamic Republic of Iran, for example, wage discrimination in the private sector is estimated to be very high (see chapter 4 for further discussion). In both countries, women's wages could increase by as much as 35 percent in the absence of discrimination. However, although eliminating discrimination would have a large effect on the incomes of those women who do work, the effect on average household income will be small as long as so few women work.

The Republic of Yemen is again an interesting contrast to the other MENA countries. Its household incomes could increase by more than 6 percent if women had the same level of education as men—a potential increase even larger than the increase that would come from eliminating wage discrimination or from increasing participation rates to predicted levels. Those factors are all interrelated. Although earnings of Yemeni women are less than half those of Yemeni men, only a small portion of this difference is due to discrimination, with the largest part caused by women's very low educational status. As long as women's educational status is so low, interventions aimed at increasing their economic opportunities are unlikely to have large effects on family incomes.[12]

In all other countries—no matter how large the effects of discrimination or of gender differences in education on the incomes of working women—significant increases in household income can come about only by bringing actual rates of labor force participation closer to potential rates. For most MENA countries, further reducing the education gap will not be enough to improve the economic empowerment and labor force participation of women.

Effect on the growth of aggregate income. The simulations just discussed show how income levels would rise in response to an increase in female participation in the labor force. We now consider the effect of increased female participation on aggregate income growth.

Although the mechanism behind an increase in levels of family income is clear, the reasons that female participation could result in permanently higher rates of growth in aggregate income (or GDP per

capita) need some explanation. Klasen and Lamanna (2003) suggest four mechanisms for the growth effect:

1. The first mechanism is, increased female participation in the labor force increases the average ability of the work force by expanding the pool of innate talent from which employers can draw.[13]

2. The second mechanism relates to international competitiveness. International experience, particularly in many East Asian countries, shows that countries have been able to achieve high growth through export-oriented, female-intensive manufacturing industries. If MENA wants to improve its international competitiveness, it would need a large enough female labor force to be able to follow a similar growth strategy.

3. The third mechanism relates to the importance of women's employment and income for their bargaining power within families. Evidence from other regions indicates that women tend to spend a greater share of their income (relative to men) on the education and health of their children (box 3.3). Assuming this investment is also true in MENA, the increased human capital of the next generation could have long-term growth effects.

4. The fourth mechanism relates to governance. There is significant cross-regional evidence that women in general are less prone to political corruption and nepotism than men (World Bank 2001). If the same generality holds in the realm of business, improving the access of women to jobs might improve governance in business.

To estimate the effect of increased female participation on income growth, Klasen and Lamanna (2003) use regression analysis on a panel data set for the four decades from 1960 to 2000 to analyze the determinants of GDP per capita growth. Because of data limitations, the set of "MENA countries" is limited to Algeria, Egypt, the Islamic Republic of Iran, Jordan, Morocco, Syria, and Tunisia. The analysis focuses on the ratio of female to male participation rates. The regressions also control for the male participation rate,[14] education, fertility, and a variety of variables that are commonly found to affect economic growth. The point estimates from these regressions are then used to estimate how much higher the income growth might have been if female participation in the labor force were at the rates predicted for each country. Klasen and Lamanna use the same predicted rates—which were based on fertility, female education, and the age profile of the female population—as those we have used throughout this chapter.

Taking a simple average over this set of countries, Klasen and Lamanna find that during the 1990s, annual growth in per capita GDP could have

BOX 3.3

Effects of Women's Earnings on Expenditure Patterns

Greater female participation in the labor force is likely to affect not only what the level of household income is but also what it is used for. Ample evidence from a variety of regions suggests that how income enters the household affects how that income is spent. In Côte d'Ivoire, increasing women's share of cash income significantly increases the share of the household budget allocated to food, after controlling for average per capita expenditure (income), household size, and demographic characteristics. It also decreases the shares of household expenditures allocated to alcohol and tobacco (Hoddinott and Haddad 1995). Thomas (1997) finds a similar story using Brazilian data. He finds that, at the margin, additional income in the hands of women results in a larger share of the household budget going toward nutrition, health, and education.[1] Studies examining men's versus women's control over other types of assets (assets brought to marriage, credit, and transfers from government sources) show similar effects: the greater the woman's control over household resources, the greater is the share of resources devoted to children.

[1]The endogeneity of labor income is addressed in the Hoddinott and Haddad (1995) study by using differences in educational attainment between husband and wife, and by using proportions of land and business capital operated or owned by wives as instruments for the share of women's income. Thomas (1997) tests for endogeneity of labor income by repeating the analysis using nonlabor income: he finds similar results with both labor and nonlabor income.

been 2.6 percent rather than the 1.9 percent actually experienced. When compounded over time, this difference of 0.7 percent per year would produce a significant increase in the level of income per capita.

Unemployment and Female Participation in the Labor Force

The low rates of participation of women in the labor force in MENA countries clearly result from both supply and demand factors. The remaining sections of this chapter explore some macroeconomic factors that have operated primarily through the demand for female labor. Because macroeconomic factors affecting labor demand are explored at length in the companion reports on trade and employment (World Bank 2003g, 2003i), this discussion focuses on only the gender-related aspects.

The first and most significant macroeconomic factor is unemployment. MENA as a whole has very high unemployment rates, which have been increasing over the past decades (World Bank 2003g). The overall weak growth performance of MENA during this period has led to poor

labor market outcomes and has not allowed the absorption of the large increases in the supply for labor. The high unemployment rates in the region may have suppressed the demand for female labor and may also have discouraged women from entering the labor force. Given the region's very high rates of unemployment, policymakers and others are understandably concerned that increased participation of women in the labor force could exacerbate the already serious situation. This section will argue that such concerns are unfounded.

Women Face Higher Unemployment than Men Do . . .

Throughout the world, women tend to have higher rates of unemployment than men have (figure 3.9). In most countries in MENA (Bahrain, Egypt, Jordan, Kuwait, Lebanon, Qatar, Saudi Arabia, Syria, and United Arab Emirates), female unemployment is higher than male unemployment. Only in Algeria, the West Bank and Gaza, and the Republic of

FIGURE 3.9

Male and Female Unemployment Rates in MENA Countries and World Regions, Most Recent Year

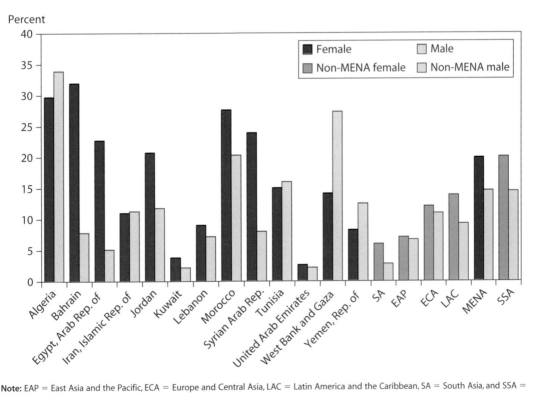

Note: EAP = East Asia and the Pacific, ECA = Europe and Central Asia, LAC = Latin America and the Caribbean, SA = South Asia, and SSA = Sub-Saharan Africa.
Sources: Regional data and data for Algeria, Egypt, Syria, the West Bank and Gaza, and Lebanon from ILO; others from World Bank household and labor force surveys.

Yemen are unemployment rates for men significantly higher than those for women. For the region as a whole, unemployment is about 20 percent higher for women than for men.

Moreover, measured unemployment rates probably underestimate the underutilization of women's labor because, although men tend to continue looking for work, women are more likely to report themselves as housewives even if they would work if a job were available. This effect is illustrated in the following example: In Egypt, unemployment rates in 1997 were 7 percent for men and 21 percent for women. An additional 2 percent of men were identified as outside the labor force because, although they wanted to work, they didn't think they would find work and, therefore, did not bother looking. Among women, 11 percent fell into this "discouraged worker" category. If discouraged workers were included in unemployment rates, 32 percent of women would be reported as unemployed, compared to a much lower 9 percent of men.

For both men and women, unemployment rates tend to be highest among those who have more education. Among women, however, unemployment rates tend to peak at a higher level of education than for men. Figure 3.10 demonstrates female unemployment by level of education.

FIGURE 3.10

Female Unemployment Rates by Educational Level in MENA Countries, Various Years

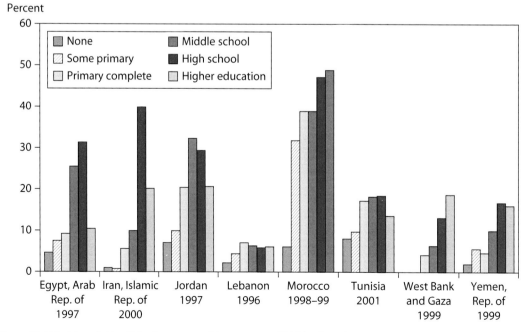

Source: World Bank household and labor force surveys of the most recent official date for each country.

...But Higher Female Labor Force Participation Is Not Associated with Higher Unemployment

Higher unemployment rates for women than for men indicate that the employment of women does not displace the employment of men, and that there is not a simple correlation between the supply of female labor and the rate of male or overall unemployment. Moreover, empirical evidence shows that the direction of causality, in the relationship between unemployment and the increases in labor supply, is not straightforward.

In theory, the relationship between overall unemployment and women's participation in the labor force could be positive or negative. The following discussion considers three possible forms of this relationship.

The first form—and the one of greatest concern to policymakers—is that by augmenting the total labor force, the increases in women's participation would raise unemployment levels. It is certainly possible that in the short run, the economy may not be flexible enough to absorb a sudden increase in the supply of labor. But it is unlikely that an increase in women's participation would be sudden and would increase male unemployment because (as discussed in chapter 4) men and women generally do not compete for the same types of jobs. More important, because increases in women's participation occur gradually over long periods, concerns about short-term absorption capacity are misplaced.

The second form of the relationship describes the reverse causality. Several microeconomic studies have shown that women tend to enter the labor force during periods of high male unemployment in order to supplement family income. This is the so-called added worker effect.[15]

Both of these forms of the relationship imply that increases in unemployment coincide with increases in female participation in the labor force. The third explanation implies the opposite, particularly that existing high rates of unemployment may discourage women from entering the labor force. Even if they would work if a job were available, such discouraged potential workers are not counted as being in the labor force because they do not actively seek employment and are instead identified as wives or mothers. Men in similar situations are more likely to identify themselves as actively seeking work, because they do not have an obvious alternative identity.[16]

Indeed, it is possible that all three of these mechanisms operate simultaneously. Which mechanism dominates is, therefore, an empirical matter. Data from OECD countries show a weak negative correlation between unemployment and female participation in the labor force, while data from MENA countries show a somewhat stronger negative

FIGURE 3.11

Female Labor Force Participation and Unemployment in MENA and OECD Countries, 2000
(percent)

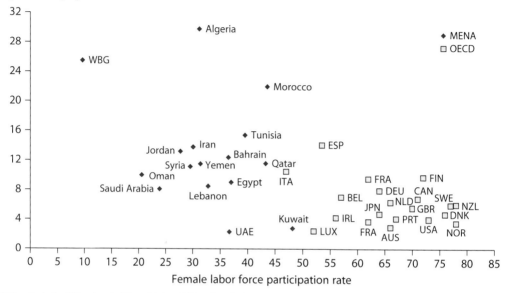

Note: AUS = Australia, AUT = Austria, BEL = Belgium, CAN = Canada, DEU = Germany, DNK = Denmark, ESP = Spain, FIN = Finland, FRA = France, GBR = Great Britain, IRL = Ireland, ITA = Italy, JPN = Japan, LUX = Luxembourg, NLD = Netherlands, NOR = Norway, NZL = New Zealand, OECD = Organisation for Economic Co-operation and Development, PRT = Portugal, SWE = Sweden, UAE = United Arab Emirates, USA = United States of America, and WBG = West Bank and Gaza.
Source: Scarpetta forthcoming; World Bank 2004.

correlation, if anything. Some of the countries with low female partici-
pation are also those with relatively high unemployment rates
(figure 3.11). According to this figure, the dominant line of causality ap-
pears to be that high unemployment may constrain female participation
in the labor force.

The practical implication of the finding is that it would be necessary
first to reduce MENA's high unemployment in order to effect increases
in female participation. A second important implication is that—at least
in the long run—the fear that increased participation of women would
lead to higher unemployment is unfounded. On the contrary, it can be
argued that a healthy economy that is more inclusive of women in the
labor force is also likely to enjoy lower unemployment. In this context,
the challenge for MENA is the overall expansion of opportunities for
both men and women, building on their specific skills and talents. The
critical factors for creating these opportunities rest on the overall devel-
opment model and its implied patterns of growth, rather than on the
creation of opportunities for one group at the expense of the other.

Mixed Effect on Female Employment from Old Patterns of Growth

A large role for the public sector, extensive government controls and interventions, inward-looking trade policies, and a weak investment climate limited the scope and dynamism of the private sector and shaped the extent and nature of female employment in MENA. While women have enjoyed favorable opportunities in the public sector, they have faced significant disadvantages in the private sector, often working in jobs with low wages (and presumably low productivity) and little potential for future growth. The informal sector and agriculture are two such areas in which women frequently work. In this section, we briefly examine the roles of women in the public and informal sectors and in agriculture.

Women Have Tended to Work More in the Public Sector

In most of the region, women have tended to participate heavily in public sector employment. Reasons include (a) the fact that public service professions such as teaching and nursing have been considered appropriate and acceptable for women; (b) the public sector's egalitarian (and affirmative action) practices in hiring and wage setting;[17] and (c) the favorable conditions of work in the public sector, including generous maternity leave benefits and working hours shorter than those typical in the private sector.

Within MENA, Algeria has the highest concentration of female employment in the public sector, with more than 85 percent of its female labor force in public employment in 1990 (figure 3.12). In 1987/88 in both Jordan and Egypt women also held comparatively large shares of public employment: 54 percent and 66 percent, respectively, although by 1998 the share in Egypt had dropped to 57 percent. In Syria, it remained stable at about 42 percent throughout the 1990s, while in Morocco, by contrast, the share was a low 7 percent throughout the 1990s.

Not only has the public sector employed significant portions of the female work force, but also in many countries in the region, public sector jobs have accounted for a larger proportion of women's jobs than of men's (figure 3.13). In Egypt and Jordan, in particular, a far higher proportion of working women than working men hold public sector jobs. Despite these high levels of participation, women face limited upward mobility as they tend to occupy a relatively small proportion of decision-making positions.

Although women have benefited from public sector jobs in the past, those benefits will not be as significant for the next generation of female workers. Even if public sector employment is not reduced, the share of

FIGURE 3.12

Female Employment in the Public Sector in MENA Countries, Various Years

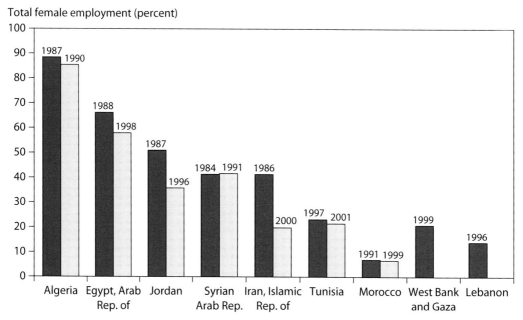

Total female employment (percent)

Sources: For Algeria, People's Democratic Republic of Algeria 1990 and ILO 2003b; for Egypt, Arab Republic of Egypt 1988 and Egypt 1998; for Morocco, Morocco 1999; for the Islamic Republic of Iran, Statistical Center of Iran 2000; for Jordan, Hashemite Kingdom of Jordan, Department of Statistics 1997; for Lebanon, *Population and Housing Survey* 1996; for Tunisia, INS 1997 and 2001; for the West Bank and Gaza, Palestinian Central Bureau of Statistics 1999; for Republic of Yemen, Republic of Yemen Central Statistical Organization 1999.

FIGURE 3.13

Public Sector Employment as a Percentage of Women's and Men's Jobs, Various Years

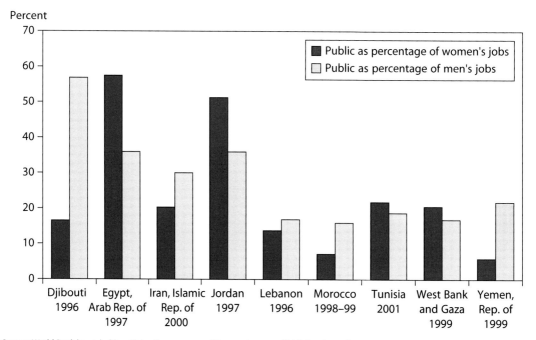

Percent

Source: World Bank household and labor force surveys of the most recent official date for each country.

the labor force working for the public sector is not likely to grow. Moreover, as the demographic bulge moves beyond school age, there will be a declining need for teachers—traditionally an important public sector job for women. As a result, the public sector cannot be as important a source of jobs in the future as it was in the past.

Women and Men Are in Informal and Unregulated Categories of Work

In the state-led era, most countries in MENA adopted protective labor regulations that provided workers with job security and adequate benefits, including maternity leave. Those regulations were more or less universally enforced in the large public sectors but were very imperfectly enforced in the private sector. Moreover, the existence of the informal sector is due, in large part, to the desire of enterprises—especially very small, low-budget enterprises—to avoid compliance with costly and burdensome regulations, including labor regulations and mandatory employee benefits. As reforms have gotten under way in the past decade, there has been limited explicit deregulation. Instead, efforts to encourage employment creation in the private sector have meant that private businesses have enjoyed lesser enforcement of labor laws for new labor market entrants.

Informal employment is typically estimated as the residual resulting from subtracting employment in registered enterprises. Figures 3.14 and 3.15 present two sets of data. Figure 3.14 uses the typical definition mentioned, and it excludes agricultural workers. Figure 3.15 uses a more comprehensive method, with rich data sets from a small number of MENA countries. It permits a more extensive view of unregulated work and includes agricultural workers, in addition to people usually considered to be working in the informal sector, and all individuals working without a contract or benefits, even in the formal sector.

Both methods of estimation show that most workers in MENA work outside the regulated labor market. However, whereas figure 3.14 indicates that men are more likely than women to be in informal employment, figure 3.15 indicates the opposite. The difference is likely due to the fact that many women perform unpaid agricultural work, which is included in figure 3.15 but not figure 3.14. Within the broad category of unregulated work, women and men tend to have different work arrangements. Women are more likely than men to be engaged in nonwage work (self-employment or work on a family farm), while men are more likely than women to work for wages, albeit without a contract or benefits. This pattern holds in Egypt, Jordan, Lebanon, Morocco, Tunisia, and the Republic of Yemen. Djibouti and the West Bank and Gaza appear to be exceptions.

FIGURE 3.14

Informal Employment as a Percentage of Total Nonagricultural Employment, 1994–2000

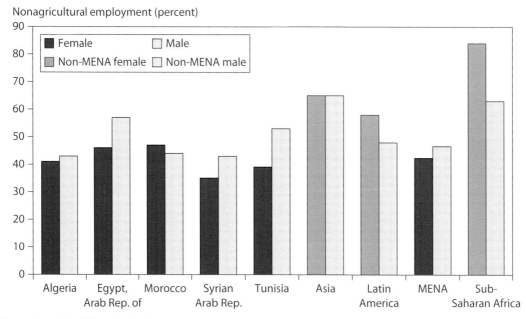

Nonagricultural employment (percent)

Source: International Labour Organisation 2002.

FIGURE 3.15

Informal Sector Work as a Percentage of Labor Force Participation in MENA Countries, Various Years

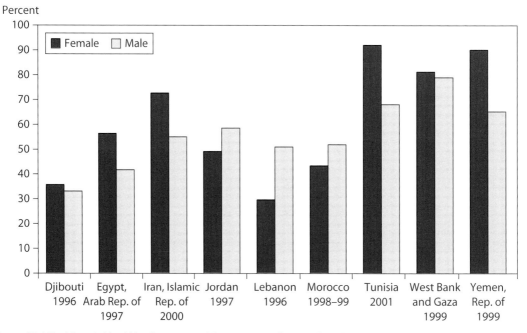

Percent

Source: World Bank household and labor force surveys of the most recent official date for each country.

Women Remain in Agriculture Longer than Men Do

The share of agriculture in employment in MENA declined rapidly up to the mid-1980s, stabilized in the late 1980s, and then resumed its decline in the 1990s. In a pattern familiar to many parts of the world, as agriculture declines, women do not leave the sector as fast as men. In fact, in Egypt, the Islamic Republic of Iran, and Tunisia, growing shares of women's jobs are in agriculture (figure 3.16).

There is not enough information in MENA on this topic, but research performed in the African context may provide some insight as to why women often earn less than men in agriculture and what factors lead women to be less productive. In Africa, women farmers often find it difficult to adopt productivity-enhancing technologies because they have land rights only through men;[18] they are obliged to provide labor to male-controlled activities, which sometimes take precedence over working on the tasks they themselves control; and they may have relatively little freedom to reinvest their income in labor-saving equipment or other technology (Dey Abbas 1997). Country studies in Sub-Saharan Africa show that the percentage of women obtaining credit from formal financial institutions is less than half that of men. Because women are less mobile than men, banks are harder for them to reach; more women than men are illiterate, making documentation difficult; and women lack collateral, particularly land titles (Saito 1994). Furthermore, extension

FIGURE 3.16

Women Are Not Leaving Agriculture as Quickly as Are Men in MENA Countries, 1970–2000

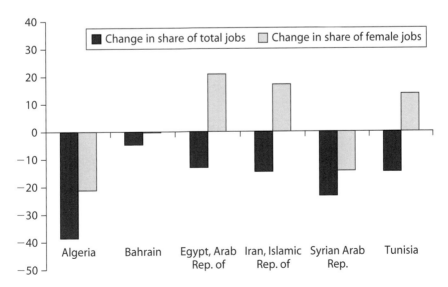

Source: United Nations 2000a.

services may be targeted more toward typically male tasks or may be un-available to women because agents are men and because communication between women and men is culturally frowned upon.

Farm work—frequently poorly paid or unpaid—is unlikely to provide a positive future for working women in MENA. Evidence shows that there will be fewer agricultural jobs in the future and, where women continue to work in agriculture, their labor is likely to be poorly used and poorly rewarded.

The Challenge of Inclusion in the Private Sector

In all MENA countries, the factors, including education and fertility, that have brought increasing numbers of women into the labor force are stronger than ever and are likely to create a surge in female participation in the labor force. A projection of this growth over the next two decades was shown in figure 3.1.

The overall rate of growth of the female labor force, which reached more than 5 percent in the 1990s, is projected to grow at about the same rate during the 2000s when compared to a rate lower than 3 percent for men (figure 3.1). The number of women entering the labor force is projected to increase by 18 million during the 2000s (compared to 6 million in the 1980s and 12 million in the 1990s), or 43 percent of the total increase in the labor force. Although the growth rate is likely to start declining by the end of the decade, the total number of women entrants will continue to be large.

This surge is bringing new generations of increasingly educated women into the labor market. As discussed, the old development model has been unable to provide jobs for women or for educated workers, and rates of unemployment are highest among these two groups (figure 3.17).

How has women's representation in the paid private sector changed over time? Are women increasingly or decreasingly working in high-growth sectors? Rich household survey data for Morocco and Egypt allow analysis of the proportion of women in paid private sector employment, and the data show two opposite trends during the past decade. The case in Egypt is generally representative of the region as a whole. In 1988, the proportion of women in Egyptian nongovernmental paid employment was only 15 percent, and it fell to an even lower 10 percent during the 1990s. The defeminization of nongovernmental paid employment took place across all job types. Despite the fact that some disproportionately female job types grew faster than average, their defeminization counteracted the effect of this growth, resulting in overall defeminization.

In contrast to the defeminization observed in Egypt, Morocco and Tunisia have had some success in increasing women's participation in the

FIGURE 3.17

Paid Private Sector Employment as a Percentage of the Labor Force, Men and Women in MENA Countries, Various Years

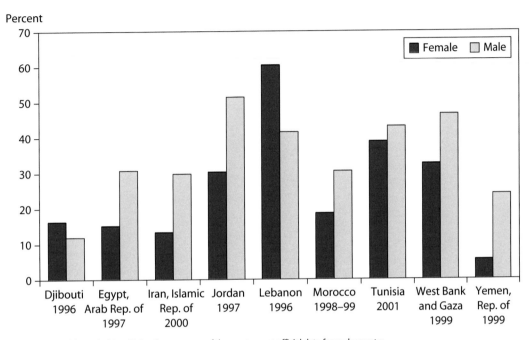

Source: World Bank household and labor force surveys of the most recent official date for each country.

paid private sector. In 1991, the proportion of women in nongovern-mental paid employment in Morocco was 18 percent—significantly higher than the proportion in Egypt—and the proportion increased to 22 percent by 1999.

Feminization of the Moroccan private sector can be attributed largely to developments in textile and garment manufacturing in the 1990s. In 1991, this sector accounted for only 7.5 percent of nongovernmental paid employment, but over the decade, it grew faster than average while becoming more feminized; it accounted for 74 percent of the feminiza-tion that occurred in Morocco. Meanwhile, job types that were tradi-tionally closed to Moroccan women—and that constitute more than half of all nongovernmental employment in that country—appear to be becoming somewhat more accessible to women.

The cases of Morocco and Tunisia show that women's increased ac-cess to the labor market can be achieved initially by promoting the growth of sectors that have traditionally been open to female participa-tion, such as textiles and garment manufacturing. This trend conforms to widely documented international trends showing that the feminization of employment usually accompanies an increase in export processing zones and assembly-type production (Çağatay and Berik 1991; Joekes 1987;

Standing 1989, 1999). In the longer run, jobs that traditionally have been closed to women can be gradually opened to increase the female share in employment. It is no accident that the countries, such as Tunisia and Morocco, that have experienced significant growth in manufactured exports, have done considerably better at increasing the female share of employment than countries that have relied on remittances, service exports, and oil for their foreign exchange earnings.

As demonstrated in the companion reports (World Bank 2003e, 2003g, 2003i), most of the job creation opportunities for both women and men will inevitably be found in the private sector. A broad reform agenda is needed to move the region toward more integration into the world economy, to diversify economies from the excessive weight of the energy sector, and to create a climate conducive to private sector investment and employment creation. The challenge is great, especially in terms of creation of job opportunities for women.

The environment must be flexible enough to create jobs that use the range of talents and education of women as well as of men. The environment must make labor force participation attractive to women, including work arrangements (for example, work hours) that are compatible with women's other roles. And the environment must make the hiring of women attractive to employers, for example, through financing mechanisms for maternity leave and child care that make the cost of male and female labor comparable.

A cross-country analysis suggests that excessive labor regulation limits opportunities and is associated with higher unemployment, especially for youth and women (World Bank 2003b). If the private sector cannot absorb the greater—and increasingly well-educated—potential female labor force, women will wind up either unemployed or too discouraged even to look for work. If, however, the private sector can meet the challenge, the potential benefits to women, their families, and society are enormous. Those benefits will allow all to profit from past investments in girls' education, will reduce the burden on existing workers, and will increase household income and economic growth. Hence, policies to increase female participation in the labor force must strongly focus on implementing measures to reduce gender discrimination in the private sector.

Appendix: Labor Force Participation Rates That Vary with the Data Source

This report uses two main sources of data on rates of labor force participation: the International Labour Organisation (ILO) and a series of nationally representative household and labor force surveys carried out by

government statistical organizations, the Ministry of Social Affairs (in Jordan), and a research institute (in the case of Egypt). Although the finding that female rates of participation are significantly lower in MENA than in other regions is supported by both sets of data, there are some notable differences in the rates for particular countries, as shown below:

FIGURE 3A.1

Labor Force Participation Rates, by Data Source

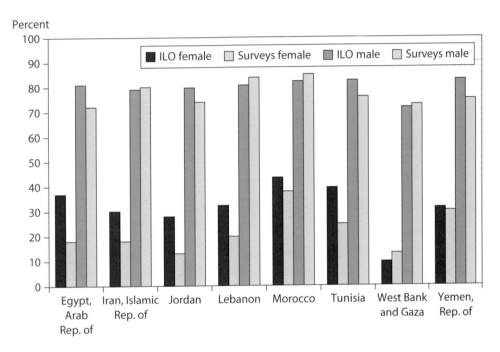

The ILO data and the household and labor force surveys provide roughly comparable numbers for male participation and for female participation in Morocco, the West Bank and Gaza, and the Republic of Yemen. However, the rates provided for the participation of females differ substantially for Egypt, the Islamic Republic of Iran, Jordan, Lebanon, and Tunisia.

Why might different sources of data produce different rates of labor force participation? And why might those rates differ more for women than for men? Certainly, the definition of labor force participation used will affect the size of the labor force identified. For example, if one analyst excludes workers in the informal sector or unpaid workers, and if another analyst uses a broader definition, the rates of labor force participation provided by those two analysts will differ. In the current case, however, we have applied the ILO definitions, so the use of different definitions does not explain such gaps.

The ILO definition of the labor force includes the following:

[A]ll persons of either sex who furnish the supply of labor for the production of economic goods and services as defined by the United Nations systems of national accounts and balances, during a specified time-reference period. According to these systems, the production of economic goods and services includes all production and processing of primary products, whether for the market, for barter, or for own consumption, the production of all other goods and services for the market and, in the case of households which produce such goods and services for the market, the corresponding production for own consumption. (ILO 1982)

Consistent with the ILO definition, we include the following five categories of individuals in our calculations of labor force participation:

1. Public sector workers

2. Private sector regular workers, including individuals who are paid by the week, month, or year or who have an employment contract, receive benefits, or both

3. Private casual workers, including individuals who are paid by the day, who do not have an employment contract, or who do not receive benefits

4. Private nonwage workers, including individuals who are employers, who are self-employed, or who work in a family enterprise or on a family farm

5. Unemployed workers, including all those who are seeking work, including those who have previously worked as well as those who have never worked.

As with the ILO definition, we exclude from the labor force the housewives, students and apprentices, retired persons, and discouraged workers (individuals who are available to work but are not actively seeking work).

Although the analysis of the household and labor force surveys applies the same definition of labor force participation as the ILO, another source of variation might help explain the differences shown above. Surveys typically use a series of questions to determine an individual's status rather than simply asking individuals directly whether they participate in the labor force. The series of questions is intended to ensure the inclusion of individuals who might not think of themselves as workers because they work either a few hours a day or seasonally, or because they assist (rather than bearing primary responsibility for) family enterprises or agricultural activities. Because these categories of work are particularly

common among women, we would expect female rates of participation in the labor force to be particularly sensitive to differences in the questions asked.

Unfortunately, the specific questions used to identify labor force participants differ among countries. All of the household and labor force surveys that we use identify nonwage workers, although those in Egypt and Morocco do not specifically ask about unpaid work. Furthermore, only those in the Islamic Republic of Iran, Tunisia, and the Republic of Yemen specifically inquire about seasonal work and only the one in Morocco specifically inquires about work for own consumption.

We do not have information on the specific list of questions that were asked by the surveys underlying the ILO data, nor do we have any reason to presume that those surveys are any more or less thorough than the household and labor force surveys we use. Also, it is interesting to note that the gap between the numbers in the ILO data and those in our household and labor force surveys does not correspond to the thoroughness of the questions we asked. For example, the gap is large in Tunisia, where the questions we asked are relatively thorough. Nevertheless, differences in the survey questions may provide a plausible explanation for part of the differences in rates of labor force participation.

Notes

1. There are also mechanisms that link female participation in the labor force to achieving lower fertility and higher education. These topics are discussed in chapter 2.

2. Latin America had approximately the same rates of female participation in the labor force as did MENA in 1960, but the rates have increased more rapidly since.

3. The economic dependency ratio should not be confused with what demographers refer to as the dependency ratio. The dependency ratio is defined as the ratio of the number of individuals less than age 15 or more than age 65, divided by the number of individuals ages 15–64. Whereas the dependency ratio reflects only the age distribution of the population, the economic dependency ratio reflects the number of people who are being supported by a single income.

4. Men's participation rates are also relevant to the economic dependency ratio. However, because men's rates vary little across countries, they are not a major factor in explaining cross-country differences in economic dependency.

5. For a thorough treatment of unemployment in MENA, refer to the companion report, *Unlocking the Employment Potential in the Middle East and North Africa: Toward a New Social Contract* (World Bank 2004).

6. Eventually in MENA, as in other regions, the working-age bulge in the population will retire, creating a new type of dependency burden and requiring the incoming working-age population to support a very large elderly population.

7. Female-headed households comprise the following shares of all households: Algeria, 11 percent; Djibouti, 18 percent; Egypt, 13 percent; Gaza, 8 percent; Iran, 6 percent; Jordan, 10 percent; Kuwait, 5 percent; Lebanon, 14 percent; Morocco, 17 percent; Oman, 13 percent; Syria, 9 percent; Tunisia, 11 percent; and Yemen, 14 percent (United Nations Statistical Division n.d. and United Nations Economic and Social Commission 1999).

8. Women in female-headed households are 37 percent more likely to be economically active than women in male-headed households in Morocco, 6 percent more likely in the Islamic Republic of Iran, and 1 percent more likely in Djibouti.

9. For lack of data, comparable simulations were not possible for the labor-importing, resource-rich countries of the Gulf Cooperation Council.

10. In all MENA countries, the average woman in the population has fewer years of education than the average man. However, when we look only at the labor force, we see a different picture. In Jordan, the Islamic Republic of Iran, and the West Bank and Gaza, the average woman in the labor force has more education than the average man in the labor force. And when we look only at those individuals who are paid wages, we find that in all countries for which we have data (except Djibouti), the average woman has more education than the average man. This issue is addressed more fully in chapter 4, when we discuss discrimination.

11. Our estimate of wage discrimination is based on the part of the gender wage gap that cannot be explained by differences in observed productive characteristics, including education and experience.

12. Of course, enhancing women's educational status could, itself, expand women's economic opportunities. If we are to keep things simple for this simulation, it is most useful to think of increasing female participation, eliminating wage discrimination, and equalizing education as three separate changes.

13. It should be recognized, however, that higher female participation would not necessarily imply a more productive labor force. In addition to innate talent, the ability of the work force is determined by its education. At present, female wage workers have more education than male wage workers, on average. (This statistic does not mean that the female population is more educated than the male population. Rather, it reflects the fact that female wage workers are not representative of the female population: the women who work for wages tend to be among the most-educated

women in the population.) So long as the females who enter the labor force have more education than the average male worker, we will see the average education of the labor force increase as female participation increases. However, if the female labor force ultimately becomes representative of the female population, then increases in female participation may result in a decrease in the average education of the labor force.

14. If we control for the male participation rate, increases in the ratio of female to male participation rates imply an increase in the size of the total labor force (and an increase in the proportion of the population that is working). As in the simulations of level effects, these simulations presume job growth is sufficient to absorb the new labor force entrants.

15. For case studies from Peru and Mexico, see Ilahi (1999a and 1999b) and Cunningham (2001). See also Safa (1999) and Başlevent and Onaran (2002).

16. This mechanism was found in an econometric study of unemployment and female labor force participation in Great Britain and Italy by Del Bono (2003). Interestingly, Del Bono finds that unemployment has a negative effect on fertility as well. It is commonly assumed that factors that cause a decrease in fertility will cause an increase in female participation in the labor force and vice versa. This study provides a useful insight into MENA, where rates of unemployment are high and where fertility rates have declined without concomitant increases in female participation in the labor force.

17. Chapter 4 includes a detailed assessment of wage discrimination in the public and private sectors. Except in Morocco, wage discrimination is estimated to be higher in the private sector than in the public sector. In fact, wage setting in the public sectors in Djibouti, the Islamic Republic of Iran, Tunisia, and the Republic of Yemen favors women.

18. In MENA, this problem is not as prevalent, because women are able to hold land rights in their own names.

Constraints on Women's Work

Chapter 3 showed that women's participation in economic activity in the Middle East and North Africa (MENA) countries is low by international standards and by what would be expected when looking at the demographic and socioeconomic characteristics of the women in those countries. Macroeconomic demand factors such as unemployment and growth patterns provide some degree of explanation for the low participation of women in the labor force. However, the widespread underparticipation of women in the region's work force suggests that additional constraints exist on the supply side.

This chapter first considers the role of wage gaps and occupational segregation, which normally discourage women's participation in the labor force. It then outlines factors that constrain the flexibility of women as workers and their ability to combine work and family responsibilities. Although many of those factors are economic in nature, they are often manifestations of underlying social norms and behaviors. Thus, women's participation in the labor force must be analyzed within its socioeconomic context. In particular, it is necessary to understand how power relationships within the family—and their reflection in decision-making within the household—come to affect broader processes of social and economic change in both society and labor markets. We will briefly review the traditional gender paradigm in the region to provide a context for this analysis.

The main messages of this chapter are as follows:

1. Female participation in the labor force in MENA is low largely because women leave the labor force when they marry and have children. This pattern differs from that of other regions, where women's participation peaks in their late 30s to late 40s.

2. Wage discrimination against women and job segregation in MENA play a role in discouraging women from working; however, they are not out of line with patterns found in other regions. In combination with existing social norms and the traditional gender paradigm, they pose additional constraints on women's access to work.

3. Labor laws generally discourage discrimination against women. However, a host of regulations, many of them based on outdated foreign models, discriminate against women and against the families of working women. Meanwhile, aspects of labor laws that are intended to safeguard women in fact discourage employers from hiring them.

The Traditional Gender Paradigm in MENA

In MENA, gender roles and power dynamics within the household determine to a large extent women's access to and interaction with the state and the public sphere. Those dynamics are shaped by elements that can be grouped into what we will call the *traditional gender paradigm*.[1] This paradigm is based on the recognition (a) that men and women differ biologically and that these biological differences determine their social function, (b) that men and women carry different and complementary responsibilities within the family, and (c) that they have different but equitable rights associated with those responsibilities. The paradigm assumes that a woman will marry (early); that her recognized contribution to the family will be as a homemaker; that the households will be headed by a man, who will retain the highest authority; and that the man will have a job that will allow him to provide for his family. In return, women are expected to confine themselves to the family as wives and mothers—roles in which they are perceived as vulnerable and in need of protection. This protection is to be provided by the husband or by a close male family member. Men's responsibility as protectors is seen as justification for their exercise of authority over women in all areas of decisionmaking and action that relate to the public sphere.[2] As a result, a woman's interactions with the state and society are mediated through her husband or a male family member.

The traditional gender paradigm pervades much of the law that shapes the everyday life of the MENA countries. It results in a distinction between the public (male) and private (female) spheres. Its four elements, explained below, play defining roles in women's economic activity and participation in the labor force.

Key Elements of the Traditional Gender Paradigm

The traditional gender paradigm has the following four elements:

1. *Centrality of the family.* Constitutions, religions, charters, and legislation in MENA assign the family, not the individual, as the primary building block of society. Both men and women agree that the centrality of the family in society is an important cultural asset. For

both men and women, the communal interest overrides individual interests and strongly affects an individual's outlook and choices. The value placed on the family suggests that women's ability to combine work with family responsibilities will be a key factor in increasing women's participation in the labor force. This factor will need to be addressed in broader policies because it underscores an important social and cultural asset.

2. *Establishment of the man as the sole breadwinner.* In households across the world, the man is normally considered the primary breadwinner and head of the household,[3] but in many MENA countries this expectation continues to be written into law. Several laws of the region refer to women and children in the same context as needing protection, implying that women could not and need not provide for themselves. Such provisions call into question women's right to work, as women's work is considered optional and not essential.[4] For instance, at times of high unemployment, women tend to be perceived as taking jobs away from men rather than being entitled to jobs themselves. Furthermore, women's work outside the home has often been viewed as a sign of the inability of the male relatives to provide for the family. That perception puts social and psychological pressure on men if their wives work outside the home.

 Opposition to changing the male breadwinner model also comes from women, many of whom are unsure about alternative mechanisms of protection under the law and whether those mechanisms, if they exist, will be enforced. Some women fear that accepting a share of responsibility for the family income will worsen their condition. Some fear that by working for wages they will reduce men's responsibility as providers and will place a double burden on themselves of taking care of the household and having to earn an income. Hence, any change to the current male breadwinner model would need to demonstrate the benefits to both women and men.

3. *Imposition of social conditions on women by the "code of modesty."* A woman's honor is seen as central to the family's honor, reputation, and social respect. Here again, both women and men consider this an important cultural distinction of MENA societies. The preservation of the family's reputation, however, is seen as the responsibility of the man. Hence, it is also considered his right to control the access of his female kin, wife or sister, to the outside world (the public sphere), including controlling her ability to work and travel (boxes 4.1 and 4.2).

 The assignment of public space to men and private space to women is common in most cultures around the world. Furthermore, the

BOX 4.1

A Typical Dilemma

Manal (a software engineer): "I am married and my husband is always telling me that women should stay at home and look after their husbands and children, which is fine except that in today's world both parents have to work in order to secure a good future for their children. Is a woman allowed to work and interact with men, and even to travel to other countries on training without her husband, if this is required by her job? What if her husband does not allow her to travel on training? Is she obliged to listen to him?"

Source: http://www.islamonline.net/livedialogue/english/Browse.asp?hGuestID=mnVZqu.

notion of *mahram*[5] in Islamic societies often delineates what types of male–female interactions are permissible. Basically, *mahram* determines whether and how a man and woman can interact in public or in private. They can interact freely with certain of their close relatives in the private space. Interaction with nonkin (that is, beyond these defined relations), whether in the private or public sphere, is conditioned. Interactions in the public space, outside the house, are always permitted but controlled. For example, women need not wear the veil when interacting with kin within the private sphere. Women normally wear the veil in the public space or when interacting with kin and nonkin. Different countries and even different groups or regions (mainly urban or rural) within a country may adhere to this concept to different extents, and certain countries may not adhere to it at all. In those circles where *mahram* is strictly observed, women may have a more constrained access to the public sphere, and the public domain may be considered the realm of men and potentially not hospitable for women. Solutions must take into consideration that, unless the public space is more engendered by catering to these specific needs,[6] women will find it very difficult to venture into a predominantly male environment, and their participation will remain limited. When the public space is considered to be physically or reputationally inappropriate, women are likely to be secluded within the home.

4. *Unequal power in the private sphere.* Family laws throughout the region treat men and women differently.[7] In many countries, the laws specify that a wife must obey her husband because he provides for her (table 4.1). A wife's disobedience can be a cause for divorce, and consequently the wife can lose financial support and custody of her

BOX 4.2

Clashes between Public and Private Empowerment

Egypt: Balance of Power

As Singerman (forthcoming) points out, unless the balance of power within marriage changes, women will continue to suffer constraints on their public and professional lives:

> While women are the demographic and political product of an independent Egypt which increased public education and professional opportunities for women, granted them suffrage, and encouraged them to contribute to Egypt's development, they are nevertheless still constrained in their daily and professional lives. Personal Status Law still allows a man to claim his wife has been "disobedient," and if she works, seeks education, or travels without his approval, he is not obligated to support her after a divorce. Thus, much of the international and national direction of the Egyptian women's movement and others across the MENA recognizes the importance of changing the balance of power within marriage, particularly its legal dimension, if [women] are truly to benefit and take advantage of these other changes. Women could become ambassadors, deans of Islamic philosophy, international corporate lawyers, wealthy businesswomen, leaders of organizations, scholars, and politicians, yet they still feared divorce, financial ruin, and losing the custody of their children if they worked, wanted to further their education, or traveled without the permission of their husbands.

Republic of Yemen: Husnia's story

Below is the true story (excerpted from Paluch 2001) of an educated woman in a country with a low rate of female literacy. She and her country could not benefit from her skills as long as her husband did not consent. She paid a heavy price for not wanting to play the traditional role:

> I was very attached to my father. He was different from most Yemeni men and insisted that I study. When I finished my university, I was offered a job that would have helped me to attain my Ph.D. abroad. I chose to get married instead since my fiancé, who was then studying abroad, did not want to wait much longer and promised me that I could continue my studies after we married.
>
> After the birth of my son, I did not want to have another child immediately. But my husband wanted more children right away. He said, "I got married for two reasons, first to have many children and second to have a wife who stays at home. So you are not going to work and you can forget about your studies." After some time, I decided to seek a divorce. With my brothers' help, I could get a divorce and keep my son, on the condition that I not ask for any financial support for my son and not remarry. After the divorce, I applied for another scholarship and finished my Ph.D. in Europe. I have not remarried.

TABLE 4.1

Selected Obedience Clauses in Family Laws in MENA Countries

Country	Clauses stating that a wife owes obedience to her husband
Egypt, Arab Rep. of	Article 6 (bb) of Law 44 stipulates that if a wife refuses to obey her husband without any legitimate reason, she loses her maintenance. Refusal to obey without a legitimate reason refers to a situation in which the wife leaves the marital home and declines to return at the husband's request.
Iran, Islamic Rep. of	Under article 11.v, a husband must maintain his wife in return for his wife's obedience (*tamkin*).
Iraq	Under article 24/1, a husband must provide maintenance to his wife if she is not disobedient.
Jordan	According to article 37, "Upon the wife who has received the immediate part of the dowry falls obedience … and if she does not obey she loses her right to *nafaqa*."
Morocco	The *Mudawanna* (Personal Status Law) stipulates that a woman owes obedience to her husband.
Qatar	Under Shari'a law, the husband must maintain his wife as long as she is under his control.
Saudi Arabia	Under a law based on Shari'a principles, a husband must maintain his wife as long as she is under his control.
Syrian Arab Rep.	Under article 73, a wife forfeits her right to maintenance if she works outside the home without her husband's permission. Article 74 states that if the woman is disobedient, she is not entitled to maintenance for as long as her disobedience continues.
Yemen, Rep. of	Article 40 states, "The husband has the right to obedience from his wife in what brings about the family's interest … [and] the husband cannot forbid his wife from … leaving to manage her money."
Country	**Gender-neutral codes on obedience**
Kuwait	According to article 89, it is not considered a violation of matrimonial duties for a wife to go out for any lawful purpose, nor for her to engage in any permitted work, provided that her work does not conflict with the interest of the family.
Libya	Article 23 states, "Maintenance for the wife by a husband … shall be compulsory from the date of the valid contract." There is no mention of disobedience in the law.
Tunisia	According to article 23, "A woman must respect her husband's prerogative and obey him" was changed to "Each of the spouses shall treat the other kindly and avoid any prejudicial action."

Note: Family laws or personal status codes are bodies of legislation that govern marriage, divorce, custody, and inheritance and are generally based on the Shari'a.
Source: Hijab, El-Solh, and Ebadi 2003.

children, who are usually given to the father after they pass infancy. Hence, a woman who interacts with the outside world without her husband's consent may be taking substantial risks.

Traditional Norms That Affect Labor Market Behavior

In most other regions of the world, labor force participation rates remain high for women of all age groups (figure 4.1). In East Asia and the Pacific, in Europe and Central Asia, and in Sub-Saharan Africa, for example, those rates rise steadily by age group and reach their peak levels for women in their late 30s to late 40s. In MENA—where for every age group the rates are dramatically lower than the rates in other regions—they also decline quickly once women reach the age for marriage and childbearing.[8]

Household survey data for individual MENA countries confirm that women are much less likely to work if they are married and, particularly, if they have children younger than 6 years of age (figure 4.2). In some

FIGURE 4.1

Age-Specific Female Participation Rates in MENA and World Regions, 2000

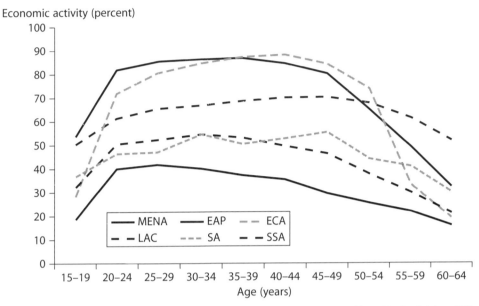

Economic activity (percent)

Age (years)

Note: EAP = East Asia and the Pacific, ECA = Europe and Central Asia, LAC = Latin America and the Caribbean, SA = South Asia, and SSA = Sub-Saharan Africa.
Source: World Bank 2003j.

countries (Djibouti, the Arab Republic of Egypt, the Islamic Republic of Iran, and Jordan) the big drop for females being in the labor force occurs when women get married, while in Morocco it occurs when they have children. The latter pattern is more common in other regions.

Today, families in the region need flexibility to adapt to changing economic circumstances. Few are affluent enough for women to play only the traditional role of homemaker.

Most of the labor laws in MENA are supportive of a greater economic role for women. They strive for equal treatment and, if implemented appropriately, would promote the welfare of women and their families. Laws stipulate that women should receive equal compensation for work of equal value. They offer generous maternity leave benefits and protect women against job termination in case of marriage or pregnancy.

Yet, even where laws are favorable, the traditional paradigm, in practice, exerts a big effect on actual behavior in the labor market. Wage discrimination and sex-based job segregation remain, as do wide gaps between the intent of the family-friendly laws, such as those about maternity leave and childcare, and their effects in practice.

A host of other labor market regulations do discriminate against women. They include those governing nonwage employment benefits,

FIGURE 4.2

Participation Rates for Married and Unmarried Women in MENA Countries, 1990s

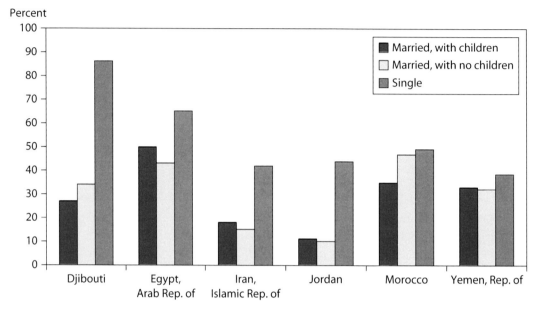

Source: World Bank labor force surveys.

which affect the families of women workers, and those restricting women's hours and the types of work they may perform. Such regulations ultimately limit the flexibility of women workers and their ability to find jobs in private industry and services.

Discrimination in Wages, Benefits, and Job Segregation

Because the traditional paradigm defines gender roles, it may affect women's aspirations and their selection of jobs and professions that they believe to be acceptable, respectable, or appropriate. Traditional social norms also affect personal and societal tolerance for gender discrimination and shape the opportunities that are open to women.

Discrimination and inequality in the labor force normally manifest themselves in wage discrimination and occupational segregation, in which different groups work in different industries (horizontal segregation) or in which one group tends to dominate in supervision and the other in production activities (vertical segregation). This section explores the role of wage and nonwage discrimination in reducing the scope of participation of women in the labor force.

Gender Gaps in Wages

The higher the potential earnings, the more likely individuals are to participate in the labor force, other things being equal. The cutoff point at which individuals decide that work is preferable to alternative uses of time is referred to as the *reservation wage*. For women, family responsibilities often make the reservation wage quite high—for example, high enough to pay for childcare and other household services that would have to be purchased in the market, rather than be produced at home. In some cases, wage discrimination will lower potential earnings and may cause women to decide that it is not worthwhile to work.

Women throughout the world are typically paid less than men. The reasons for this gender wage gap include systematic differences in the qualifications of men and women workers. Because higher qualifications tend to raise workers' productivity, employers are justified in paying more to workers with higher qualifications. However, when men and women are equally productive and qualified, then the differences in wages and salaries are not justified and are, therefore, discriminatory.

To examine the extent to which differences in pay are due to discrimination, researchers divide the wage gap into two parts. The first part reflects differences in productivity, which is typically measured by education and years of experience.[9] The remaining part, which is unexplained by differences in measures of productivity, is used as a measure of the upper bound on wage discrimination.[10] Table 4.2 reports on gender wage gaps and the decomposition of those gaps. In industrial countries, for example, if a man earns one dollar, a woman working the same amount of time would earn 77 cents (table 4.2, column 1). Part of this gap of 23 cents reflects the fact that the average working man has more education and experience than the average working woman. However, when we compare men and women with the same amounts of education and experience, 79 percent of the gap still exists, presumably as the result of discrimination (table 4.2, column 2). If women were compensated for their qualifications in the same way that men are, women's wages would increase by an average of 24 percent (table 4.2, column 3), so that a woman would earn 96 cents for every dollar earned by the average man instead of 77 cents (table 4.2, column 4).

Gender wage gaps in Egypt, Jordan, and Morocco are small relative to the gaps in other regions (table 4.2, column 1). And if women in Egypt, Morocco, and the Republic of Yemen were paid according to the same formula as men, the wage of the average woman would increase by only a relatively small margin (table 4.2, column 3). Although it is difficult to generalize across the region, by using these two measures as a proxy, MENA appears, at first glance, to be within the normal range of discrimination found in other regions.

TABLE 4.2

Wages and Discrimination in MENA Countries and World Regions, 2000 or Most Recent Year

Location	Ratio of women's wages to men's wages	Percentage of wage gap unexplained by productive characteristics	Percentage increase in women's wages if discrimination were eliminated	Estimated ratio of women's wages to men's wages in the absence of discrimination
Industrial countries	0.77	79	24	0.96
East Asia and Pacific	0.71	71	29	0.92
Europe and Central Asia	0.77	103	31	1.01
Latin America and the Caribbean	0.76	78	25	0.95
South Asia	0.54	70	60	0.86
Sub-Saharan Africa	0.71	63	26	0.90
MENA	**0.73**	**117**	**32**	**0.93**
Djibouti	0.43	38	50	0.65
Egypt, Arab Rep. of (1998)	0.96	324	14	1.09
Iran, Islamic Rep. of	0.82	56	12	0.92
Jordan	0.83	167	35	1.12
Morocco (1991)	0.86	100	17	1.00
Yemen, Rep. of	0.64	13	7	0.68
Tunisia	0.82	71	15	0.95
West Bank and Gaza	0.56	109	86	1.04

Sources: For MENA countries, World Bank household and labor force surveys; for other regions, World Bank 2001.

However, MENA differs from other regions in that, among its wage earners, women generally have more education than men, while they hold the same job level (table 4.3).[11] Women's greater level of qualification implies that if discrimination were eliminated, the average woman's wage would not only be higher than it is, but also be higher than that of the average man. In Egypt, for example, the average female earns 96 percent of the wage of the average male, and yet she has 13 years of education, compared to his 8.4. If she were paid according to the same formula as a man (with 8.4 years of education), her wages would increase by 14 percent to become equal. However, because she is more qualified (with 13 years of education), she should earn more than he does. To be precise, she could potentially earn 109 percent of his wage.

Chapter 3 highlighted the fact that women may have difficulty finding work in the private sector. To what extent do women's wage patterns differ between the public and private sectors? According to column 3 of table 4.4, the private sector appears to discriminate more than the public sector in all countries other than Morocco. In fact, in the public sectors of Djibouti, the Islamic Republic of Iran, Tunisia, and the Republic of

TABLE 4.3

Average Years of Education: Men and Women in the Labor Force in MENA Countries, 1989–99

Country	Wage earners		Labor force participants		Population	
	Male	Female	Male	Female	Male	Female
Djibouti	6.0	3.0	5.0	3.0	5.0	2.0
Egypt, Arab Rep. of (1998)	8.4	13.0	7.9	6.6	8.1	6.1
Iran, Islamic Rep. of	7.0	9.1	5.9	6.9	6.8	5.8
Jordan	9.3	12.3	9.2	12.1	9.1	7.9
Morocco (1999)	4.1	4.6	3.6	2.6	3.9	2.4
Tunisia	9.4	9.6	7.8	7.5	6.9	5.4
Yemen, Rep. of	6.2	6.6	4.9	2.2	5.1	2.4
West Bank and Gaza	9.1	12.2	9.0	9.5	8.6	7.2

Source: World Bank household and labor force surveys and World Bank staff estimates.

TABLE 4.4

Wages and Discrimination, Public and Private Sectors in MENA Countries, 2000 or Most Recent Year

Country and sector	Ratio of women's wages to men's wages	Percentage of wage gap unexplained by productive characteristics	Percentage increase in women's wages if discrimination were eliminated	Estimated ratio of women's wages to men's wages in the absence of discrimination
Djibouti, public	1.34	101	−26	1.00
Djibouti, private	0.87	86	13	0.98
Egypt, Arab Rep. of (1998), public	0.99	530	6	1.05
Egypt, Arab Rep. of (1998), private	0.77	88	26	0.97
Iran, Islamic Rep. of, public	1.95	84	−41	1.15
Iran, Islamic Rep. of, private	0.56	89	70	0.95
Jordan, public	1.07	−189	13	1.21
Jordan, private	0.73	127	46	1.07
Morocco (1991), public	0.92	247	21	1.11
Morocco (1991), private	0.88	64	9	0.96
Tunisia, public	1.28	31	−7	1.19
Tunisia, private	0.78	57	16	0.91
West Bank and Gaza, public	1.02	−420	8	1.10
West Bank and Gaza, private	0.53	99	87	1.00
Yemen, Rep. of, public	1.17	27	−4	1.13
Yemen, Rep. of, private	0.90	119	14	1.02

Source: World Bank household and labor force surveys.

Yemen, there is a positive discrimination in favor of women. If women were paid according to the same number of years of education as their male counterparts who hold the same positions, women's wages would fall. This decrease is implied by the negative unexplained portion of the gender wage gap.

The numbers in column 3 of table 4.4 represent discrimination, rather than some unobserved difference in productivity. To that extent, women's opportunities may be unduly constrained, and this discrimination may serve as a disincentive for entry into the labor force. Certainly, the lower amount of wage discrimination in the public sector than in the private sector may also explain why women's participation in the former is greater than in the latter.

How has discrimination changed over time? Unfortunately, Egypt is the only country for which relevant data are available at two points in time; in that country, discrimination seems to have remained unchanged among wage workers as a group and within the government, to have increased within the state-owned enterprises, and to have decreased within the private sector (box 4.3).

Family Benefits and Other Nonwage Compensation That Favor Men

Another probable source of discouragement for working mothers in the region is the subtle forms of discrimination against women—and, hence, the families they support—that take place with regard to nonwage employment benefits. Such benefits can provide powerful mechanisms for continued labor market attachment, and employers offer them to attract and maintain employees' attachment.

In MENA countries, the tax and employment-related benefits that families receive can generally be channeled only through the man. In the United Arab Emirates, for example, only male employees may receive allowances for children's education and housing.[12] In addition to regulations on stipends and family allowances, discriminatory laws on social security and pensions need attention (table 4.5). Although such regulations were put in place to prevent couples from "double dipping," channeling benefits only through men effectively discriminates against the families of working women.

The differential treatment of working men and women is based on the premise that the man is the head of the household, the male breadwinner model, unless he is old or has a disability. Many of these benefits are structured to accommodate transfers from the state to households, such as various social safety net schemes and allowances for housing or children's education. At times such benefits are also mandated by

BOX 4.3

Trends in Egyptian Wage Differentials

The figure below shows that the crude gender wage gap decreased between 1988 and 1998. This decline occurred in all parts of the economy: among wage workers as a group and within the government, the state-owned enterprises, and the private sector. The decline in the wage gap may be due to a decline in discrimination, or it may be due to increases over time in women's qualifications. Thus, to isolate the change in discrimination, we performed the analysis again, correcting for changes in women's qualifications. The results show that discrimination seems to have remained unchanged among wage workers as a group and within the government, to have increased within the state-owned enterprises, and to have decreased within the private sector.

Egypt: Crude and Corrected Gender Wage Differentials by Sector of Ownership, 1988 and 1998

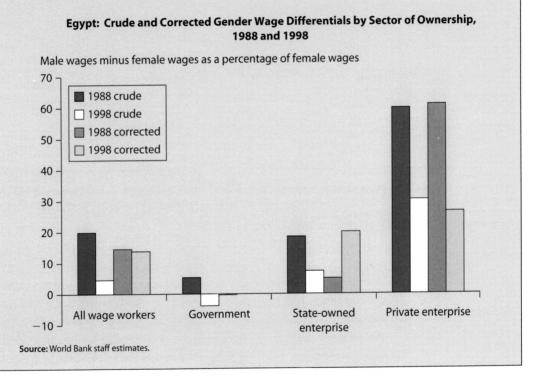

Source: World Bank staff estimates.

the state through the private sector to reach households. Such regulations, when passed through men only, hence reinforce the traditional paradigm by failing to recognize that these benefits could also be transferred through women, particularly in cases in which the husband works but may not have access to such benefits.

Like discrimination in wages, discrimination in nonwage benefits depresses the returns that a woman receives for her work effort and, thus, lowers her incentive to participate in the labor force. Furthermore, by

TABLE 4.5

Laws on Employee Pensions for Men and Women in MENA Countries as of 2002

Country	Men and women are equally entitled to nonwage benefits[a]	Survivor pension stops if widow marries	Woman's pension can be passed on to husband upon her death without certain conditions
Algeria	Yes	—	Yes
Bahrain	Yes	Yes	Yes
Djibouti	No	Yes	No
Egypt, Arab Rep. of	Yes	—	No
Iran, Islamic Rep. of	No	Yes	No
Iraq	Yes	—	No
Jordan	No	Yes	No
Kuwait	No	—	No
Lebanon	No	—	No
Libya	Yes	—	Yes
Morocco	No	—	Yes
Oman	No	—	Yes
Qatar	No	—	—
Saudi Arabia	—	Yes	No
Syrian Arab Rep.	No	—	No
Tunisia	Yes	—	Yes
United Arab Emirates	No	—	—
Yemen, Rep. of	Yes	Yes	No

— Not available.

a. Discrimination in nonwage benefits varies between countries and can include discrimination in the housing allowance, children tax allowance, and dependent spouse allowance (which is offered only to a man for a dependent wife), plus discrimination against unmarried female versus unmarried male employees.

Source: Hijab, El-Solh, and Ebadi 2003.

channeling benefits through men only and by denying women workers the right to pass on their pension benefits to their husbands, existing laws ultimately discriminate against the *spouses* of female workers, rather than the workers themselves. Achieving gender equality here would benefit men and families. With the feminization that has taken place in the public sector, where nonwage benefits are prevalent, and with an increase in the number of men working for better paying but less stable jobs in the private sector, the existing provisions leave many families at a disadvantage solely on the basis of the sex of the main earner or policyholder. Such discriminatory laws once existed in many other regions, but gradually countries have revised their laws (box 4.4). Countries in the MENA region are among the few countries worldwide that maintain this gender bias in the assignment of benefits (see table A.2 in the appendix).

A few countries in MENA explicitly treat men and women equally, thereby avoiding the distortions. In Algeria, Iraq, and the Syrian Arab

BOX 4.4

Female Income Earners as Main Providers of the Household: Gender-Related Cases in the United States

Laws around the world have traditionally viewed men as the primary breadwinners (and as heads of the family) and women as dependents. In the United States, two landmark cases in the Supreme Court helped secure more equal treatment of the families of female workers.

Social Security Laws (Wiesenfeld v. Weinberger)

In 1972, Paula Wiesenfeld, a New Jersey schoolteacher, died in childbirth. Her husband, Stephen Wiesenfeld, wanted to raise their son himself, but money was a problem, as Paula had been the family's main breadwinner. Had he been a widow, he would have been immediately eligible for social security benefits on the basis of his spouse's earnings, but because the social security law had not conceived of men in a childcare role, he was ineligible. In the 1975 U.S. Supreme Court, Ruth Bader Ginsberg, then a lawyer for the American Civil Liberties Union, argued that the law served no legitimate governmental interest. She pointed out that the case concerned the entitlement of a female wage earner's family to social insurance of the same quantity as that accorded to a family of a male wage earner. She highlighted that the son had been denied the equal protection of the law and had been deprived of the personal care of his sole surviving parent.

The U.S. Supreme Court agreed unanimously that the existing law discriminated among surviving children on the basis of the sex of their surviving parents and that this classification violated the equal protection rights of both males and females under the U.S. Constitution. To provide more adequate protection to the family as a unit, the Social Security Administration replaced the term *widow* with the term *surviving spouse*, so that social security benefits are now provided to survivors regardless of gender.

Employee Benefits (Frontiero v. Richardson)

In a 1973 U.S. Supreme Court case, the husband of 23-year-old U.S. Air Force Lieutenant Sharron Frontiero was a college student receiving a low monthly income. Because the U.S. Air Force refused to recognize him as the dependent of his wife, the young couple had no right to the housing benefits that were provided only to married men, and the husband could not use medical facilities that were available only to female spouses. The U.S. Department of Defense argued that requiring proof of spousal dependency from service people would be an administrative burden, and that it was more cost-effective to assume that all wives were dependent and all husbands were not. Ruth Bader Ginsberg argued that many female spouses of servicemen did not meet the test of dependency because they were earning more than half of their own living expenses. She stressed that by

(Box continues on the following page.)

BOX 4.4 (continued)

denying the woman lieutenant the benefits her male counterparts received, the Air Force was effectively paying her less than it paid them. Ginsberg convinced the Court that the couple faced double-edged discrimination: against Sharron Frontiero as a breadwinner and against her husband as a family member.

Source: Strum 2002.

Republic, for example, female employees have the same eligibility for allowances as their male colleagues, although in Syria, unmarried women cannot pass on their pensions to their families, whereas unmarried men can. In Libya, a woman's legal heirs have the same rights to her pension as a man's heirs (Hijab, El-Solh, and Ebadi 2003).

Another type of distortion created by the pension system arises from gender-specific retirement ages. In most MENA countries, the mandatory retirement age is 5 years lower for women than it is for men, which has several repercussions on a woman's pension allowance. The intention of the law is to protect women by enabling them to retire early. However, because the lower retirement age is mandatory, it does not give women the opportunity to accumulate more years. This disadvantage can be further aggravated if women choose to enter the labor force at a later age, after their reproductive years (and in a country with high fertility rates, this delay can be significant). In addition, employers are likely to prefer hiring a 50-year-old man to a 50-year-old woman, who must retire earlier. Having a lower retirement age effectively means that women are less able to accumulate the same level of experience—and, hence, postretirement income—as their male counterparts. It essentially reduces a woman's economic earning potential and the return of her work to her family.[13]

Gender-Based Job Segregation That Reduces Economic Efficiency

Women workers across the world usually perform different tasks (occupational or vertical segregation) and work in different industries (industry or horizontal segregation) from those of men. For example, occupational or vertical segregation exists when more men hold managerial positions and more women hold secretarial positions. Industry or horizontal segregation exists when more men are found in the oil industry and more women are found in social services. Such sex-based segregation may be the result of choices made freely by men and women on

the basis of their skills or preferences. But if it results from constrained opportunities, it is of concern for these reasons:

• Segregation is economically inefficient, and it leads to lower labor participation by females. As defined by the International Labour Organisation (ILO), sex-dominated occupations or industries are those where workers of one sex make up more than 80 percent of the labor force. Worldwide, ILO (2003b) reports that while about half of workers are in sex-dominated occupations and industries, women are employed in a narrower range of occupations and industries than are men: male-dominated nonagricultural occupations are seven times as numerous as female-dominated occupations.

• Because segregation artificially limits the pool of available talent, it leads, in certain occupations, to an oversupply of workers, who must work at low levels of pay. Consider the extreme case of segregation caused entirely by employer discrimination against women entering male-dominated industries. Because there are fewer explicitly "female" sectors, this scenario would lead (in addition to fewer opportunities for women) to an oversupply of workers in those female-dominated industries, thereby causing lower wages than otherwise would have been the case; it would also lead to decreased productivity from overcrowding.[14] Furthermore, it would lead to an undersupply of qualified workers in male-dominated industries, thereby causing higher wages than otherwise would have been the case. This situation would result in output inefficiencies, because the negative effect on the economy of the reduced productivity of labor in the female-dominated industries would not necessarily be counterbalanced or overcome by increasing productivity in male-dominated sectors. The lack of counterbalance would exist especially if the male sectors did not enjoy the participation of the labor force's full talents or if employers had to incur additional costs to import the required qualified workers.

• Sex-based occupational segregation raises both equity and efficiency concerns because it affects women's socioeconomic status. It typically reflects gender inequalities in power, skills, and earnings (ILO 2003b) and may be, as Rubery, Fagan, and Maiser (1996) point out, "not only a symptom but a cause of continuing gender inequality." Such segregation perpetuates gender gaps in earnings, limits women's opportunities for job mobility and career advancement, and reduces the women's possibilities for autonomy at work (Chang 2000).

• Furthermore, if women choose occupations on the basis of family considerations, or if a large presence of women in an occupation makes

that occupation more friendly to workers with family responsibilities, then the concentration of women in those types of occupations may reinforce a gendered division of labor in which women's, but not men's, labor force decisions are influenced by family and household responsibilities (Chang 2000). Social norms can further reinforce this process.

In MENA, while sex segregation by occupation varies widely within the region, the overall level of segregation is no higher than the average for other world regions, although it is lower than that of Europe or the Americas (table 4.6).

In the three MENA countries (Egypt, the Islamic Republic of Iran, and Morocco) for which information is available, segregation has increased over the past decade in all cases except industry segregation in the Islamic Republic of Iran (table 4.7).[15] In the rest of the world, segregation has remained constant or has declined (Sayed and Tzannatos 1998).

Measures to extend the range of occupations and industries that are open to women are an important means of promoting both economic efficiency and gender equality in the region.

TABLE 4.6

Occupational Segregation in MENA and World Regions, 2000 or Most Recent Year

Country or region	Duncan index for occupational segregation
Djibouti	0.51
Egypt, Arab Rep. of	0.46
Iran, Islamic Rep. of	0.22
Jordan	0.44
Lebanon	0.37
Morocco	0.13
Tunisia	0.19
West Bank and Gaza	0.42
Yemen, Rep. of	0.31
MENA average	**0.34**
West Africa	0.23
East Asia and the Pacific	0.32
South Asia	0.20
Central and Eastern Europe	0.26
Rest of Europe	0.40
Americas	0.45

Note: The Duncan index is a commonly used measure of segregation (Duncan and Duncan 1955). Here it is calculated as one-half of the absolute difference between the sectoral employment ratios of women and men to their respective (female and male) labor force. The index takes a minimum value of zero when women and men have identical employment distributions across sectors (that is, when the percentage of women in each sector is the same as the percentage of women in total employment). It takes a maximum value of one, when there is complete dissimilarity (that is, when women and men never work in the same sector).
Sources: Data for MENA come from case studies. Data for other regions come from Sayed and Tzannatos 1998.

TABLE 4.7

Trends in Occupational and Industrial Segregation in MENA Countries, 1988–2000

Country (year)	Duncan index for occupational segregation	Duncan index for industry segregation
Egypt, Arab Rep. of (1988)	0.35	0.38
Egypt, Arab Rep. of (1998)	0.46	0.51
Iran, Islamic Rep. of (1992)	0.18	0.47
Iran, Islamic Rep. of (2000)	0.22	0.39
Morocco (1991)	—	0.31
Morocco (1999)	—	0.33

— Not available.
Source: World Bank household and labor force surveys.

Restrictions on Women's Flexibility as Workers

Although wage discrimination and job segregation may provide part of the explanation for women's low participation in the labor force throughout MENA, such discrimination also exists in other regions where women have significantly higher participation rates. Thus, MENA's dramatically lower rates suggest that other powerful disincentives exist concerning women entering and staying in the labor force. Those factors can be economic and noneconomic in nature, and many may be deeply rooted in social norms, as the example in box 4.5 suggests.

Constraints on Women Originating from the "Code of Modesty"

The degree of women's participation in public life is influenced by the extent to which a society identifies with determinants within the code of modesty (see p. 95). Actual laws and practices vary from country to country, by social class, and between urban and rural areas. Nevertheless, in all MENA countries, preservation of the family's reputation is associated, to a certain degree, with the behavior of its women and the ability of men in the family to protect the honor of their female relatives and, thereby, the honor of the family. Several countries have incorporated this concept into actual laws that restrict women's movement or affect their accountability to their husbands or guardians.

Laws in a number of MENA countries, for example, stipulate that a wife must obtain her husband's permission to work and travel. In a 1997/98 survey in Morocco, 85 percent of women said they needed the permission of their husband or guardian to leave the house, and in a 1999 survey, more than 85 percent of men stated that women do more

BOX 4.5

Garment Workers in Morocco: Daughters but Not Wives

The overwhelming presence of females in garment factories in Fez, Morocco, belies the common belief that women do not belong in the world of business and the public. Factories partly assuage this contradiction by hiring mainly young, unmarried women.

Work in the factories is tedious and physically exhausting, yet workers complain most bitterly of the fact that it is shameful. They speak of being disrespected by high-level factory staff members and of being treated like maids inside the factory. The public also looks down on them. One 27-year-old single woman who had been a garment worker for more than 10 years noted, "People see you in the street and say that you are just a factory girl, that you have no value."

Doing factory work in Fez connotes a low class status. For females, it also suggests a lack of family honor and the real or potential loss of personal virtue. Female factory workers are assumed to be related to males who cannot support and protect them appropriately and who cannot control and monitor their daughters.

Nonetheless, this lack of control over daughters is far less threatening to the community than the potential lack of control over women who are wives. By law, a wife who works is not obligated to give her salary to her husband, but unmarried women are subservient to their fathers. Men in Fez overwhelmingly disapprove of the idea of wives working and try to ensure that women they marry will not work for a wage after marriage. Married women are also less desired workers by factory owners because they cannot be easily exploited, for this exploitation would entail shaming their husbands.

Source: Cairoli 1999.

important work within the house than outside. Men said that they would tolerate a woman's employment, as long as it was temporary—to help the family during a time of need—but that once her employment was no longer necessary, the woman should stop working and stay at home.[16] This view is shared in other countries in the region or in certain circles of society. By and large, it puts into question a woman's need to work on a continuous basis, particularly if no financial necessity exists or if the husband does not agree.

The labor laws of many countries in the region regulate the types of jobs that women may undertake and the hours that women may work (table 4.8). Those laws are not unique to the MENA region and have existed in one form or another in other regions. However, most other countries are in the process of having such laws phased out. These regulations, which are based on foreign models that have since been updated in their countries of origin, make women less flexible as workers and, thus, discourage women from working and employers from hiring them.

TABLE 4.8

Legal Restrictions on Women's Work and Mobility in MENA, 2003

Country	Restrictions on time and hours of work	Restrictions on types of work	Restrictions on mobility (husband's or guardian's permission required for travel or passport)
Algeria	Yes	Yes	No
Bahrain	Yes	Yes	No
Djibouti	No	No	No
Egypt, Arab Rep. of	Yes	Yes	No (as of 2000)
Iran, Islamic Rep. of	No	Yes	Yes
Iraq	Yes	No	Yes
Jordan	Yes	Yes	No (as of 2003)
Kuwait	Yes	Yes	Yes
Lebanon	No	Yes	No
Libya	Yes	Yes	No
Oman	Yes	Yes	Yes
Morocco	Yes	Yes	No
Qatar	—	—	Yes
Saudi Arabia	Yes	Yes	Yes
Syrian Arab Rep.	Yes	Yes	No[a]
Tunisia	Yes	No	No
United Arab Emirates	Yes	Yes	No
West Bank and Gaza	Yes	Yes	No (as of 2003)
Yemen, Rep. of	Yes	Yes	No

— Not available.
a. A man can obtain a letter from the Ministry of Interior to be presented to Immigration Control to prevent his wife or female relative from leaving the country.
Source: Hijab, El-Solh, and Ebadi 2003. (See also table A.3 in the appendix.)

The laws have been more difficult to change in MENA because of the underlying social norms and because of their resonance with the code of modesty. Though intended to protect women, they instead now constrain many young educated women who seek jobs in the formal sector (World Bank 1995).

Restrictions on types of jobs. Most countries stipulate within their constitutions equal opportunity for employment for all citizens, with some even specifying equal opportunity for women. Many, however, also apply labor laws that restrict certain work for women, making women less flexible as workers (see also table A.4[b] in the appendix). For example, with the exception of Djibouti, Iraq, and Tunisia, all countries have labor laws that prohibit so-called hazardous jobs for children and women. In some countries, such jobs include making clothes, working in warehouses, selling printed materials on the street, and painting. Some countries explicitly restrict women's entry into certain sectors. For example, in the

Islamic Republic of Iran, women cannot become judges, and in Morocco, women cannot hold posts in certain ministries (the Ministries of Interior, Civil Protection, National Defense, and National Security). In Saudi Arabia, it is prohibited—under any circumstances—to integrate adolescent girls and women with men in places of work or facilities attached to those sites. This prohibition effectively bars women from most sectors and from attaining higher levels of management. According to Hijab, El-Solh, and Ebadi (2003), an August 3, 1985, royal decree "prevents the Saudi Arabian woman from working in all spheres except in female schools and nursing" (Altorki 2000).

Restrictions on hours of work. Prohibitions on women working at night exist throughout the region. Some countries provide exceptions. Oman is typical; its law states, "Women can be employed between 6:00 p.m. and 6:00 a.m. in travel agencies, airlines, and airports if they are in senior positions or positions of confidence, also in hospitals and other medical care facilities" (Article 80, Labor Law; Hijab, El-Solh, and Ebadi 2003). Many countries also prohibit women from working more than a specified number of hours per day or week. In Libya, women are not permitted to work more than 48 hours a week, including overtime.

Restrictions on hours of work for women were introduced to protect women's health and in recognition of their responsibilities as wives and mothers; however, the restrictions may end up affecting women's employment opportunities and wages.[17] Such regulations discourage employers from hiring women for jobs that may (even occasionally) involve overtime or night work. Nataraj, Rodgers, and Zveglich (1998)—using the basis of partial equilibrium modeling of a competitive labor market—show that by reducing firms' flexibility in employing women workers, restrictions on hours of work reduce the demand for women workers at

BOX 4.6

Night Taxis in the Islamic Republic of Iran

The information age and new technologies open new opportunities for women to penetrate the work world by acquiring new jobs and new working times. In 2000, in the holy city of Mashhad—a major site of Shia pilgrimage—more than a hundred women started working as taxi drivers, one of the most male-dominated professions in the world. Trained in martial arts, carrying cellular phones, and still wearing their veils, those women work nightshifts regularly, protected through a central dispatch office.

Source: Bahramitash 2001.

any given wage and encourage employers to hire men instead, because men do not face those restrictions.

To some extent, changes in technology can help women overcome traditional barriers to night work and to certain work environments, barriers that were initially put in place to protect women's safety (box 4.6). With globalization, the demand for an around-the-clock work force can open up additional opportunities in occupations that involve interaction across different time zones (for example, in high-end services such as technical consulting, call service centers, and trading). If women are constrained by hours of work, they will not be able to take up such opportunities.

Rather than regulating women's hours differently from those of men, countries could meet the goal of protecting women merely by enforcing the other existing statutory work hours and overtime limits that apply to both women and men.

Restrictions on mobility. In several countries, laws require women to obtain permission from male relatives to perform normal work functions such as travel (Hijab, El-Solh, and Ebadi 2003). In a number of countries, women are required to present some type of written permission from their husband or a male guardian for unaccompanied travel abroad. In some countries, such a permission is even required for travel inside the country. Others require that women be accompanied by a male *mahram* guardian. Increasingly, countries are lifting the requirement for women to obtain permission to travel when they will be traveling alone. Yet most countries, such as the Islamic Republic of Iran or Kuwait, still require a woman to obtain her husband's signature to apply for a passport. In some countries, even if there are no regulations concerning a woman's ability to travel alone, it is still possible for a man to get an official letter, which is placed at the airport and can stop a female relative from leaving the country (Hijab, El-Solh, and Ebadi 2003). In a few countries, such as Bahrain and Libya, however, regulations explicitly state that men and women are treated the same with regard to freedom of movement. Some countries, such as Egypt and Jordan, have recently made amendments to laws (in 2000 and 2003, respectively) that previously required a woman to have a husband's or male guardian's signature for the passport application. It will take some time before the effect of those changes on women's lives and opportunities can be measured.

Such mobility constraints clearly disadvantage women in the labor market. They can also reduce economic efficiency, for example, by effectively denying women strategic professional opportunities, such as training in new production or teaching techniques. In general, many women in the world face some standard constraints on mobility. An extensive literature documents the spatial containment of working women. These

BOX 4.7

Protection of Women's Safety

Certain governments and cities around the world have tried to cater to women's needs. For instance, in each public parking lot in the city of Zurich, Switzerland, areas and even entire floors are dedicated to parking for women—*Frauenparkplaetze*. These areas are better lit and better guarded to ensure the safety of women drivers. Much of this additional security is being paid for by private businesses that need women workers, clients, and consumers.

constraints, for example, may result from simple inaccessibility of infrastructure, which tends to affect women's mobility more strongly than men's. In addition, women tend to look for work close to home, often forgoing better jobs that require long commuting or too much time. This situation can affect women's access to the labor market and, to a large extent, women's productivity if it prevents them from exploring new opportunities (Hanson and Pratt 1988; Hanson, Kominiak, and Carlin 1997; Hujer and Schnabel 1994; Ofek and Merrill 1997; Preston and McLafferty 1992; and Wyly 1998). Although less has been written about this issue in the developing world, containment is likely to be strong in MENA as well, where transport and public commuting systems are not well developed and are less gender sensitive.

Many of the concerns underlying the restrictions on women's mobility and hours of work can be addressed by providing an environment for women that is physically and reputationally safe—for example, by providing regular reliable transport,[18] by imposing strict laws preventing sexual harassment at work and enforcing those laws, and by teaching respectful behavior in public spaces to acknowledge the cultural and social values and the women's different needs (box 4.7).

Other Factors Limiting Women's Work

State policies in some countries have, at times, given negative signals or have supported practices that have driven women out of the labor force. Several countries have actively used policies to employ men instead of women, particularly at times of high unemployment, in view of men's traditional role as the head of a household. In the Islamic Republic of Iran, for instance, the government undertook a campaign (*paksazy*) to

BOX 4.8

Gender Distinctions That Hinder Business Development

In many cases, gender distinctions prevent the startup of new businesses. Doumato (1999) gives this example:

> In 1996, a female Saudi electronics engineer initiated a plan to open more areas of employment for women in Saudi Arabia. Her venture capital group, operating out of offices in Riyadh and Boston, wanted to invest in high-tech manufacturing companies that would agree to include women in their work force—from assembly-line workers to plant managers. After a year of trying to obtain official approvals for her company's "affirmative action" project, she had received plenty of compliments for her ingenuity, but not the licenses she needed to go ahead. Her project, as she put it, "is not going to happen."
>
> The stumbling block lay in the difficulty of devising ways to keep men and women employees who work in the same company separated from each other on the job. The obvious alternative, an all-woman work force, she says, is not an option: no manufacturing business in Saudi Arabia could function, she says, without male intermediaries. She is right, and even the employment of male intermediaries by women entrepreneurs is in question: the Ministry of Commerce announced in 1995 that women would no longer be issued commercial licenses for businesses requiring them to supervise foreign workers, interact with male clients, or deal regularly with government officials.

As reported by the newspaper *Al-Madinah* on November 19, 2003 ("Saudi Women's Bank Accounts Waiting to Be Tapped"), Saudi women's bank accounts contained in November 2002 an estimated $26.6 billion in idle funds as a result of laws that prohibit women from opening businesses of their own. In fact, Saudi Arabia has large numbers of women business owners who have inherited family-owned businesses—many of which are among the country's largest enterprises. Saudi women business owners have issued a report noting, "Incentives for investment in neighboring countries have forced Saudi women either to invest abroad or [to] keep their money in banks." The report blames the flight of at least SR 21 billion to foreign countries on regulations that prevent women from conducting business. In consultation with chambers of commerce and industry, Saudi women business owners are asking the government to allow women to open businesses, and they have urged the repeal of the law requiring women to use male intermediaries. One woman business owner interviewed by the press reported that her company has assigned female family members to various managerial tasks to prepare them to assume greater responsibilities in the future.

"purify" the workplace; the campaign offered early retirement incentives to persuade women to leave their jobs. The government also gave a lifetime income of $100 per month to husbands of women who resigned (F. E. Moghadam 2001). This policy has now been discontinued, but it resulted in a decline in the number of working women.

In several MENA countries, the law requires a woman's interaction with the state, in terms of both requesting and receiving services, to be mediated through a male relative (see chapter 5). The extent of the intermediation required and the areas it must cover vary across the region (box 4.8).[19]

Combining Work and Family Responsibilities

The high dropout rate of women from the labor force when they marry and have children (see figure 4.2) and the value that MENA societies place on the family suggest that women's ability to combine work with family responsibilities will be a key factor in keeping more women in the labor force.[20]

Women who leave the labor force upon marriage, rather than when they begin bearing children, may be strongly influenced by traditional attitudes and beliefs. Practical barriers and incentives that reflect the traditional gender paradigm and that are designed to save employers money also play a role, particularly when employees seek to avoid paying for potential maternity leave, which they are legally bound to provide. Employers may provide positive incentives to quit; in Saudi Arabia, for example, a woman who resigns because of marriage receives a benefit equal to 11 percent of her average annual salary over the years she served. In Bahrain, although an employer cannot legally terminate a female employee because she marries, the employer can change the type of work she performs after marriage. In Egypt, women in the public sector, but not the private sector, tend to stay in jobs after marriage; researchers attribute this tendency to pressures that private sector employers place on women employees to leave when they marry (Assaad 1997a).

Government-Mandated Maternity Leave Policies

Maternity leave policies (especially job protection policies) are crucial for keeping women in the labor force after childbirth and can benefit women, their families, and their employers as well. By encouraging continuity of employment, the policies encourage women to be committed to their employers and to invest in their careers, and they encourage employers to train and promote their female employees.

TABLE 4.9

Maternity Leave Laws in MENA Countries

Country	Maternity leave at full or partial pay	Maternity leave without pay	Work breaks for breastfeeding	Employer pays maternity-related medical care	Job protection during maternity	Incentives to retire upon marriage
Algeria	14 weeks	5 years	—	Yes	Yes	—
Bahrain	45 days	15 days	Yes	—	Yes	—
Djibouti	14 weeks	—	Yes	—	Yes	—
Egypt, Arab Rep. of	50 days	1 year if 50+ employees	Yes	—	—	—
Iran, Islamic Rep. of	12 weeks	—	Yes	Yes	Yes	—
Iraq	6 months	—	Yes	—	—	—
Jordan	10 weeks	1 year if 10+ employees	Yes	—	Yes	—
Kuwait	—	100 days	—	—	—	Yes
Lebanon	7 weeks	—	—	—	Yes	Yes
Libya	90 days	—	Yes	—	—	—
Morocco	1 year	2 years	—	—	—	—
Oman	—	6 weeks	—	—	—	—
Qatar	40–60 days	—	—	Yes	—	—
Saudi Arabia	10 weeks	—	Yes	Yes	Yes	Yes
Syrian Arab Rep.	105 days	1 month	Yes	—	—	—
Tunisia	30 days	—	Yes	—	Yes	Yes
United Arab Emirates	4 months	2 months	—	—	—	—
West Bank and Gaza	10 weeks	—	Yes	—	—	—
Yemen, Rep. of	60 days	6 months	Yes	—	—	—

— Not available.

Note: In some cases, women are required to have worked for the employer for a specified time before being eligible for maternity leave. In other cases, women who take maternity leave are not eligible for their annual leave in the same year.

Sources: Hijab, El-Solh, and Ebadi 2003; (for Qatar) United Nations 2000a; and (for Iraq, Morocco, and Tunisia) United States Social Security Administration and International Social Security Association 1999.

The labor laws of all MENA countries provide for generous maternity leave—usually paid and usually at the employer's expense (table 4.9). This coverage is in line with the significant emphasis that MENA societies give to the centrality of the family, which is also important to women. However, these important social objectives may not be adequately covered within the prevailing incentive environment for employers. The cost for these benefits creates disincentives for employers to hire women. Some companies encourage women to quit upon marriage. The burden of high benefit costs also encourages the development of informal employment arrangements in which legislated benefits are not paid. It is interesting to note that employers generally perceive women as

BOX 4.9

Models for Funding Maternity Benefits

International Labour Organisation (ILO) research covering Argentina, Brazil, Chile, Mexico, and Uruguay challenges the conventional belief that hiring a woman is more costly than hiring a man. The study found that the costs are nearly identical, differing by about 2 percent when considering wages and 1 percent when considering nonwage costs. In those countries, the cost of maternity-related benefits and the wages paid during maternity leave are not borne by the employers but come out of taxes (Chile) or social security funding (Argentina, Brazil, Mexico, and Uruguay). When such costs are funded by the social security system—as in the countries other than Chile—the employer's contribution is not linked to the number or the age of women employees, but rather to the total number of employees of both sexes. This form of funding seeks to ensure an essential value: the protection of women against possible discrimination because of maternity, in the spirit of the ILO conventions on maternity protection.

Source: Abramo and Todaro 2002.

higher-cost employees, mainly because of, for instance, maternity leave and employer childcare provision. This perception, however, is not always accurate. In several countries, family allowances are channeled only through the man, and employers must pay benefits of up to 10 percent of a male worker's salary throughout his career, whereas the cost of a woman's maternity leave is usually borne for no more than three months, two or three times throughout her entire employment life.

In countries where increasing female participation in the labor force is a goal, publicly financed maternity leave policies are clearly preferable to employer-paid policies, because they reduce gender-specific distortions (box 4.9). However, publicly financed programs require a level of institutional capacity that may be lacking in some countries.

Support for Working Mothers

The greater a woman's child-rearing responsibilities, the less likely it is that she will choose to enter paid work. Evidence from MENA shows that women's participation in the labor force is lower if no other women are in the household with whom to share childcare responsibilities. Estimates indicate a decreased likelihood of participation of 2 percent in the

Islamic Republic of Iran, 5 percent in the Republic of Yemen, and 8 percent in Djibouti.

Childcare. Extended families are an important source of support for working women, but with the trend toward nuclear families and with the difficulties of commuting in overcrowded urban areas, depending on relatives for childcare is becoming more and more difficult. In most MENA countries, there are well-developed markets for nannies, which facilitate the labor force participation of women. However, the beneficiaries of those services are mainly wealthier women. A large percentage of families would not be able to afford to pay for those services.[21]

As noted above, the laws of some MENA countries require employers to provide childcare centers at their own expense. In Libya and Tunisia, for example, employers with more than 50 female employees are required to provide childcare (Hijab, El-Solh, and Ebadi 2003). While the goal is laudable, the cost makes employers hesitate to hire married women of childbearing age. Mandating such benefits on the basis of the number of female employees can be counterproductive if it leads employers to limit their hiring of women. In countries where employer-paid childcare policies are effective, the mandate is based on a firm's total number of employees.

Education sector policies, if they are well conceived and implemented, play an important role in filling childcare gaps. Options include providing childcare for preschool children; compulsory schooling from a young age; pre-primary education (discussed in chapter 2); school hours, length of school year, and holidays that are coordinated with typical work schedules; and after-school programs (box 4.10). [22] Market provision of childcare services is only slowly beginning to appear as an increasing number of women are working. Moreover, educated women, who tend to have fewer children, are likely to have higher expectations of caregivers than could be provided by domestic (often poorly educated) servants. They demand not only a safe place for care, but also an intellectually stimulating environment, such as what is usually provided by professional institutions and centers.

Part-time work. Throughout the world, the rise in female participation rates has been closely connected to the availability of part-time jobs.[23] Part-time jobs are beneficial to firms because such jobs allow firms to allocate more labor toward weekly peak hours and because they enlarge the labor supply. Part-time jobs are useful to women because they allow women to combine work with family care. Studies have found that most

BOX 4.10

Mothers in Germany: Briefcase or Baby Carriage?

Although Germany is an advanced industrial country, its approach to tackling one of its biggest development challenges could be of relevance to MENA countries. They are each coming from two opposite sides of the fertility spectrum, but they both face similar problems and possibly similar solutions. While Germany invests highly in the education of its citizens, it does not benefit fully from this investment. Many college-educated women remain at home taking care of children, which means that the country is sitting on a treasure trove of highly educated housewives who are ready and willing to participate in the labor force.

In 2000, the average fertility rate for German women was 1.36 children, one of the lowest rates in Europe. Germany is becoming a country dominated by aging DINKies (double income, no kids). The low birth rate affects the country's economic dynamism and will cause future problems in financing health care and pensions. Yet many young women feel that they cannot have both children and a career.

Traditionally in Germany, child rearing has been considered a private, not a public, matter. Family values once dictated that mothers be shielded from the outside world, that they leave the kitchen only to go to church (*Kinder, Kueche, Kirche*). Even today, many women feel like a *Rabenmutter* (cruel mother) if they put their children in a kindergarten. This belief continues to pervade much of German society, and the result is that childcare facilities are poor or nonexistent, especially in western Germany. They are better in the east because communists needed women in the work force. Of the facilities that do exist, most close at midday, making it difficult for working mothers to work full time. As a result, only 60 percent of German women work, fewer than in the United States or Scandinavia.

Until childcare options are available for working parents, female participation in the labor force is likely to remain low, which is a detriment to Germany's economic growth. Thus, it essential for the country to find ways to make motherhood and career more compatible. In his New Year's speech, Chancellor Schroeder stressed the need for federal childcare programs. Germany plans to spend about 1.5 billion euros a year on childcare and 4 billion euros on all-day schools over the next four years, in an effort to strike a balance between graves and cradles. This is a concerted departure from the view that the briefcase and the baby carriage don't mix.

Source: Germany's Declining Population 2003 (p. 27).

women in part-time jobs do not want full-time jobs.[24] Part-time work does not simply redistribute a fixed amount of labor over a larger number of workers. By expanding both demand and supply of labor, the permissibility of part-time work can create new employment (Nickell and van Ours 1999).

BOX 4.11

Jobs, Jobs, and More Jobs . . . from Dutch Disease to the Dutch Miracle

Although circumstances in MENA and the Netherlands may at first seem very different, the Dutch experience provides a number of parallels.

In the late 1970s and early 1980s, the Dutch economy deteriorated markedly in response to years of excessive wage growth as a result of North Sea gas. This wage growth eroded business profits and led to uncontrolled government expenditures. Productivity increased only as a result of capital intensity as rapid wage growth induced firms to substitute capital for labor. Employment stopped growing. Given the Netherlands' tradition of high social benefits, the stagnant economic growth and lower employment worsened the fiscal situation. This situation gave rise to the term *Dutch Disease*.

Within the constraint of keeping the guilder tightly linked to the deutschemark, the Netherlands in 1982 introduced a reform package focused on social security and labor market reforms. It was spearheaded jointly by the labor unions, the private sector, and the government. Low wage moderation and labor with flexibility were key components of the package.

The reforms are noteworthy for the remarkable employment creation and the turnaround in labor force participation that they achieved. Instead of keeping large numbers of workers on unemployment benefits, the reforms sought to provide some employment for everyone. This effort required a shift from full-time, lifetime jobs for men toward more varied combinations of paid employment, family responsibilities, education, and leisure for both men and women. Providing more flexibility in career and working hours, child-rearing, and care for the elderly was at the heart of the Dutch welfare state. Those values were maintained in the reform program. The one-and-one-half income families helped to reduce households' dependence on single breadwinners. This achievement was accomplished through a rapid rise in the participation of women in the work force. The increase in the working-age population meant that wage pressures were less likely to emerge; thus, it was easier for stakeholders to support the moderation of wages.

The initial conditions in the Netherlands were key to the success of the reforms. They included a long dependence on natural resources, rapid demographic growth of the labor force in the 1970s, dependence on one breadwinner, low participation rate of women in the work force, and labor unions' strong vested interest in the status quo.

The increase in the participation in the labor force by women with children enhanced the need and created extra income for family-oriented services, whose jobs are mostly taken up by women. The Netherlands experienced dynamic growth in the provision of private care services, replacing those that were traditionally provided through communal or public sectors.

Sources: IMF 2000; Visser and Hemerijck 1997.

Information is difficult to find on regulations that encourage or discourage part-time work in MENA. Part-time work has been used effectively in the Netherlands to increase the labor force participation of women and to lower unemployment (box 4.11).

Notes

1. Much of the literature refers to this paradigm as the "patriarchal gender contract." See, for example, Moghadam (1998).

2. The paradigm and the degree of its implications on women vary from country to country and within countries, depending on socioeconomic class, but they prevail to some degree throughout the region.

3. *Head of household* is defined in terms of needing to work to support a family. This definition excludes people who can choose whether or not to work or whether to work on a part-time basis. See Khalaf (2002).

4. For instance, article 115 of the Personal Status Code of Morocco affirms, "Every human being is responsible for providing for his needs [*nafaqa*] through his own means, with the exception of wives, whose husbands provide for their needs." In the Islamic Republic of Iran, the Manpower Policy of 1983 states, "The man's salary should be of a level that is sufficient to provide for his family. Thus, there would be no need for dependents to work," while article 1106 of the Civil Law states, "Payment of living expenses is the responsibility of the husband, who must ensure the well-being of his family." See Haidar (2001).

5. *Mahram* determines the categories of people between whom marriage is prohibited. These categories cover blood kinship relations, certain marriage relations, and milk relations. Blood kinship restrictions include one's descendants (that is, one's daughters or sons, their offspring, and any maternal and paternal offspring such as full- and half-sisters or -brothers, as well as nieces or nephews) and one's maternal and paternal aunts and uncles, although it is permissible to marry a cousin. In the case of kinship by marriage, one may not marry a spouse's mother or father or ascendants of the mother or father. The relationship of milk is peculiar to Islam and refers to the relationship of a woman to a child she suckles but who is not her own. In that case, the woman and her husband are considered the same as the child's mother and father, and the marriage restrictions listed above apply.

6. An *engendered environment* is one that allows for women's participation, as well as men's, by taking into account the different practical needs of men and women.

7. Inequalities in the private sphere can stem from a variety of factors that play a role in the power dynamics within a marriage, such as

differences in age, education, social position, personality, and knowledge. But in MENA, inequalities in the private sphere are also determined by the differential treatment of men and women under family laws that are based on religious interpretations.

8. There are some wide differences within the region in labor force participation rates for women. Those differences reflect the diversity in the economies of the region and in the household structures.

9. Researchers generally use data on education and experience because data on actual productivity are rarely available. A useful refinement used by some studies is to limit the exploration to workers within homogeneous job categories (such as workers within a single industry or occupation).

10. Estimates of wage discrimination are complicated by three issues. First, even when their education levels are the same as men's, women tend to work in jobs in which any worker—man or woman—would have low productivity and, therefore, low wages. Looking at a variety of occupations, Said (2001) estimates that 35 percent of the gender pay gap in Egypt is attributable to segregation in occupations. Second, while our estimates control for education and potential work experience, we cannot control for variables such as individual effort. Third, the estimates of discrimination among wage earners do not tell us anything about the discrimination in hiring decisions, the discrimination that occurs outside the labor market (for example, in the education system) and that affects wage gaps, or the discrimination among nonwage earners.

11. This pattern holds for all countries in the region except for Djibouti.

12. Many countries allow women to receive allowances if certain conditions are met. In Lebanon, for example, a woman can claim income tax deductions for children only if she is the sole breadwinner or if the children's father is dead or has a disability. In Kuwait, women pass their pension on to their survivors only if their spouse is "certified by the Medical Committee to be incapacitated from work or gainful employment." See Hijab, El-Solh, and Ebadi (2003).

13. Studies of Argentina and Chile, for example, find that raising the female retirement age of 60 to the male retirement age of 65 would increase a woman's average monthly benefit by 50 percent and narrow the gender gap in benefits by 10–15 percentage points. In addition to narrowing the gap in benefits, equalizing retirement ages reduces the public transfer toward women and makes labor market incentives more equal (James, Edwards, and Wong forthcoming).

14. A declining marginal product of labor implies that adding a worker to a particular sector will diminish that sector's marginal output.

15. This situation occurs mainly because women were welcomed into previously male-dominated professions in order to provide services to women only. Women became doctors, hairdressers, sports coaches, and so forth. Hence, the general segregation policies, in fact, opened up the demand for women in previously male-dominated professions.

16. Rabea Naciri, reporting on the 1997/98 survey by the Government of Morocco Statistics Department and by the Democratic Association of Women in Morocco.

17. Together with occupational bans for women, restrictions on working hours were among the first labor market legislation introduced in 19th-century Europe and were embodied in conventions. Those protective measures for women were increasingly deemed discriminatory in the 20th century, and many industrial countries reversed their legislation, but the measures remain in force in many developing countries (Nataraj, Rodgers, and Zveglich 1998).

18. See, for example, Report on Women's Difficulties 2001.

19. For instance, the Jordanian Civil Status Law requires a "family book," or *daftar*, to conduct all official transactions, including voting or being a candidate for elected office, registering children for school or university, obtaining civil service jobs, or gaining access to social services such as food assistance. Upon marriage, a woman is transferred from her father's *daftar* to that of her husband. Recent legislation now allows women to start their own *daftar* if they are divorced or widowed. The prior legislation required them to reregister under the *daftar* of a male family member; however, reregistration became problematic when the male family member was working abroad or was deceased.

20. Hence, proponents of women's empowerment must avoid proposals that undervalue or threaten to destabilize the family. Crittenden (1963), writing about the women's movement in developed countries, noted, "At the turn of the 20th century, the women's movement contained two contradictory strands: one that denigrated women's role within the family, and one that demanded recognition and remuneration for it. The first argued that only one road could lead to female emancipation, and it pointed straight out of the house toward the world of paid work. For the rest of the 20th century, the women's movement followed the first path to great victories. However, in choosing that path, many women's advocates accepted the continued devaluation of motherhood, thereby guaranteeing that feminism would not resonate with millions of wives and mothers."

21. Various estimates indicate that there are several million female immigrant maids in MENA, in addition to maids who were MENA nationals. In the Gulf Cooperative Council countries, there is nearly one immigrant maid for every woman in the population. In other parts of

the region, however, quality and affordable childcare services remain scarce and do affect women's participation in the labor force.

22. On the whole, the literature—mainly on industrial countries—supports the premise that having more attractive childcare options increases mothers' employment. For a review, see Gornick, Meyers, and Ross (1996).

23. See, for example, Engelhardt and Prskawetz (2002) on Organisation for Economic Co-operation and Development countries.

24. For example, 78 percent of part-time female workers in the Netherlands and 94 percent in the United Kingdom do not want full-time work (Nickell and van Ours 2000).

The Gender Policy Agenda to Meet Demographic and Economic Needs

This book began by asking why the factors that have led to women's greater economic empowerment in other regions of the world have been less effective, thus far, in the Middle East and North Africa (MENA). Previous chapters explored the extent and the factors behind the progress and limitations on women's participation in the economy. Chapter 4 discussed, in particular, the economic and social constraints on women's entry into and attachment to the labor force and emphasized that the traditional gender paradigm no longer fits with the demographic and economic realities of the region.

This chapter presents a framework for developing an agenda for change. Its main messages are as follows:

1. Gender equality in terms of access to opportunity and security is intimately tied to good governance, thereby implying greater inclusiveness and accountability of the existing institutions in applying fairness and equity. But the pressures of economic necessity and the disciplines of the global economy, combined with a demographic tidal wave of educated and assertive women, make it also no longer possible to ignore the gender dimension of development challenges in the region. A new agenda for change with respect to gender needs to be integrated into the new development model so the region will ensure economic efficiency and social equity.

2. An agenda for change to enable women greater access to opportunity and economic security would require adjustments in (a) the *public sphere*, by making existing legislation more consistent with women's constitutional rights and by ensuring equal access to the labor market, quality education, and better skills, and (b) the *private sphere*, by redressing the power structure within the family and by providing market solutions for women who need to reconcile work and family responsibilities.

3. Moving toward implementation of this gender policy agenda requires an active role of leadership from the state to spearhead reform and to build coalitions for change, plus greater inclusiveness of women in political life, which should support change at the grassroots level.

The primary force for change in MENA is the demographics of the region. One out of every three people in MENA is a woman below the age of 30. Most have been brought up in families with fewer children than the families in which their mothers were raised and with greater access than their mothers had to education. They marry later, and they have benefited from an adolescence during which they could build an individual identity. They have greater expectations from life and they want to make greater contributions to their societies. They already defy the status quo at the family level and are increasingly ready to challenge old policies and institutions. Such women are likely to be to MENA what the baby boom generation was to the West 30 years ago, when it brought about the end—or at least the beginning of the end—of discrimination against women. The emergence of women from the home and their steadily increasing prominence in public life have transformed societies and the economic landscapes of many countries. In MENA, too, women are becoming an important force in the transformation of societies.

A transformation is also noticeable among men. This change is most visible in the marriage patterns in the region, which show higher divorce rates, later ages at marriage, larger percentages of nuclear households, and increasing numbers of men and women remaining unmarried into middle age or later. Although both men and women are still under pressure to maintain the tradition of the male breadwinner model, younger and more educated men concur on the need for more flexibility to share responsibilities, power, and rights for the upkeep of their families (Aghacy 2001; Omar 2001). And in many middle-class and urban areas, men are increasingly looking for more educated and professional wives as a way of hedging against future economic uncertainties.

The secondary force for change is the economics of the region. Few families in the region are affluent enough for women to confine themselves to the traditional role of homemaker. Among the working and middle classes, families already find it difficult to live comfortably on one income. Moreover, as explained in chapter 1, the region needs to adopt a new economic model, shifting from public sector–dominated to private sector–driven growth, from closed to more open economies, and from oil-dominated to more diverse sources of growth. Success in accomplishing these structural shifts will depend heavily on widening and deepening the stock of human capital and on raising the productivity of labor. Successful export economies, including those in several MENA

countries and in East Asia, have relied heavily on women's work to propel them into the global marketplace.

A Definition of the Agenda for Change

The region confronts three challenges on the gender front: to bridge gender gaps in education and health, to increase women's participation in the labor force, and to increase women's inclusion in the political and decisionmaking processes.

Within the domain of economic policy, the gender policy agenda needs to be pursued under the twin principles of *efficiency* and *equity* within society and the economy, with the goal of enabling women's greater access to opportunity and economic security (figure 5.1).

Within this framework, gender equality can be advanced by supporting two critical pillars of good governance: (a) through greater *inclusiveness* of women in the decisionmaking arena, which will create a gender-egalitarian environment for women's economic and social rights, and (b) through greater *accountability* of existing institutions for advancing fairness and equality. Gender equality is ultimately tied to good governance: respecting the rights of everyone and taking everyone's needs into account.

FIGURE 5.1

Policy Framework for a Comprehensive Gender Policy in Support of MENA's New Development Model

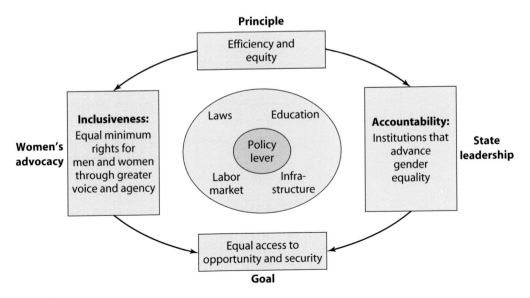

Source: Authors.

The agenda about gender consists of four broad policy areas that can facilitate the reduction of gender disparities:

1. The legislative environment

2. A supportive infrastructure

3. Continued attention to education

4. Labor laws and regulations

The two main agents for these changes will be women's advocacy and the state, as discussed later in this chapter.

Harmonizing Legal Structures

In most countries in the region, Western laws were introduced in the 19th century. The introduction of those laws confined the application of Islamic laws to the area of family law. Today the constitutions of most MENA countries give women rights equal to those of men and the full right of protection under the law (table 5.1). But a host of other legal provisions fail to give legal effect to the constitutional recognition of equal rights. Hence, women in the region face considerable legally sanctioned differential treatment, which perpetuates gender stereotypes about the relative abilities of men and women and, ultimately, their status in society. Such treatment also constrains women's ability to participate effectively in the public sphere.

The legal differences between a woman's constitutional rights and ordinary legislation need to be reformed to eliminate discrimination and differential treatment. The laws were created with the goal of protecting families by assigning clear responsibilities for their upkeep. But the husband's responsibility to provide for the family confers rights and authority on him—reinforced through a host of laws, policies, and institutions—that he retains even if, in practice, he does not or cannot provide fully for his family and even if he does not want to exert this kind of authority. As a result, women are considered to be financially, legally, and socially dependent on men, even in cases when the family needs two income earners.

The needed reforms apply primarily to two types of laws:

1. Laws that require a woman's interactions with the state and the market—the public sphere—to be mediated through and under the control of a man, such as her ability to apply for a passport and her need for permission to work, marry, and travel. These laws directly affect a woman's decisionmaking capacity and her access to opportunity.

TABLE 5.1

Equal Rights under the Constitution

Country	Description
Algeria	"All citizens are equal before the law. No discrimination shall prevail because of bind [kin], race, sex, opinion, or any other personal or social condition or circumstance." (Constitution, 1996, chapter IV, article 29.)
Bahrain	"All persons shall be equal in human dignity, and all citizens shall be equal before the law in regard to their rights and obligations without discrimination among them on the grounds of race, origin, language, religion, or belief." (Constitution, 1973.)
	"All citizens are equal before the law in rights and duties. There is no discrimination between them on the grounds of sex, origin, language, religion, or creed." (National Charter, 2001, chapter 1.)
Djibouti	"Equality assured to all without regard to language, origin, race, gender, or religion." (Constitution, 1997, article 1.)
Egypt, Arab Rep. of	"All citizens are equal before the law. They have equal public rights and duties without discrimination between them due to race, ethnic origin, language, religion, or creed." (Constitution, 1980 Amendment, chapter III, article 40.)
	"The State shall guarantee the proper coordination between the duties of woman towards the family and her work in the society, considering her equal with man in the fields of political, social, cultural, and economic life without violation of the rules of Islamic jurisprudence. (Constitution, 1980 Amendment, article 11.)
Iran, Islamic Rep. of	"All citizens of the country, both men and women, equally enjoy the protection of the law and enjoy all human, political, economic, social, and cultural rights, in conformity with Islamic criteria." (Constitution, 1989, chapter III, article 20.)
Iraq	"Citizens are equal before the law, without discrimination because of sex, blood, language, social origin, or religion." (Interim Constitution, 1990.) In addition, Law 191/1975 provides for equality of women with men as regards rights and financial advantages.
Jordan	"Jordanians shall be equal before the law. There shall be no discrimination between them as regards to their rights and duties on grounds of race, language, or religion." (Constitution, 1952, chapter II, article 6.)
Kuwait	"All people are equal in human dignity and public rights and duties before the law, without distinction to race, origin, language, or religion." (Constitution, 1962, article 29.)
Lebanon	"All Lebanese are equal before the law. They equally enjoy civil and political rights and equally are bound by public obligations and duties without any distinction." (Constitution, 1990, chapter II, article 7.)
Libya	"All citizens are equal before the law." (Constitution, 1969, article 5.)
	"The members of the Jamahiryyan society, men or women, are equal in everything that is human. The distinction between men and women is a flagrant injustice which nothing justifies." (Human Rights Charter, 1988, principle 21.)
Morocco	"All Moroccans are equal before law." (Constitution, 1992, article 5.)
Oman	"All citizens are equal before the law and are equal in public rights and duties. There shall be no discrimination between them on the grounds of gender, origin, color, language, religion, sect, domicile, or social status." (Constitution, 1966, article 17.)
Qatar	"Equality among Qataris irrespective of race, sex, or religion." (Provisional Constitution, 1970.)
Saudi Arabia	"Equality in accordance with Islamic Shari'a." (Constitution, 1992, article 8.)
	"The State protects human rights in accordance with the Islamic Shari'a." (Constitution, 1992, article 26.)
Syrian Arab Rep.	"The citizens are equal before the law in their rights and duties." (Constitution, 1973, article 25/3.)
	"The State ensures the principle of equal opportunities for all citizens." (Constitution, 1973, article 25/4.)
Tunisia	"All citizens have the same rights and the same duties. They are equal before the law." (Constitution, 1991, chapter I, article 6.)
United Arab Emirates	"Equality, justice, safety, security, and equal opportunity to all citizens are the pillars of society." (Constitution, 1996, article 14.)
Yemen, Rep. of	"The state shall guarantee, to all its citizens, equal political, economic, social, and cultural opportunities and, to that effect, shall enact all the required laws." (Constitution, 1991, chapter III, article 19.)

Sources: For Bahrain, Djibouti, Iraq, Kuwait, Libya, Oman, Qatar, Saudi Arabia, and the Syrian Arab Republic, the source is Hijab, El-Solh, and Ebadi 2003. For Algeria, the Islamic Republic of Iran, Lebanon, Morocco, Tunisia, and the Republic of Yemen, the source is the International Constitutional Law Web site (http://www.oefre.unibe.ch/law/icl/home.html). For Egypt, the source is http://www.sis.gov.eg. For Jordan, the source is the Web site of King Hussein (http://www.kinghussein.gov.jo). For the United Arab Emirates, the source is the Federal National Council Web site (http://www.almajles.gov.ae), which includes an unofficial translation of the Arabic version.

2. Laws that regulate benefits and entitlements that men can pass on to their families but women cannot. These laws govern social security, insurance, pensions, nonwage benefits, and other social transfers that affect a family's economic security. Nationality laws are also important in this arena; few countries in MENA allow a woman to pass on her nationality—her basic right as a citizen—to her spouse or family and, hence, allow her foreign-born spouse and their children to work and to have access to social services, such as education and health.[1]

Building an Infrastructure to Support Women and the Family

Given the importance of the family in MENA, increases in the participation of women in the labor force will need to go hand-in-hand with the provision of active support to families. This step is important to minimizing the social cost that is normally feared when a woman is absent from the home. As noted in chapter 4, policies that support mothers' employment may be adopted with the explicit goal of increasing women's attachment to the labor force. An empirical study of 14 countries in the Organisation for Economic Co-operation and Development revealed that the pattern and mix of such policies explained cross-national differences in the level and the continuity of women's attachment to the labor market (Gornick, Meyers, and Ross 1996). Such policies include various types of support for childcare, such as incentives for part-time work, a national childcare policy for preschool and school-age children, and even adjustments in public school hours to make them more compatible with those of working parents.

Other areas that are critical are investments in standard infrastructure, such as roads, infrastructure, information and communication technology, and drinking water. Access to drinking water has often been cited as a key factor in rural girls being able to attend school, as has distance to school and the availability of transportation. As mentioned in chapter 4, women are more constrained by their environment than are men. Safe and available transportation, for instance, can significantly improve a woman's access to jobs that may not be readily available in her immediate neighborhood.

Providing Skills for the Labor Market

Chapter 2 highlighted the achievements and the challenges of the education agenda. Gender equality will not be achieved with substantial disparities in the social sectors. In some countries of the MENA region—for instance, Morocco and the Republic of Yemen—achieving education parity is still a real challenge. Providing women the skills they need for the

job market is a challenge in nearly every country of the region. Improved curricula and elimination of gender stereotyping in schools are key elements of such a strategy. Opening up all educational fields to women and encouraging diversity in specific fields are important for attracting the best and the brightest to every discipline, regardless of sex. The provision of lifelong learning and vocational skills is also known to be critical for women, particularly because many women marry early (and are, hence, unable to finish school) or leave the labor market for a variety of reasons, and they may need to upgrade their skills to reenter the market.

Reforming Labor Market Policies

In conjunction with the above policy changes, facilitating the increase in female participation in the labor market will involve a review and reform of all labor market regulations that discourage women's entry into the private sector or that hinder a woman's ability to stay employed during her major life events. The specifics of reforming labor market regulations will differ from country to country, but they may include (a) eliminating regulations that limit women's access to certain categories of jobs or that restrict their working hours and (b) eliminating regulations for family benefits (such as the provision of childcare on premises) that are based on the sex of the employee. Such regulations distort the costs of women employees relative to men. Policies that support working mothers may need to be established. Reforms could also include new legislation in areas such as sexual harassment, part-time employment, portability of social security and insurance benefits, informal work conditions, or self-employment.

A Rallying Agent for Change

The public sphere is the sphere of power, influence, and patronage and, as such, has been traditionally reserved for men. A call for gender equality is effectively a transgression of women into this space and a claim to share power and control. Gender equality can easily be seen as a threat to the social order and as an erosion of the established power structure. Yet gender inequality is holding back the region in areas where it most needs to make progress: in improving its economic growth, creating productive employment, and reducing poverty.

Gender equality will remain an abstraction unless a substantial number of women believe that they have rights and must do something to exercise their rights. But governments, too, need to play proactive roles in promoting gender equality. Change will need to be led from the top *and* be supported by the grass roots.

Inclusion: More Participation by Women in Political Life

Studies show that keeping women outside of government at any level limits the effectiveness of a state and its policies. Women tend to hold views different from those of men about issues in the public domain and to bring different perspectives to decisionmaking within political bureaucracies. Although men and women broadly see the same significance about issues, women's perspectives can differ from those of men.[2] Studies have also shown that systematic discrimination against and exclusion of segments of the population on the basis of race, gender, ethnicity, or religious background ultimately hurt everyone. Such discrimination will influence a country's larger social climate, affect the development prospects and trust in government, and undermine the effectiveness of the government's institutions (Fukuyama 1995; Putnam 1993; Woolcock 2000, as cited in World Bank 2001).

Greater participation of women themselves in the political process will be key to achieving change. At present, the traditional gender paradigm makes itself felt not only in important aspects of law but also in women's poor representation in political life and at all levels of public decisionmaking. And though many countries do accord women equal rights as citizens and voters through their national constitutions and laws, women's participation in politics and governance is far from widespread (table 5.2).

Women as voters. The right to vote is fundamental to political empowerment. In many countries of the region, women have enjoyed voting rights for decades. In other countries, women still do not have the right to vote but men do. And in a few countries, neither men nor women have the right to vote (see table 5.2).

However, even where women can vote, the power of women's vote is not effectively used in most MENA countries in which elections are held. Yet for a politician, a female vote is equal to a male vote. It is important for women to form visible interest groups whose votes candidates must campaign to attract. Voter registration and education campaigns rarely target women, yet women are potentially an important electoral force (box 5.1) whose power is likely to increase as more elections take place around the region.

Women's high illiteracy rates, which can translate into low political awareness, low participation in elections, and perhaps even use of those women's votes by others, continue to be barriers to women's potential political voice.

Women in parliament. Women's share of seats in national parliament is the most common country-level indicator of their political empowerment, and it is the only political indicator that is used to track progress toward

TABLE 5.2

Political Participation in MENA Countries

Country	Year right to vote established	Voting age (years)	Type of suffrage
Algeria	1962	18	Universal
Bahrain	1973	18	Universal, limited
Djibouti	1946	18	Universal
Egypt, Arab Rep.	1956	18	Universal, compulsory
Iran, Islamic Rep. of	1963	15	Universal
Iraq	1980	18	Universal
Jordan	1974	20	Universal
Kuwait	—	21	Males only
Lebanon	1952	21	Compulsory for males; authorized for women with an elementary education
Libya	1964	18	Universal, compulsory
Morocco	1963	21	Universal
Oman	2003	21	In 2000, a limited and selected group of Omanis voted in elections; in 2003, universal limited elections were held
Qatar	1995	—	Universal, limited to municipal elections
Saudi Arabia	n.a.	n.a.	None
Syrian Arab Rep.	1949, 1953	18	Universal
Tunisia	1957, 1959	20	Universal
United Arab Emirates	n.a.	n.a.	None
West Bank and Gaza	—	18	Universal
Yemen, Rep. of	1967	18	Universal

— Not available.
n.a. Not applicable.
Source: U.S. Central Intelligence Agency 2002.

the Millennium Development Goal of gender equality and empowerment of women. Compared with other regions of the world, women in MENA have the smallest share of seats in national parliaments, at less than 6 percent (table 5.3).[3] But the picture in the region today is better than it was 16 years ago; the number of countries with women parliamentarians has risen from 3 in 1987 to 11 in 2003.[4]

The Convention on the Elimination of All Forms of Discrimination against Women, ratified by 13 countries in MENA, sets a target for women of 30 percent of the seats in national parliaments; this goal is clearly ambitious for MENA countries.

The policy intervention that is most effective at increasing the proportion of women in public office has been the establishment of quotas that reserve a specific number or percentage of positions for women in political parties or in local and national assemblies.[5] At least 45 countries, including rich and poor countries and old and new democracies, have used

BOX 5.1

Women in Politics in the Islamic Republic of Iran

Power of Women Voters

Iranian women have exercised considerable power as voters. As a pro-reform voting block, along with a coalition of traditional leftists, business leaders, and young people, women were instrumental in moderate Mohammad Khatami's victories in the elections of 1997 and 2001. Women activists, both secular and traditionalist, took their issues to the public through print media, women's religious gatherings, and (sometimes) radio and television. The language they used was often simple and marked by everyday concepts and metaphors, and usually it was in the context of real-life stories. Their media strategy, along with intensive campaigning, resulted in a record number of women candidates in the 2001 elections: 12 of the 518 women who ran won seats in the Iranian parliament.

Islamic Feminism

A new wave of Islamist feminists is challenging and reforming Islamic doctrine from within. Using the language of the religious and political leaders, those women demand that the state live up to its promise of Islamic equality between men and women. They have already changed women's consciousness in the Islamic Republic of Iran and encouraged women to distinguish between patriarchal tradition and Islam itself. Although Islamist women activists may appear to be diametrically opposed to secular feminists and to derive part of their political legitimacy from their critique of secular groups, in practical terms the two camps have similar goals, and their demands are generally analogous. Both groups strive to improve women's social and legal situation. Their effectiveness in the political context of the Islamic Republic of Iran, however, depends on occupying opposing camps, because as long as secular feminists make their voice heard, the Islamist women activists who articulate their demands within the Islamic perspective appear as an authentic movement more acceptable to the political leaders of the republic.

Source: Hoodfar 1998.

quotas to help improve women's participation at either the national or the local level (Htun and Jones 2003).[6] Most of their systems reserve a "critical minority" of 30 to 40 percent of parliamentary positions (Dahlerup 2002).

Quotas for women evoke both vehement opposition and impassioned support. Their opponents argue that quotas discriminate against men, that they may lead to election of underqualified women, and that they work against women because those who are elected may be perceived as tokens. Supporters argue that quotas compensate for real impediments

TABLE 5.3

Women in Parliament in World Regions, 2003

Region	Average percentage of members of parliament who are women
Industrial Countries	23.51
Central Asia	11.89
East Asia and the Pacific	10.91
Latin America and the Caribbean	15.04
MENA	**5.82**
South Asia	6.42
Sub-Saharan Africa	11.40
Global	13.34

Note: Where there are two houses, figures are weighted averages of lower and upper houses.
Source: Inter-Parliamentary Union Web site (http://www.ipu.org/).

that bar women from their fair share of political seats and that some positive discrimination is not a luxury but a necessity (Karam 2002).

In MENA, several countries (Djibouti, the Arab Republic of Egypt, Jordan, and Morocco) have implemented some form of quotas for women in national parliaments or local bodies. Although quota systems are contentious, they appear to hold great promise for broadening women's political participation in MENA countries. Establishing quotas on party lists for which women candidates have to compete and establishing quotas at the local and municipal levels will be highly effective in creating a pipeline of future women candidates.

Women cabinet ministers. Women in decisionmaking positions within the executive branch can play an important role in providing a diverse perspective on government policy. The number of women ministers has risen gradually in MENA as a whole; however, four countries still have had none, and in other countries women occupy mostly positions in social ministries rather than in central and more strategic ministries, such as planning or finance.

Women in local politics. Very gradually and, in some cases, with the help of quotas allocated by political parties, women are increasing their presence in local politics in the region.

Decentralization of government authority to the local level can open new opportunities for women's participation in decisionmaking. Transferring authority on aspects of education, health, and infrastructure services likely will entail the involvement of local nongovernmental organizations (NGOs) and grassroots organizations in which women participate. Women's groups can be more persuasive and effective at local

levels, where issues are more tangible and where women can be more per-
suasive, than they can be at the national level. Where decentralization poli-
cies involve the creation of local management boards, governments can
require the participation of women on those boards; it is often easier for
women to gain seats on local boards than on national ones. It will be
important to ensure that women have the appropriate skills to participate
effectively.

Women in civil society.[7] Women's participation has been much greater in
civil society movements and NGOs than in formal government. Strict
regulations on laws of association, freedom of speech and inquiry, and
political parties still limit the activities of civil society in much of the
region, but the proponents of women's empowerment have been at the
forefront of demands for greater inclusion, accountability, and democ-
racy in governance. The 1980s and 1990s saw a proliferation of
women's groups active in human rights and struggles for democratiza-
tion and calling for gender equality (Karam 1999b).[8] Some have advo-
cated for women's legal rights; others have worked to empower women
politically by launching voter registration campaigns (Al-Hamad 2002).
And, as more of the region's nations have strengthened or established
deliberative bodies, those activists have begun to create stronger and
more dependable relationships with legislatures. In Morocco, for in-
stance, women's associations have been very active and vigilant about
women's rights. They were also helped significantly by a pronounce-
ment of King Mohammed VI on October 10, 2003, that called for a
substantive review and revision of Morocco's Personal Status Code
(*Mudawanna*) with the objective of providing women greater equality in
the private sphere.

Going forward, women's advocacy groups in greater numbers need to
take ownership of the agenda for change in MENA and to ensure that
gender issues are considered concurrently with other economic and
social reforms. They can play key roles in the following:

- Formulating and drawing attention to the agenda for change

- Networking and developing partnerships among local, national,
 regional, and international organizations that work in gender and
 political empowerment-related issues

- Engaging with political parties to encourage them to promote women
 in elected and nonelected positions and to conduct leadership train-
 ing for women members

- Publicizing the best practices of political parties in support of women's
 empowerment

- Raising public awareness regarding the promotion of women candidates for elected office

Women consumers. Numerous studies in the industrial world show the far-reaching influence of women consumers. Women make 80–85 percent of family purchasing decisions and, as companies increasingly recognize, can have a profound effect on companies' success and market shares.[9] Companies ranging from Toyota to home improvement businesses regularly survey women consumers to engender and develop products to improve the company's bottom line. Developing women consumer groups in MENA would be an effective means to develop the women's voice within the public arena and to implement change in the corporate world and the private sector in a more gender-sensitive manner.

Leadership training and capacity building. Women political candidates and their staff members can benefit substantially from training to help them conduct more effective campaigns and to become more effective legislators. The best training programs focus on civic education and advocacy; they provide tools that can help strengthen political parties, provide practical assistance to women candidates, and train elected women leaders in parliamentary procedures and rules.

The media. Only a few journalists in the press and television are conversant with gender issues, which tend to be discussed mainly in women's magazines, if at all. In many countries, the mainstream press has not focused on women as an important readership. The media can play a major role in defining and publicizing campaign issues and in challenging prejudices in society that work against women's participation in the public sphere. More extensive support for networking and training for media personnel in gender issues remains a need in MENA (Karam 1999a). Using the media can yield impressive results.

Accountability: State Leadership Still Matters Greatly

Women's participation in the political process for change is crucial, but its growth is likely to be gradual. In MENA's political setting, the bottom-up approach will not succeed unless it is matched by concerted government leadership and a commitment toward establishing a more gender-egalitarian environment. The position of state elites, their policies and institutions, and their definition of policies over time are at the center of the debate (Sanasarian 1982). States can promote progress through the following:

- *Gender-sensitive policies.* Promote gender-inclusive policies by identifying and raising the profile of the issues and by putting in place

processes for change. Beyond their immediate benefits, government actions to increase women's role in public policy and administration can also have a broader, catalytic effect by putting issues on the agenda for broad public discussion and by changing the climate of opinion.[10] And, over time, as women establish themselves in greater numbers as leaders, they may help to trigger or to fast-forward a broader process of beneficial social and political change.

- *Coalitions for change.* Unlike in the past, when state policies to advance the interests of women could be more or less successfully mandated from above, reforms now require far more broad-based ownership in order to be sustainable. The reforms that are now needed are likely to affect different interest groups differently and may change power structures within society. In some cases, the reforms may go against a powerful vested interest in order to provide greater benefit to all. Thus, the leadership role of the executive will need to shift away from decreeing change and toward both generating broadly based political will and building coalitions for reform. Unless this approach is taken, the ownership of reform will be weak, and any success will be short-lived. Reaching out—in partnership and dialogue with other domestic centers of power and authority, including religious authorities and their deliberative bodies, civil society organizations, and the media—strengthens the legitimacy and popularity of any new policy proposal. Publicly deliberating and creating publicity about new initiatives and vetting new programs in front of supportive and critical audiences will prepare the public for unfamiliar change.

- *Interpretation of the law and legal institutions.* Because contradictory laws and regulations make women's rights opaque in several areas, the discretion of the judiciary is critical in the implementation of law in the region. In most MENA countries, women can enter the legal profession but the judiciary posts are, in practice, reserved for men. Some governments have taken bold steps and appointed judges (box 5.2). But the numbers are still quite small across the region, and the judiciary remains a male domain.[11]

 Another impediment to the fair implementation of law is women's lack of knowledge about their legal rights, partly for lack of education. Advocacy groups around the region have highlighted the need to educate women about their legal rights as a starting point for women's empowerment.

- *Gender-disaggregated information and gender research.* Lack of data makes it difficult to gauge the effect of policies and decisions on women, difficult to formulate positions that can be placed into electoral campaigns at the local or national level, and difficult for the

BOX 5.2

Women in the Judiciary

- In Algeria, nearly 20 percent of Supreme Court judges are women.

- Djibouti has one female Supreme Court justice, and women represent 33 percent of public prosecutors (*magistrates*). In addition, 52 percent of clerks are female.

- The Arab Republic of Egypt appointed a woman head of the Administrative Prosecution Authority in 1998, and 4 years later it appointed its first female judge.

- In Lebanon, half of the lawyers and nearly one-third of the judges are women; however, no woman judge has yet held a seat in one of the high councils such as the Constitutional Council, the Supreme Judicial Council, or the Justice Council. Among the sect-based courts, which apply religious laws, none except the Anglican court has accepted a woman judge.

- The Syrian Arab Republic appointed its first women judges in 1975, and by 2001 the number of women judges had grown to 170.

- In Tunisia, the first woman judge was appointed in 1968. Since 1998, the legal profession has grown so that 24 percent of its members are women at all levels. Of the 28 members of the Superior Council, two are women. Women head both the Supreme Audit Organization and the Court of Appeals, and women occupy 15 percent of high-level judicial posts.

Sources: Arab Regional Resource Center on Violence against Women Web site (http://www. amanjordan. org/english/); CREDIF 2000; Elbendary 2003; and Lebanon Nongovernmental National Committee for the Follow-up of Women's Issues 1999.

executive branches of governments to make informed policy decisions on issues affecting women. Only a few think-tanks and networks focus on women's issues. Few universities have women's studies programs or even fields within other disciplines that train people to understand and develop gender policies. Better information is needed—not only in the social sectors such as health, but also on the roles that women play in the economic and political spheres—to help guide policy choices; to design, implement, monitor, and evaluate policy interventions; and to set targets and benchmarks to measure progress. Governments play the major role in gathering and publishing statistics, but women's NGOs, research organizations, and networks should be assisted to build up gender-relevant information and to make it widely available.

- *National machineries to promote women's interests.*[12] More than half of the countries in MENA have ministries for women's affairs.[13] National

women's agencies or machineries serve a number of functions. They are the agencies most often charged with mainstreaming gender issues and concerns into national and local policies and programs. They are often involved in developing and implementing gender-sensitive budget initiatives and in drafting national gender plans of action. And they draw attention to and provide advice on advancing the status of women with respect to international obligations such as the Millennium Development Goals and the Convention on the Elimination of All Forms of Discrimination against Women (box 5.3).

BOX 5.3

Convention on the Elimination of All Forms of Discrimination against Women

Ratified by 163 nations, the Convention on the Elimination of All Forms of Discrimination against Women (CEDAW) is the most comprehensive and detailed international agreement to seek the advancement of women. The CEDAW establishes rights for women in areas not previously subject to international standards. It provides a universal definition of discrimination against women so that those who would discriminate on the basis of sex can no longer claim that no clear definition exists. It also calls for action in nearly every field of human endeavor: politics, law, employment, education, health care, commercial transactions, and domestic relations. The CEDAW establishes a committee to review periodically the progress being made by its adherents.[1]

By accepting the CEDAW, states commit themselves to undertake a series of measures to end discrimination against women in all forms, including the following:

- Incorporating the principle of equality of men and women in their legal system by abolishing all discriminatory laws and by adopting appropriate ones that prohibit discrimination against women

- Establishing tribunals and other public institutions to ensure the effective protection of women against discrimination

- Ensuring the elimination of all acts of discrimination against women by persons, organizations, or enterprises

Thirteen of the 19 MENA countries have ratified the CEDAW. All except for Djibouti included reservations. The three main reservations that all MENA countries have concern article 9 (discrimination in granting nationality to children), article 16 (discrimination relating to marriage and family relations), and article 29 (arbitration). For more on CEDAW, see table A.5 in the appendix.

[1] See http://www.un.org/womenwatch/daw/cedaw/.

The investments in education and health in the MENA region are beginning to have their effect on empowering women and will have a magnifying effect in the next decade. As MENA reconsiders its development policies to create better opportunities for its promising generation of youths, it needs to view gender issues as part of the solution. Tackling those issues effectively and in a sustainable manner will take considerable political will and stamina. It is a long road ahead, but the journey must begin today for families of the region to benefit from all the human and other resources that are at their command.

Notes

1. It is interesting to note that a large number of men across the Muslim world trace their lineage to Prophet Muhammad, who had no sons and whose only heirs were from his daughter, Fatima. The prophet himself authorized that his line would pass through his son-in-law, Ali.

2. For instance, research carried out in the United Kingdom in 1996 found that although both women and men set priorities for economic issues, women were more concerned about part-time work, low pay, and pensions, while men were more concerned about unemployment. And in two Indian states—West Bengal and Rajasthan—a recent study found that women elected as leaders invest more than men in the public goods that are most closely linked to family concerns. More often than local councils headed by men, local councils headed by women implemented policies sensitive to family needs (Chattopadhyay and Duflo 2001).

3. Within MENA, Bahrain has the largest share of women members in parliament at 13 percent, followed by Tunisia at 12 percent. At the other extreme, Kuwait and the United Arab Emirates have none. The shares are smallest in the Republic of Yemen at 1 percent, and in the Arab Republic of Egypt and Lebanon at 2 percent. Qatar and Saudi Arabia have never had parliaments. Qatar has an Advisory Assembly, for which women can vote.

4. The Palestinian Authority, which is not included in the data above, has also achieved gains for women. According to the 2002 *Human Development Report* for Palestine by the United Nations Development Programme (UNDP), 552 candidates—among them 25 women—ran in the 1996 elections for the Palestinian Legislative Council. Five of the 88 council seats went to women candidates (UNDP 2002).

5. Quota systems are of three broad types: (a) gender quotas adopted by political parties, a system that is widely used in Europe; (b) legal requirements that mandate a certain percentage of women on party lists, a system that is used in France (*parité*) and in Latin American countries

such as Argentina; and (c) the reserved seats system, a system that allocates a certain number of parliamentary seats to particular minority groups and that is used extensively in Asian and African countries.

6. In the developing world, Latin America is the region with the most countries (12) using political reservations for women. In Sub-Saharan Africa, the countries of Mozambique, South Africa, and Uganda are role models for women's political representation. In Asia, the most prominent effort to increase women's representation in government is in India; two constitutional amendments of 1992 require that at least a third of the seats in local councils (*panchayats*) and municipal councils—and the same number of chairpersons—be reserved for women (Grown, Gupta, and Khan 2003).

7. Civil society is the realm of associational life that mediates between the state and its citizens. It includes nongovernmental organizations from professional associations to advocacy organizations. As Moghadam (2002) notes, civil society organizations "balance the strength and influence of the state; they are supposed to protect citizens from abuses of state power; they play the role of monitor and watchdog; they embody the rights of citizens to freedom of expression and association; and they are channels of popular participation in governance."

8. Recent activism continues a long history of women's organizing in MENA. During the first half of the 20th century, powerful women's organizations emerged in the Arab Republic of Egypt and developed close ties with women's organizations and activists in Lebanon, Palestine, and the Syrian Arab Republic (Hoodfar 1998). Women's organizations participated actively in the anticolonial struggle in the 1940s and 1950s in Algeria and Egypt, among other countries.

9. About two-thirds of women surveyed in Canada expressed that a company's understanding of women's different needs is important in their decisions and that they would not buy anything if the product did not demonstrate this understanding (Yaccato 2003).

10. Indeed, the repercussions may go beyond national boundaries; the success of women's reservations in the Moroccan parliament has motivated women in other MENA countries to demand gender quotas and reservations. In November 2002, hundreds of delegates attending the Arab Women's Summit in Amman approved a declaration calling on Arab states to follow Morocco's lead (Davis-Packard 2003).

11. Studies in countries outside the region have found that in cases of divorce, custody, and child support, women receive substantially less-favorable decisions in male-dominated courts than in courts with women judges or lawyers. In some cases, the character of such decisions changed significantly after legal NGOs provided legal support for women. Such studies have not been carried out for MENA. But it is reasonable to

assume that the shortage of female legal professionals may lead to less favorable interpretations of the law for women.

12. A *national machinery* is defined by the United Nations as any organization established with a specific mandate for the advancement of women and the elimination of discrimination against women at the central national level.

13. Some countries without a national women's machinery have begun discussions for establishing one; in the Republic of Yemen, for instance, the National Committee for Women has been advocating the establishment of a Ministry for Women's Development to keep issues of women's empowerment on the agenda of the cabinet. See http://www.amanjordan.org/english/.

Appendix: Legal and Statistical Background

TABLE A.1

Strategic Opportunity, Legal Equality, Work, Benefits, and Pension

Country	Strategic opportunity	Equality of all persons before the law (men and women)		Work		Benefits and pension	
	Right for women to work as lawyers or judges or to hold public office	Legal right for women to execute their own contracts	Right for women to testify in court in their own cases	Law or constitution that provides for equal pay	Equal opportunity for both men and women to work in all sectors	Equal entitlement to nonwage benefits[a]	Equal claim to a pension[b]
Algeria	Yes	Yes	Yes	Yes	Yes	Yes	Yes
Bahrain	Yes	Yes	Yes	Yes	Yes	Yes	Yes
Djibouti	Yes	Yes	Yes	Yes	Yes	No	No
Egypt, Arab Rep.	Yes	Yes	Yes	Yes	Yes	Yes	No
Iran, Islamic Rep. of	Yes and no[c]	Yes	Yes	Yes	No[d]	No	No
Iraq	Yes	Yes	Yes	Yes	Yes	Yes	No
Jordan	Yes	Yes	Yes	Yes	Yes	No	No
Kuwait	Yes	Yes	Yes	Yes	Yes	No	No
Lebanon	Yes	Yes	Yes	Yes	Yes	No	No
Libya	Yes	Yes	Yes	Yes	Yes	No	Yes
Morocco	Yes	Yes	Yes	Yes	No[e]	No	Yes
Oman	Yes	Yes	Yes	No	Yes	No	Yes
Qatar	Yes	Yes	Yes	Yes	Yes	No	—
Saudi Arabia	No	No	No	Yes	No[f]	—	No
Syrian Arab Rep.	Yes	Yes	Yes	Yes	Yes	No	No
Tunisia	Yes	Yes	Yes	Yes	Yes	Yes	Yes
United Arab Emirates	Yes	Yes	Yes	Yes	Yes	No	—
West Bank and Gaza	Yes	Yes	Yes	—	—	—	—
Yemen, Rep. of	Yes	Yes	Yes	Yes	Yes	Yes	No

— Not available.

a. For female and male employees, discrimination in nonwage benefits varies between countries. It can include discrimination in housing allowances, in children or dependents tax allowances, or in dependent spouse allowances (offered only to the man for a dependent wife), plus discrimination against unmarried female employees versus unmarried males.

b. That is, the husband is entitled to his deceased wife's pension without requirements of dependency or special conditions such as disability.

c. Women can be members of parliament, have posts at the ministerial and subministerial levels, and work as lawyers, but they cannot be judges.

d. Women cannot be judges.

e. Posts in the following ministries are not available to women: Interior, Civil Protection, National Defense, and National Security.

f. It is forbidden to integrate women with men in places of work or facilities attached to such places, which effectively bars women from working in most sectors and attaining high-level positions. Women's employment on a broad level is restricted to the health and education sectors. Women can own businesses, but they are not allowed to administer their own official business affairs; they have to appoint a male agent. The law requires that the functions of a company chief executive officer (CEO) be carried out only by men; women therefore cannot be CEOs of their own companies. In addition, all legal and official contracts, registrations, licenses, and so forth pertaining to the business must be signed and applied for only by men.

Sources: Hijab, El-Solh, and Ebadi 2003 and U.S. Social Security Administration and International Social Security Association 1999, 2002.

TABLE A.2

Pension and Benefits Regulations in Comparable Countries in Various Regions

Country	Equal entitlement to insurance and benefits (for female and male employees)	Survivor's pension that stops if widow or daughter remarries	Equal claim to pension[a]
Argentina	Yes[b]	No	Yes
Brazil	Yes	No	Yes
China	Yes	No	Yes
Hungary	Yes	No	Yes
Indonesia	Yes	No	Yes
Malaysia	Yes	No	Yes
Poland	Yes	No	Yes
Russia	Yes	No	Yes
Singapore	Yes	No	Yes
Taiwan, China	Yes	No	Yes
Thailand	Yes	No	Yes
Venezuela, R. B. de	Yes	No	No[c]

a. That is, the husband is entitled to his deceased wife's pension without requirements of dependency or special conditions (such as disability).
b. Equal family or children allowance, but medical benefits for a husband will require payment of additional contribution.
c. Widower must have a disability.
Sources: For Argentina, Brazil, China, Indonesia, Malaysia, Poland, Singapore, Taiwan (China), Thailand, and República Bolivariana de Venezuela, U.S. Social Security Administration and International Social Security Association 1999. For Hungary and the Russian Federation, U.S. Social Security Administration and International Social Security Association 2002.

TABLE A.3

Equal Constitutional Rights, Freedom of Movement, and Marriage

Country	Constitutions that stipulate equal rights and duties for all citizens under the law (both men and women)	Freedom of mobility: right for a woman to travel or obtain a passport without husband's or guardian's permission signature[a]	Marriage		
			Minimum legal age	Right for women to conclude their own marriage contract	Right for women to get a divorce by the court[b]
Algeria	Yes	Yes	Females—18; males—20	No	Yes
Bahrain	Yes	Yes	None	Yes and no[c]	Yes
Djibouti	Yes	Yes	Females and males—18	Yes	Yes
Egypt, Arab Rep.	Yes	Yes (as of 2000)	Females—16; males—18	Yes	Yes
Iran, Islamic Rep. of	No[d]	No	Females—13; males—15	No	Yes
Iraq	Yes	No	Females—17; males—18	No	Yes
Jordan	Yes	Yes (as of 2003)	Females and males—18	No	Yes
Kuwait	Yes	No	Females—15; males—17	Yes	Yes
Lebanon	Yes	Yes	Females—17; males—18	Yes	Yes[e]
Libya	Yes	Yes	Females and males—20	Yes	Yes
Morocco	Yes	Yes	Females—15; males—18	No	Yes
Oman	Yes	No	None	Yes and no[c]	Yes
Qatar	Yes	No	None	No	Yes
Saudi Arabia	n.a.[f]	No	None	No	Yes
Syrian Arab Rep.	No	Yes[g]	Females—17; males—18	Yes	Yes
Tunisia	Yes	Yes	Females—17; males—20	Yes	Yes
United Arab Emirates	Yes	Yes	None	No	Yes
West Bank and Gaza	n.a.	Yes (as of 2003)	Females and males—18	Yes	Yes
Yemen, Rep. of	Yes	Yes	Females and males—15	No	Yes

n.a. Not applicable.

a. Some countries have recently made amendments to laws that restrict women's rights to mobility; however, it will take some time before the effects of these changes can be measured.

b. In all MENA countries, women have the right to be granted a divorce under special circumstances, such as if the husband is imprisoned, if he is unjustifiably absent, or if he unjustifiedly fails to pay maintenance. However, in certain cases (nonpayment of maintenance or physical and mental abuse), the burden of proof is entirely on the woman and, in practice, it is very difficult to get the court to approve the divorce. All countries allow women to be granted divorce through *Khul'u*, whereby a woman, for any reason she deems justifiable, can be granted a divorce as long as she pays back the dowry to the husband and renounces any marital financial rights. Many women report that even obtaining *Khul'u* is a frustrating and long procedure. Some countries require the husband's signature even in a *Khul'u* divorce.

c. Two legal systems are followed and are based on two Islamic schools: *Maliki* (women must have their male guardian represent them in marriage and no woman can execute her own contract) and *Ja'afari* (any adult man or woman of sane mental capacity can execute his or her own marriage contract).

d. In the Islamic Republic of Iran, the 20th amendment to the Constitution gives men and women equal protection under the law but does not accord them equal rights.

e. In Lebanon, women can seek a divorce pertaining to their particular religion.

f. Article 26 of the Saudi Arabian 1992 Basic Law and Constitution states, "The State protects human rights in accordance with the Islamic Shari'a."

g. A husband or male guardian can obtain a letter from the minister of interior to be presented to Immigration Control to prevent a wife or female relative from leaving the country.

Sources: Hijab, El-Solh, and Ebadi 2003. Information in columns 2 and 3 is from U.S. Central Intelligence Agency 2002. For Algeria, Bahrain, Djibouti, Iraq, Libya, Oman, Qatar, Tunisia, and the United Arab Emirates, information in column 4 is also from U.S. Central Intelligence Agency 2002. For Lebanon, the information in column 4 is from http://www.law.emory.edu/IFL/legal/lebanon.htm.

TABLE A.4(a)

Women's Right to Work: Constitutions or Country Laws That Specifically Mention the Right of Women to Work with No Discrimination in Their Employment and Opportunities

Country	Legal provision
Algeria	Article 12 of the Labor Law protects the rights specific to women at work, according to the legislation in force. Act 90-11 of April 21, 1990, article 6, confirms the right to protection against any discrimination with respect to employment, other than that based on skills and merit.
Egypt, Arab Rep.	Article 151 of the Labor Law states, "Without prejudice to the provisions of the following articles, all stipulations organizing the employment of workers shall apply without any distinctions to working females in any types of jobs."
Iraq	Article 2 of the 1988 Labor Law states, "Right of work with equal opportunities and conditions for every Iraqi national regardless of sex."
Kuwait	Article 29 41/2 of the 1996 Constitution states, "Work is a duty of every citizen necessitated by personal dignity and public good. The State shall endeavor to make it available to citizens and to make its terms equitable."
Lebanon	Article 12 of the 1990 Constitution states, "Every Lebanese has the right to hold public office, no preference being made except on the basis of merit and competence, according to the conditions established by law."
Libya	Article 4 of the Constitution states, "Work is a right, a duty for every able-bodied citizen." Principle 11 states, "The Jamahiriyan society guarantees the right to work. It is a right and a duty for everyone. . . . Everybody has the right to exercise the work of their choice."
Oman	Article 12 of the Constitution states, "Every citizen has the right to engage in work of his choice within the limits of the law. . . . Citizens are considered equal in taking up public employment according to the provisions of the Law."
Qatar	Article 9 of the Labor Law states, "A woman has the equal right as a man to be appointed to any government job and enjoy its benefits such as salary, leave and allowances."
Syrian Arab Rep.	Article 45 of the Constitution states, "The State guarantees women all opportunities enabling them to fully and effectively participate in the political, social, cultural, and economic life. . . . The State removes restrictions that prevent women's development and participation in building the socialist Arab society."
Tunisia	Article 5 of the Labor Law states, "No discrimination can be made between the man and the woman in the application of the dispositions of the present code and texts adopted for its application."
United Arab Emirates	Article 14 of the Constitution states, "Equality and social justice, ensuring safety and security and equality of opportunity for all citizens, shall be the pillars of the Society."
Yemen, Rep. of	Article 5 of the Labor Code states, "Work is a natural right of every citizen and a duty for everyone who is capable . . . without discrimination on grounds of sex, age, race, color, beliefs, or language."

Source: Hijab, El-Solh, and Ebadi 2003.

TABLE A.4(b)

Women's Right to Work: Constitutions or Country Laws That Specify the Right of "All Citizens" to Work but Include Provisions That Either Directly Restrict Women's Options or Allow the Possibility for Regulating, Restricting, or Terminating a Woman's Economic Activity

Country	Legal provision
Bahrain	Article 65 of the Labor Law for the Private Sector states that the Ministry of Labor and Social Affairs can make an order for any other regulations with respect to employment of females and their conditions of work.
Iran, Islamic Rep. of	Under the Labor Law, women cannot take the position of judge. Although a woman does not need her husband's permission to work, the husband can legally put limitations on what type of work she can or cannot do.
Jordan	Article 23 of the Constitution states, "Special conditions shall be made for the employment of women and juveniles."
Morocco	According to the Dahir, the following posts in certain ministries are not allowed for women: Interior, Civil Protection, National Defense, and National Security.
Saudi Arabia	An August 3, 1985, royal decree states, "The State prevents the Saudi Arabian women from working in all spheres except education and health.... It is prohibited under any circumstances to integrate adolescent girls and women with men in places of work or facilities attached to them." Women may own businesses, but they are not allowed to administer the business affairs; they have to appoint a male agent.

Source: Hijab, El-Solh, and Ebadi 2003.

TABLE A.5

Status of Ratification of the U.N. Convention on the Elimination of All Forms of Discrimination against Women (CEDAW)

Country	Date of ratification and accession to CEDAW	Does the country have reservations?					
		Article 2 on nondiscrimination measures	Article 7 on political and public life	Article 9 on nationality	Article 15 on law	Article 16 on marriage and family life	Article 29 on arbitration
Algeria	May 1996	Yes	No reservation	Yes, para. 2	Yes, para. 4	Yes	Yes
Bahrain	June 2002	Yes	No reservation	Yes, para. 2	Yes, para. 4	Yes[a]	Yes, para. 1
Djibouti	December 1998	No reservation	No reservation	No reservation	No reservation	No reservation	No reservation
Egypt, Arab Rep.	September 1981	Yes	No reservation	Yes, para. 2	No reservation	Yes	Yes, para. 2
Iran, Islamic Rep. of	—	—	—	—	—	—	—
Iraq	August 1986	Yes, points c and g	No reservation	Yes, para. 2	No reservation	Yes	Yes, para. 1
Jordan	July 1992	No reservation	No reservation	Yes, para. 2	Yes, para. 4	Yes, points c, g, and h	No reservation
Kuwait	May 1996	No reservation	Yes, point a	Yes, para. 2		Yes, point f	Yes, para. 1
Lebanon	April 1997	No reservation	No reservation	Yes, para. 2	No reservation	Yes, points c, d, f, and g	Yes, para. 1
Libya	May 1989	No reservation	No reservation	No reservation	No reservation	Yes, points c and d	No reservation
Morocco	May 1993	Yes	No reservation	Yes, para. 2	Yes, para. 4	Yes	Yes
Oman	—	—	—	—	—	—	—
Qatar	—	—	—	—	—	—	—
Saudi Arabia[b]	September 2000	No reservation	No reservation	Yes, para. 2	No reservation	No reservation	Yes, para. 1
Syrian Arab Rep.	—	—	—	—	—	—	—
Tunisia	September 1985	No reservation	No reservation	Yes, para. 2	Yes, para. 4	Yes, points c, d, f, g, and h	Yes, para. 1
United Arab Emirates	—	—	—	—	—	—	—
West Bank and Gaza	—	—	—	—	—	—	—
Yemen, Rep. of	May 1984	No reservation	No reservation	No reservation	No reservation	No reservation	Yes, para. 1

— Denotes that the country has not ratified or acceded to the convention.

Notes: The following are excerpted from CEDAW:

- *Article 2.* Parties condemn discrimination against women in all its forms, agree to pursue by all appropriate means and without delay a policy of eliminating discrimination against women, and, to this end, undertake:
 (a) To embody the principle of the equality of men and women in their national constitutions or other appropriate legislation if not yet incorporated therein and to ensure, through law and other appropriate means, the practical realization of this principle;

TABLE A.5 (continued)

Status of Ratification of the U.N. Convention on the Elimination of All Forms of Discrimination against Women (CEDAW)

(b) To adopt appropriate legislative and other measures, including sanctions where appropriate, prohibiting all discrimination against women;

(c) To establish legal protection of the rights of women on an equal basis with men and to ensure through competent national tribunals and other public institutions the effective protection of women against any act of discrimination;

(d) To refrain from engaging in any act or practice of discrimination against women and to ensure that public authorities and institutions shall act in conformity with this obligation;

(e) To take all appropriate measures to eliminate discrimination against women by any person, organization, or enterprise;

(f) To take all appropriate measures, including legislation, to modify or abolish existing laws, regulations, customs, and practices which constitute discrimination against women;

(g) To repeal all national penal provisions which constitute discrimination against women.

- *Article 7.* Parties shall take all appropriate measures to eliminate discrimination against women in the political and public life of the country and, in particular, shall ensure to women, on equal terms with men, the right
 (a) To vote in all elections and public referenda and to be eligible for election to all publicly elected bodies.

- *Article 9.*
 Paragraph 2. Parties shall grant women equal rights with men with respect to the nationality of their children.

- *Article 15.*
 Paragraph 4. Parties shall accord to men and women the same rights with regard to the law relating to the movement of persons and the freedom to choose their residence and domicile.

- *Article 16.*
 Paragraph 1. Parties shall take all appropriate measures to eliminate discrimination against women in all matters relating to marriage and family relations and in particular shall ensure, on a basis of equality of men and women,
 (c) The same rights and responsibilities during marriage and at its dissolution;
 (d) The same rights and responsibilities as parents, irrespective of their marital status, in matters relating to their children; in all cases the interests of the children shall be paramount;
 (f) The same rights and responsibilities with regard to guardianship, wardship, trusteeship, and adoption of children, or similar institutions where these concepts exist in national legislation; in all cases the interests of the children shall be paramount;
 (g) The same personal rights as husband and wife, including the right to choose a family name, a profession, and an occupation;
 (h) The same rights for both spouses in respect of the ownership, acquisition, management, administration, enjoyment, and disposition of property, whether free of charge or for a valuable consideration.

- *Article 29.*
 Paragraph 1. Any dispute between two or more States Parties concerning the interpretation or application of the present Convention which is not settled by negotiation shall, at the request of one of them, be submitted to arbitration. If within six months from the date of the request for arbitration the parties are unable to agree on the organization of the arbitration, any one of those parties may refer the dispute to the International Court of Justice by request in conformity with the Statute of the Court.
 Paragraph 2. Each State Party may at the time of signature or ratification of this Convention or accession thereto declare that it does not consider itself bound by paragraph 1 of this article. The other States Parties shall not be bound by that paragraph with respect to any State Party which has made such a reservation.

a. Insofar as it is incompatible with Islamic Shari'a.

b. Saudi Arabia has an overall reservation that "In case of contradiction between any term of the convention and the norms of Islamic law, the Kingdom is not under obligation to observe the contradictory terms of the convention."

Source: CEDAW.

TABLE A.6

Primary, Secondary, and Tertiary School Gross Enrollment Ratio, by Country and by Region, 1980–2000

| Country | Primary enrollment (percent) 1980 M | F | 1990 M | F | 2000 M | F | Secondary enrollment (percent) 1980 M | F | 1990 M | F | 2000 M | F | Tertiary enrollment (percent) 1980 M | F | 1990 M | F | 1997–2000[a] M | F |
|---|
| Algeria | 107.7 | 80.7 | 108.4 | 91.6 | 116.4 | 107.4 | 39.8 | 25.9 | 67.3 | 54.1 | 68.2 | 73.4 | 8.5 | 3.1 | 15.5 | 7.2 | — | — |
| Bahrain | 110.8 | 97.5 | 110.0 | 110.1 | 103.3 | 103.1 | 69.9 | 58.1 | 98.1 | 101.3 | 97.8 | 105.1 | 5.3 | 4.7 | 15.0 | 20.8 | — | — |
| Djibouti | — | — | 44.6 | 31.6 | 45.9 | 34.7 | 15.4 | 8.7 | 14.4 | 9.4 | — | — | — | — | — | — | 1.0 | 0.7 |
| Egypt, Arab Rep. | 84.4 | 61.0 | 101.4 | 85.8 | 102.9 | 96.1 | 61.3 | 38.8 | 83.8 | 68.1 | 88.2 | 83.1 | 21.3 | 10.6 | 20.0 | 11.4 | — | — |
| Iran, Islamic Rep. of | — | — | 118.1 | 106.0 | 88.0 | 84.7 | 51.7 | 31.8 | 63.7 | 46.4 | 80.7 | 75.4 | 11.6 | 5.6 | 13.7 | 6.2 | 10.3 | 9.5 |
| Iraq | 119.1 | 107.4 | 120.3 | 101.8 | — | — | 75.6 | 37.7 | 57.1 | 36.4 | — | — | 13.8 | 12.9 | 15.3 | 9.7 | — | — |
| Jordan | 82.0 | 81.2 | 70.7 | 71.1 | — | — | 61.7 | 56.1 | 43.7 | 45.6 | — | — | 8.5 | 14.9 | 15.3 | 17.1 | — | — |
| Kuwait | 104.6 | 99.6 | 61.7 | 58.7 | — | — | 84.1 | 75.9 | 43.3 | 42.5 | — | — | 40.6 | 20.6 | — | — | — | — |
| Lebanon | — | — | 122.7 | 117.9 | 100.6 | 97.2 | 61.2 | 57 | 70.5 | 75.5 | 72.0 | 79.4 | 11.3 | 4.0 | 30.9 | 27.1 | 40.5 | 44.2 |
| Libya | 128.6 | 120.5 | 108.5 | 101.7 | 114.6 | 116.6 | 88.5 | 62.6 | 84.7 | 87.3 | 87.9 | 91.1 | 9.0 | 2.7 | 19.4 | 9.7 | 49.7 | 47.9 |
| Morocco | 102.3 | 62.9 | 79.0 | 54.3 | 100.8 | 87.7 | 32.3 | 19.7 | 40.6 | 29.7 | — | — | 0.0 | — | 13.3 | 7.9 | 11.4 | 9.2 |
| Oman | 66.6 | 35.0 | 90.3 | 81.8 | 73.7 | 70.8 | 17.4 | 5.7 | 51.2 | 40.1 | 68.9 | 67.5 | 6.4 | 17.1 | 4.4 | 3.8 | 7.1 | 9.9 |
| Qatar | 106.8 | 102.3 | 100.5 | 94.0 | 104.8 | 104.5 | 64.9 | 68 | 77.1 | 84.5 | 86.4 | 91.7 | 9.0 | 4.6 | 14.6 | 42.7 | 12.7 | 37.6 |
| Saudi Arabia | 73.6 | 48.5 | 78.2 | 68.2 | 68.7 | 66.2 | 35.7 | 22.9 | 48.6 | 39.2 | 71.2 | 64.3 | 23.4 | 10.1 | 12.2 | 10.9 | — | — |
| Syrian Arab Rep. | 111.0 | 87.7 | 114.2 | 102.3 | 113.0 | 105.1 | 56.9 | 35.1 | 59.8 | 43.7 | 45.7 | 40.8 | 6.7 | 2.9 | 21.8 | 14.5 | — | — |
| Tunisia | 116.9 | 86.8 | 119.6 | 106.6 | 119.8 | 114.7 | 33.5 | 20.2 | 50.0 | 39.5 | 76.3 | 80.4 | 2.4 | 4.6 | 10.3 | 6.8 | 22.0 | 21.4 |
| United Arab Emirates | 89.5 | 88.3 | 105.8 | 102.8 | 99.2 | 98.9 | 55.3 | 48.6 | 63.0 | 71.6 | 71.1 | 79.7 | — | — | 4.8 | 15.0 | — | — |
| West Bank and Gaza | — | — | — | — | — | — | — | — | — | — | — | — | — | — | — | — | — | — |
| Yemen, Rep. of | — | — | 82.7 | 32.7 | 96.5 | 61.0 | — | — | 94.5 | 19.5 | — | — | — | — | 6.5 | 1.4 | — | — |

TABLE A.6 (continued)

Primary, Secondary, and Tertiary School Gross Enrollment Ratio, by Country and by Region, 1980–2000

Region	Primary enrollment (percent)						Secondary enrollment (percent)						Tertiary enrollment (percent)					
	1980		1990		2000		1980		1990		2000		1980		1990		1997–2000[a]	
	M	F	M	F	M	F	M	F	M	F	M	F	M	F	M	F	M	F
East Asia and the Pacific	117.8	102.7	124.4	116.4	—	—	49.9	36.1	52.4	41.3	—	—	3.5	2.0	6.0	4.3	—	—
Europe and Central Asia	100.4	98.6	98.7	97.9	—	—	85.9	82.9	84.8	85.5	—	—	25.8	33.1	31.8	36.7	—	—
Latin America and the Caribbean	106.0	103.1	106.5	104.5	131.3	127.8	41.2	42.9	45.9	51.3	83.0	89.3	15.4	11.7	17.3	16.5	18.8	21.7
MENA	98.0	73.2	103.8	87.2	98.4	90.5	51.7	32.3	65.5	48.4	77.3	74.4	14.9	7.0	15.5	8.9	—	—
Middle-income countries	112.7	100.9	116.6	109.7	—	—	55.3	45.9	59.4	53.6	—	—	9.7	9.4	13.1	13.2	16.0	15.8
South Asia	91.4	60.7	103.0	76.9	—	—	35.8	17.8	49.0	29.2	—	—	6.9	2.6	7.2	3.6	—	—
Sub-Saharan Africa	87.9	66.9	81.9	67.1	92.4	80.2	19.6	10.0	26.1	20.0	—	—	—	—	4.1	1.9	—	—

— Not available.

Note: M = male; F = female. The gross enrollment ratio is the ratio of total enrollment, regardless of age, to the population of the age group that officially corresponds to the level of education shown. Thus, in some cases, percentages may exceed 100 percent.

a. Most recent data available, from 1997 to 2000.

Sources: World Bank Global Development Finance and World Development Indicators central databases.

TABLE A.7(a)

Male and Female Literacy and Average Years of Schooling for People Age 15 and Older, by Country, 1970–2002

Country	Literacy percentages										Average years of schooling					
	1970		1980		1990		2000		2002		1970			1999		
	M	F	M	F	M	F	M	F	M	F	Total	M	F	Total	M	F
Algeria	32.7	11.6	49.5	24.5	64.3	41.3	76.3	57.0	78.0	59.6	1.6	2.5	0.8	5.4	6.2	4.5
Bahrain	61.6	37.0	78.4	59.3	86.8	74.6	90.9	82.6	91.5	84.2	2.8	3.4	2.0	6.1	6.0	6.2
Djibouti	45.4	15.4	56.4	25.6	66.8	39.7	75.6	54.4	77.0	56.8	—	—	—	—	—	—
Egypt, Arab Rep.[a]	46.4	16.8	53.7	24.7	60.4	33.6	66.6	43.8	67.8	45.9	2.3	3.1	1.6	5.5	6.5	4.5
Iran, Islamic Rep. of	45.6	22.9	60.9	38.2	72.2	54.0	83.0	68.9	84.7	71.4	1.6	2.2	1.0	5.3	6.1	4.5
Iraq	41.2	12.6	46.8	16.1	51.3	19.7	54.9	23.3	55.6	24.1	1.4	1.9	0.8	4.0	4.6	3.3
Jordan	72.3	36.8	82.2	55.4	90.0	72.1	94.9	84.3	95.5	85.9	3.3	4.4	2.1	6.9	7.7	6.0
Kuwait	65.5	45.2	73.0	59.4	79.3	72.6	83.9	79.6	84.7	81.0	2.9	3.3	2.1	7.1	7.2	6.9
Lebanon	75.9	50.8	82.7	62.9	88.3	73.1	92.1	80.3	92.7	81.6	—	—	—	—	—	—
Libya	55.4	12.2	71.3	30.5	82.8	51.1	90.8	68.1	91.8	70.7	—	—	—	—	—	—
Morocco	31.9	8.2	42.1	15.5	52.7	24.9	61.8	36.1	63.3	38.3	—	—	—	—	—	—
Oman	31.7	5.3	51.4	16.3	67.3	38.3	80.1	61.6	82.0	65.4	—	—	—	—	—	—
Qatar	62.5	46.3	71.8	65.4	77.4	76.0	80.4	83.1	81.1	84.4	—	—	—	—	—	—
Saudi Arabia	49.0	16.4	65.0	32.3	76.2	50.2	83.0	66.9	84.1	69.5	—	—	—	—	—	—
Syrian Arab Rep.	60.7	21.0	72.2	33.8	81.8	47.5	88.3	60.4	89.3	62.8	2.2	3.2	1.1	5.8	6.8	4.8
Tunisia	40.9	14.8	58.4	31.2	71.6	46.5	81.4	60.6	83.1	63.1	1.5	2.1	0.9	5.0	5.8	4.2
United Arab Emirates	59.1	37.7	67.4	59.0	71.2	70.6	74.8	79.1	75.6	80.7	—	—	—	—	—	—
West Bank and Gaza	—	—	—	—	—	—	—	—	—	—	—	—	—	—	—	—
Yemen, Rep. of	26.9	2.3	38.2	5.5	55.2	12.9	67.5	25.3	69.5	28.5	—	—	—	—	—	—

— Not available.

Note: M = male; F = female.

a. Average years of schooling data for Egypt are for 1980 and 1999.

Sources: For literacy data, World Bank Global Development Finance and World Development Indicators central databases. For average years of schooling, Barro and Lee 2000.

TABLE A.7(b)

Male and Female Literacy and Average Years of Schooling for People Age 15 and Older, by Region, 1970–2002

Regional statistics[a]

Literacy percentages

Region	1970 M	1970 F	1980 M	1980 F	1990 M	1990 F	2000 M	2000 F	2002 M	2002 F
East Asia and the Pacific	69.9	42.5	80.4	58.3	87.7	71.5	92.2	80.1	92.9	81.6
Europe and Central Asia	96.2	91.6	97.4	93.4	98.1	94.8	98.6	96.0	98.7	96.2
Latin America and the Caribbean	77.5	69.5	82.6	77.2	86.7	83.4	89.9	87.9	90.4	88.6
MENA	43.6	16.4	55.4	27.2	65.7	39.5	74.3	52.5	75.7	54.8
Middle-income countries	74.5	56.7	82.1	66.8	87.6	75.4	91.3	81.8	91.9	82.9
South Asia	45.0	17.8	52.4	25.19	59.3	33.82	65.8	42.7	67.0	44.45
Sub-Saharan Africa	38.5	18.3	49.2	27.6	59.9	39.8	69.6	53.1	71.3	55.5

Average years of schooling

Region	1960 Total	1960 M	1960 F	1980 Total	1980 M	1980 F	1999 Total	1999 M	1999 F
East Asia[b]	4.3	5.3	3.2	4.9	5.9	3.9	6.6	7.7	5.4
Europe and Central Asia[b]	4.9	5.5	4.3	6.5	7.2	5.8	7.3	7.9	6.7
Industrial countries	7.2	7.4	7.0	9.1	9.3	8.9	10.0	10.2	9.8
Latin America and the Caribbean	3.8	3.9	3.8	4.9	5.0	4.8	6.4	6.7	6.2
MENA	0.9	1.2	0.5	2.6	3.5	1.8	5.3	6.2	4.5
Southeast Asia	2.2	2.7	1.6	4.1	4.6	3.6	5.5	5.9	5.1
South Asia[b]	1.5	2.3	0.7	3.0	4.2	1.7	4.6	5.8	3.4
Sub-Saharan Africa	1.6	2.0	1.3	2.3	2.8	1.8	3.5	4.0	3.0

— Not available.

Note: M = male; F = female.

a. For all regional data, figures show the weighted average.

b. East Asia includes China, Europe and Central Asia includes Eastern Europe only, and South Asia includes India.

Sources: For literacy data, World Bank Global Development Finance and World Development Indicators central databases. For average years of schooling, Barro and Lee 2000.

TABLE A.8(a)

Health Sector Data: Infant Mortality Rates and Maternal Mortality Rates, 1980–2001

	Infant mortality rate (per 1,000 live births)		Maternal mortality rate (per 100,000 live births)	
Country	1980	2001	1990	1995
Algeria	94	39	160	150
Bahrain	23	13	60	38
Djibouti	137	100	570	520
Egypt, Arab Rep.	119	35	170	170
Iran, Islamic Rep. of	92	35	120	130
Iraq	63	107	310	370
Jordan	52	27	150	41
Kuwait	27	9	29	25
Lebanon	38	28	300	130
Libya	55	16	220	120
Morocco	99	39	610	390
Oman	41	12	190	120
Qatar	25	11	—	41
Saudi Arabia	65	23	130	23
Syrian Arab Rep.	54	23	180	200
Tunisia	72	21	170	70
United Arab Emirates	23	8	26	—
West Bank and Gaza	—	21	—	120
Yemen, Rep. of	135	79	1,400	850

— Not available.

Sources: For infant mortality rates, World Bank World Development Indicators central database. For maternal mortality rates, World Health Organization Statistical Information System database.

TABLE A.8(b)

Health Sector Data: Total Fertility Rates, by Country and by Region, 1980–2001
(births per woman)

Country	1980	1990	2000	2001
Algeria	6.7	4.5	3.0	2.8
Bahrain	5.2	3.8	2.8	2.3
Djibouti	6.6	6.0	5.3	5.2
Egypt, Arab Rep.	5.1	4.0	3.3	3.0
Iran, Islamic Rep. of	6.7	4.7	2.6	2.5
Iraq	6.4	5.9	4.3	4.1
Jordan	6.8	5.4	3.7	3.5
Kuwait	5.3	3.4	2.7	2.5
Lebanon	4.0	3.2	2.3	2.2
Libya	7.3	4.7	3.5	3.3
Morocco	5.4	4.0	2.9	2.8
Oman	9.9	7.4	4.3	4.0
Qatar	5.6	4.3	2.6	2.5
Saudi Arabia	7.3	6.6	5.5	5.3
Syrian Arab Rep.	7.4	5.3	3.6	3.5
Tunisia	5.2	3.5	2.1	2.1
United Arab Emirates	5.4	4.1	3.2	3.0
West Bank and Gaza	—	—	5.1	4.9
Yemen, Rep. of	7.9	7.5	6.2	6.0

Region	1980	1990	2000	2001
East Asia and the Pacific	3.1	2.4	2.1	2.1
Europe and Central Asia	2.5	2.3	1.6	1.6
Latin America and the Caribbean	4.1	3.1	2.6	2.5
MENA	**6.2**	**4.8**	**3.4**	**3.2**
South Asia	5.3	4.1	3.3	3.1
Sub-Saharan Africa	6.6	6.1	5.2	5.0

— Not available.

Notes: Total fertility rate is the number of children that would be born to a woman if she were to live to the end of her childbearing years and bear children in accordance with current age-specific fertility rates.

Sources: World Bank Global Development Finance and World Development Indicators central databases.

TABLE A.8(c)

Health Sector Data: Life Expectancy at Birth, by Country and by Region, 1970–2002

(years)

Country	1970 M	1970 F	1980 M	1980 F	1990 M	1990 F	2000 M	2000 F	2002 M	2002 F
Algeria	52.3	54.3	58.3	60.3	66.0	68.8	69.2	71.9	69.4	72.1
Bahrain	60.3	64.0	65.8	70.0	69.3	73.6	70.6	75.7	70.8	75.9
Djibouti	38.6	41.8	42.6	45.8	46.2	49.4	45.6	47.0	43.5	43.6
Egypt, Arab Rep.	49.9	52.4	54.3	56.8	61.4	64.3	66.3	69.5	67.3	70.5
Iran, Islamic Rep. of	53.1	52.5	56.9	59.4	63.9	65.4	67.9	69.7	68.3	70.3
Iraq	54.5	56.3	61.1	62.9	60.0	62.7	59.7	62.5	61.4	63.9
Jordan	—	—	—	—	66.7	70.3	69.9	73.2	70.4	73.6
Kuwait	64.2	68.1	68.8	72.9	73.0	76.8	74.6	78.7	74.9	79.0
Lebanon	62.3	66.1	63.1	67.0	66.0	69.9	68.6	72.2	69.0	72.6
Libya	50.4	53.4	58.8	62.2	66.7	70.4	69.3	73.8	69.9	74.9
Morocco	50.4	53.4	56.3	59.8	61.8	65.3	65.8	69.6	66.4	70.4
Oman	46.3	48.5	58.5	61.2	67.1	71.0	72.1	75.1	72.6	75.6
Qatar	59.3	63.0	64.6	68.9	70.8	73.7	74.4	75.0	74.6	75.3
Saudi Arabia	50.9	53.8	59.9	62.4	67.6	70.5	70.8	74.3	71.4	74.9
Syrian Arab Rep.	54.2	57.4	59.8	63.4	64.4	68.5	67.5	72.1	68.0	72.7
Tunisia	53.7	54.7	61.4	63.5	68.6	72.1	70.1	74.2	70.8	74.6
United Arab Emirates	59.3	63.0	66.1	70.4	72.4	74.7	74.0	76.7	74.0	76.8
West Bank and Gaza	—	—	—	—	—	—	70.2	74.1	70.5	75.1
Yemen, Rep. of	41.1	41.6	47.4	49.7	51.8	52.6	55.9	57.1	56.8	58.1

Region	1970 M	1970 F	1980 M	1980 F	1990 M	1990 F	2000 M	2000 F	2002 M	2002 F
East Asia and the Pacific	58.2	60.0	63.0	65.7	65.6	68.9	67.3	70.8	67.7	71.2
Europe and Central Asia	63.5	72.2	63.5	72.2	65.3	73.7	64.0	73.2	64.2	73.3
Latin America and the Caribbean	58.3	62.7	61.8	67.5	64.7	71.2	67.2	73.6	67.6	74.0
MENA	**51.5**	**53.1**	**56.9**	**59.4**	**63.0**	**65.6**	**66.5**	**69.3**	**67.2**	**70.1**
South Asia	49.6	48.1	53.8	53.4	58.3	58.7	61.7	63.0	62.0	63.7
Sub-Saharan Africa	42.6	45.9	46.0	49.4	48.5	51.6	45.7	47.4	45.1	46.6

— Not available.

Note: M = male; F = female.

Sources: World Bank Global Development Finance and World Development Indicators central databases.

TABLE A.8(d)

Health Sector Data: Contraceptive Prevalence Rates among Married Women, 2002
(percent)

Country	Rate
Algeria	64
Bahrain	62
Egypt, Arab Rep.	56
Iran, Islamic Rep. of	74
Jordan	53
Kuwait	52
Lebanon	61
Libya	45
Morocco	58
Oman	24
Qatar	43
Saudi Arabia	32
Syrian Arab Rep.	40
Tunisia	60
United Arab Emirates	28
Yemen, Rep. of	21

Source: Roudi-Fahimi 2003.

Bibliography

The word *processed* describes informally reproduced works that may not be commonly available through libraries.

Abramo, Lais, and Rosalba Todaro. 2002. *Cuestionando un mito: Costos laborales de hombres y mujeres en America Latina* [Examining a Myth: Labor Costs for Men and Women in Latin America]. Lima: International Labour Organisation.

Abu-Nasr, Julinda, Nabil F. Khoury, and Henry T. Azzam. 1985. *Women and Development in the Arab World*. Leiden, Netherlands: Mouton.

Abu-Zayd, Gehan. 1998. "In Search of Political Power: Women in Parliament in Egypt, Jordan, and Lebanon." In *Women in Parliament: Beyond Numbers*. Stockholm: International Institute for Democracy and Electoral Assistance. Available online at http://www.idea.int/women/parl/studies1a.htm. Accessed November 24, 2003.

Afshar, Haleh. 1998. *Women and Empowerment: Illustrations from the Third World*. London: Macmillan.

Aghacy, Samira. 2001. "Marriage Patterns in the Arab World." *Al-Raida* 18–19(93–94): 11.

Al-Hamad, Laila. 2002. "Women's Organizations in the Arab World." *Al-Raida* 19(97–98): 22–27.

Altorki, Soraya. 2000. "The Concept and Practice of Citizenship in Saudi Arabia." In Suad Joseph, ed., *Gender and Citizenship in the Middle East*. Syracuse, N.Y.: Syracuse University Press.

Arab Republic of Egypt. 1988. *Egypt Labor Force Sample Survey*. Cairo.

———. 2000. *Country Report on the Beijing Work Plan*. Report submitted to the United Nations.

Arab Republic of Egypt, Central Agency for Public Mobilization and Statistics. 2001. *The Statistical Yearbook 1993–2000*. Cairo.

Artecona, Raquel, and Wendy Cunningham. 2002. "Effects of Trade Liberalization on the Gender Wage Gap in Mexico." Background Paper for Policy Research Report on Gender and Development. World Bank Development Research Group Poverty Reduction and Economic Management Team, Washington, D.C.

Assaad, Ragui. 1997a. "The Effects of Public Sector Hiring and Compensation on the Egyptian Labor Market." *World Bank Economic Review* 11(1): 85–118.

———. 1997b. "The Employment Crisis in Egypt: Current Trends and Future Prospects." *Research in Middle East Economics* 2: 39–66.

———. 2000. *The Transformation of the Egyptian Labor Market, 1988–1998*. Report for the Egypt Labor Market Project. Cairo: Economic Forum for the Arab Countries, Iran, and Turkey.

———. 2003. "Gender and Employment: Egypt in Comparative Perspective." In Eleanor Abdella Doumato and Marsha Pripstein Posusney, eds., *Women and Globalization in the Arab Middle East: Gender, Economy, and Society*. Boulder, Colo.: Lynne Rienner.

Assaad, Ragui, and Melanie Arntz. 2000. "Does Structural Adjustment Contribute to a Growing Gender Gap in the Labor Market? Evidence from Egypt." Minneapolis: Minnesota Population Center, University of Minnesota.

Badran, Hoda. 1997. *The Road from Beijing*. Cairo: United Nations Development Programme.

Bahramitash, Roksana. 2001. "Women's Employment in Iran: Modernization and Illumination." In Fred Dallmayr, ed., *Iran from Transition to Modernization*. New York: Lexington Books.

Barro, Robert J., and Jong-Wha Lee. 2000. "International Data on Educational Attainment: Updates and Implications." CID Working

Paper 42. Center for International Development, Harvard University, Cambridge, Mass.

Başlevent, Cem, and Özlem Onaran. 2003. "Are Married Women in Turkey More Likely to Become Added or Discouraged Workers?" *Labour* 17(3): 493–58.

Batliwala, Srilatha. 1997. "What Is Female Empowerment?" Paper presented at the International Seminar on Women's Empowerment organized by the Swedish Association for Sexual Education in cooperation with the Department of Demography, Stockholm University. Stockholm, April 25. Available online at http://www.qweb.kvinnoforum.se/papers/RFSU1.htm. Accessed November 24, 2003.

Becker, Gary. 1993. "The Economic Way of Looking at Behavior." *Journal of Political Economy* 101(3): 385–409.

Benyelles, Rachid. 2002. *L'Annuaire Politique de l'Algérie 2002*. Algiers: ANEP (Entreprise Nationale de Communication d'Édition et de Publicité).

Boursaw, Jane. 2003. "Women's Business Centers Encourage New Ways of Doing Business in the U.S." *Women's enews* (February). Available online at http://www.womensenews.org/. Accessed November 24, 2003.

Bozorgmehr, Najmeh. 2003. "Iranian Women Struggle to Catch Up with World Rights." *Financial Times*, May 24.

Brand, Laurie. 1998a. "Women and the Struggle for Political Openings: The Case of Jordan." Paper presented at a Brown University workshop. Providence, April 1998.

———. 1998b. *Women, the State, and Political Liberalization: Middle Eastern and North African Experiences*. New York: Columbia University Press.

———. 2003. "Jordan: Women and the Struggle for Political Opening." In Eleanor Abdella Doumato and Marsha Pripstein Posusney, eds., *Women and Globalization in the Arab Middle East: Gender, Economy, and Society*. Boulder, Colo.: Lynne Rienner.

Bruce, Judith. 2001. "Adolescent Reproductive Health Needs in Developing Countries." Lecture given at a workshop on From Science to Action: Reproductive Health in the Arab Countries, American University, Cairo, June 1999.

Brumberg, Daniel. 2003. "Liberalization versus Democracy: Understanding Arab Political Reform." Middle East Series, Working Paper 37. Democracy and Rule of Law Project, Carnegie Endowment for International Peace, Washington, D.C.

Çağatay, Nilufer, and Gunseli Berik. 1991. "Transition to Export-Led Growth: Is There a Feminization of Employment?" *Capital and Class* 43: 153.

Çağatay, Nilufer, Diane Elson, and Caren Grown. 1995. "Gender, Adjustment, and Macroeconomics." *World Development* 23(11): 1851–68.

Cairoli, M. Laetitia. 1999. "Garment Factory Workers in the City of Fez." *Middle East Journal* 53(1): 28–43.

CAWTAR (Center of Arab Women for Training and Research). 2001. "Globalization and Gender: Economic Participation of Arab Women." Arab Women's Development Report 1. El Omrane, Tunisia.

———. 2003. "Arab Adolescent Girl: Reality and Prospects." Arab Women's Development Report 2. El Omrane, Tunisia.

Chang, Mariko Lin. 2000. "The Evolution of Sex Segregation Regimes." *American Journal of Sociology* 105(6): 1658–701.

Charrad, Mounira. 1992. "State and Gender in the Maghrib." *Middle East Report* 163 (March–April): 19–24. Available online at http://waf.gn.apc.org/j3p10.htm. Accessed November 24, 2003.

Chattopadhyay, Raghabendra, and Esther Duflo. 2001. "Women as Policy Makers: Evidence from an India-Wide Randomized Policy Experiment." World Bank, Washington, D.C. Processed.

Clark, Roger, Thomas W. Ramsbey, and Emily Stier Adler. 1991. "Culture, Gender, and Labor Force Participation: A Cross-National Study." *Gender and Society* 5(1): 47–66.

CREDIF (Centre de Recherches d'Etudes de Documentation et d'Information sur la Femme). 2000. *Les Femmes en Tunisie, 2000.* Tunis.

Crittenden, Ann. 1963. *The Price of Motherhood: Why the Most Important Job in the World Is Still the Least Valued.* New York: Metropolitan Books.

Cunningham. 2001. "Breadwinner or Caregiver? How Household Role Affects Labor Choices in Mexico." In Elizabeth G. Katz and Maria C. Correia (eds.), *The Economics of Gender in Mexico: Work, Family, State, and Market.* Washington, D.C.: World Bank.

Dahlerup, Drude. 2002. "Using Quotas to Increase Women's Political Representation." In *Women in Parliament: Beyond Numbers.* Stockholm: International Institute for Democracy and Electoral Assistance. Available online at http://www.idea.int/women/parl/ch4a.htm. Accessed November 24, 2003.

Davis-Packard, Kent. 2003. "Morocco Pushes Ahead." *Christian Science Monitor,* November 12. Available online at http://www.csmonitor.com/2003/1112/p15s01-wome.html. Accessed November 24, 2003.

Del Bono, Emilia. 2003. "Total Fertility Rates and Female Participation in Italy and Great Britain: Estimation of a Reduced-Form Model Using Regional Panel Data." Queen's College, University of Oxford, United Kingdom. Processed.

Deutsch, Ruthanne. 1998. "Does Childcare Pay? Labor Force Participation and the Earnings Effects of Access to Childcare in the Favelas of Rio de Janeiro." IDB Working Paper s84. Inter-American Development Bank, Washington, D.C. Available online at http://www.iadb.org/res/publications/pubfiles/pubWP-384.pdf. Accessed November 24, 2003.

Deutsch, Ruthanne, Andrew Morrison, Claudia Piras, and Hugo Nopo. 2001. "Working within Confines: Occupational Segregation by Gender for Three Latin American Countries." Paper presented at a seminar on Women at Work: A Challenge for Development. Santiago, March 17.

Development Studies Program. 2002. *Palestinian Human Development Report.* Ramallah, West Bank and Gaza: Birzeit University. Available online at http://home.birzeit.edu/dsp/DSPNEW/hdr/hdr_summary.htm. Accessed November 24, 2003.

Dey Abbas, Jennie. 1997. "Gender Asymmetries in Intrahousehold Resource Allocation in Sub-Saharan Africa: Some Policy Implications for Land and Labor Productivity." In Lawrence Haddad, John Hoddinott, and Harold Alderman, eds., *Intrahousehold Resource Allocation in Developing Countries: Models, Methods, and Policy*. Baltimore: Johns Hopkins University Press.

Dollar, David, Raymond Fisman, and Roberta Gatti. 1999. "Are Women Really the 'Fairer' Sex? Corruption and Women in Government." Policy Research Report on Gender and Development, Working Paper 4. World Bank, Washington, D.C.

Doumato, Eleanor Abdella. 1999. "Women and Work in Saudi Arabia: How Flexible Are Islamic Margins?" *Middle East Journal* 53(4): 584.

Duaibis, Salwa. 1999. "Palestinian Women Acknowledged." *Cornerstone: Sabeel Newsletter* 14. Available online at http://www.sabeel.org/old/news/newslt14/duaibis.htm. Accessed November 24, 2003.

Duncan, Otis, and Beverly Duncan. 1955. "A Methodological Analysis of Segregation Indices." *American Sociological Review* 20(April): 210–17.

Ebadi, Shirin. 2003. *Hoquqe Zan dar qavanine jomhuri-e Eslami-e Iran* [Women's Rights in the Laws of Islamic Republic of Iran]. Tehran: Ganje Danesh.

Egypt, Government of. 1998. Egypt Labor Market Survey (ELMS). Cairo.

El-Baz, Shahida. 1997. "The Impact of Social and Economic Factors on Women's Group Formation in Egypt." In Dawn Chatty and Annika Rabo, eds., *Organizing Women: Formal and Informal Groups in the Middle East*. New York: Berg.

———. 1999. *The Arabian Woman between the Pressure of Reality and Aspirations for Freedom*. Beirut: Center for Arab Unification Studies.

Elbendary, Amina. 2003. "Women on the Bench." *Al-Ahram Weekly*. January 9–15. Available online at http://weekly.ahram.org.eg/2003/620/fr2.htm. Accessed November 24, 2003.

El-Kholy, Heba. 1996a. "The Alliance Between Gender and Kinship Ideologies: Female Sub-Contractors in Cairo's 'Informal Economy.'"

In *Proceedings of the Regional Arab Conference on Population and Develop-ment.* Cairo and Brussels: International Union for the Scientific Study of Population (IUSSP).

―――. 1996b. "Poverty Alleviation Programs: An NGO Perspective." Paper presented to the United Nations Development Programme Arab Regional Conference on Poverty Alleviation in the Arab World. Syria, February.

El-Mahdi, Alia. 2000. "The Labor Absorption Capacity of the Informal Sector in Egypt." Minneapolis: Minnesota Population Center, University of Minnesota.

El-Solh, Camillia, and Judy Mabro, eds. 1994. *Muslim Women's Choices: Religious Belief and Social Reality.* New York: Berg.

Elson, Diane. 1999. "Gender Budget Initiative." Gender and Youth Affairs Division Background Papers. U.K. Commonwealth Secretariat, London.

Eltigani, Mohammed Eltigani Eltahir. 2001. "Levels and Trends of Fertility in Oman and Yemen." Paper presented at a workshop on Prospects for Fertility Decline in High Fertility Countries, Popula-tion Division, Department of Economic and Social Affairs, United Nations Secretariat. New York, July 9–11.

Engelhardt, Henriette, and Alexia Prskawetz. 2002. *On the Changing Correlation between Fertility and Female Employment over Space and Time.* Working Paper WP2002-052. Max Planck Institute for Demo-graphic Research, Rostock, Germany.

Es,im, Simel. 2002. "Gender Analysis of Budgets as a Tool for Achiev-ing Gender Equality in the Arab World." "Special Issue on the Arab Human Development Report 2002." *Forum Newsletter* 9(2): 33–36.

Fargues, Philippe. 2003. "Women in Arab Countries: Challenging the Patriarchal System?" *Population and Societies* 387(February): 1–4.

Forsythe, Nancy, Roberto Patricio Korzeniewicz, Nomaan Majid, Gwyndolyn Weathers, and Valerie Durrant. 2003. *Gender Inequalities, Economic Growth, and Economic Reform: A Preliminary Longitudinal Evaluation.* Employment Paper 2003/45. International Labour Organisation, Geneva.

Fukuyama, Francis. 1995. *Trust.* New York: Free Press.

GenderReach. 1999. "Women's Political Participation: The Missing Half of Democracy." *Gender Matters Information Bulletin* 3(July). Available online at http://www.genderreach.com/pubs/ib3.htm. Accessed November 24, 2003.

"Germany's Declining Population—Kinder, Gentler." 2003. *Economist,* December 6–12.

Gindling, T. H., and Maria Crummett. 1997. "Maternity Leave Legislation and the Work and Pay of Women in Costa Rica." University of Maryland, Baltimore. Processed.

Goldin, Claudia. 1995. "The U-Shaped Female Labor Force Function in Economic Development and Economic History." In T. Paul Schultz, ed., *Investment in Women's Human Capital.* Chicago: University of Chicago Press.

Göle, Nilufer. 1996. *The Forbidden Modern: Civilization and Veiling.* Ann Arbor: University of Michigan.

Gomaa, Salwa Shaarawi. 1998. "Political Participation of Egyptian Women." Cairo: UNICEF Egypt and the American University in Cairo Social Research Center.

Gopal, Gita, and Maryam Salim, eds. 1998. *Gender and Law: Eastern Africa Speaks.* Directions in Development Series. Washington, D.C.: World Bank.

Gornick, Janet, Marcia Meyers, and Katherin Ross. 1996. "Supporting the Employment of Mothers: Policy Variations across Fourteen Welfare States." LIS Working Paper 139. Luxembourg Income Study, Luxembourg.

Grown, Caren, Diane Elson, and Nilufer Çağatay. 2000. "Introduction." "Special Issue on Growth, Trade, Finance, and Gender Inequality." *World Development* 28(7): 1145–56.

Grown, Caren, Geeta Rao Gupta, and Zahia Khan. 2003. "Promises to Keep: Achieving Gender Equality and the Empowerment of

Women." Draft Background Paper for the Task Force on Education and Gender Equality of the Millennium Project. International Center for Research on Women, Washington, D.C.

Haidar, Raana. 2001. "Women's Employment in Islamic Republic of Iran." Cairo Demographic Center, Cairo. Processed.

Hanson, Susan, and Geraldine Pratt. 1988. "Reconceptualizing the Links between Home and Work in Urban Geography." *Economic Geography* 64(4): 299–321.

Hanson, Susan, Tara Kominiak, and Scott Carlin. 1997. "Assessing the Impact of Location on Women's Labor Market Outcomes: A Methodological Exploration." *Geographical Analysis* 29(4): 281–97.

Hashemite Kingdom of Jordan, Department of Statistics. 1997. *Jordan Household Income and Expenditure Survey*. Amman.

Hassan, Sherif Omar. 1998. "Gender and Islamic Law: Some General Observations on the Status of Women under Islamic Law." Paper presented at the Gender and Law Workshop, World Bank Institute. Washington D.C., June 15–16.

Hatem, Mervat. 1994. "Privatization and the Demise of State Feminism in Egypt." In Pamela Sparr, ed., *Mortgaging Women's Lives: Feminist Critiques of Structural Adjustment*. London: Zed Books.

———. 1996. "Economic and Political Liberalization in Egypt and the Demise of State Feminism." In Suha Sabbagh, ed., *Arab Women: Between Defiance and Restraint*. New York: Olive Branch Press.

Hijab, Nadia. 1988. *Women Power: The Arab Debate on Women at Work*. Cambridge, U.K.: Cambridge University Press.

———. 1996. "Women and Work in the Arab World." In Suha Sabbagh, ed., *Arab Women: Between Defiance and Restraint*. New York: Olive Branch Press.

———. 2001. "Laws, Regulations, and Practices Impeding Women's Economic Participation in the Middle East and North Africa." Report prepared for the World Bank, Washington, D.C.

Hijab, Nadia, Camillia El-Solh, and Shirin Ebadi. 2003. "Social Inclusion of Women in the Middle East and North Africa." Paper prepared for the World Bank, Washington, D.C.

Hoddinott, John, and Lawrence Haddad. 1995. "Does Female Income Share Influence Household Expenditures? Evidence from Côte d'Ivoire." *Oxford Bulletin of Economics and Statistics* 57(1): 77–96.

Hoodfar, Homa. 1998. "Muslim Women on the Threshold of the Twenty-First Century." *Women Living under Muslim Laws, Dossier* 21(September): 112–23.

Howard, Jane. 2002. *Inside Iran: Women's Lives.* Washington, D.C.: Mage.

Htun, Mala. 1998. "Women's Political Participation, Representation, and Leadership in Latin America." Paper presented at the Women's Leadership Conference of the Americas Issue Brief, Harvard University. Cambridge, Mass., April.

Htun, Mala, and Mark Jones. 2003. "Engendering the Right to Participate in Decision-Making: Electoral Quotas and Women's Leadership in Latin America." In Nikki Craske and Maxine Molyneux, eds., *Gender, Rights, and Justice in Latin America.* New York: Palgrave.

Hujer, Reinhard, and Reinhold Schnabel. 1994. "The Impact of Regional and Sectoral Labor Market Conditions on Wages and Labor Supply: An Empirical Analysis for Married Women Using West German Panel Data." *Empirical Economics* 19(1): 19–35.

Husseini, Rana. 2002. "Arab Women Rank Lowest Worldwide in Parliamentary Presence." *Arab World News*, March 12. Available online at http://www.amanjordan.org/english. Accessed November 24, 2003.

IDEA (International Institute for Democracy and Electoral Assistance). 1998. *Women in Parliament: Beyond Numbers.* Stockholm. Available online at http://www.idea.int/women/parl/toc.htm. Accessed November 24, 2003.

IDEA (International Institute for Democracy and Electoral Assistance) and Stockholm University. 2003. *Global Database of Quotas for Women.* Available online at http://www.idea.int/quota/index.cfm. Accessed November 24, 2003.

Ilahi, Nadeem. 1999a. "Children's Work and Schooling: Does Gender Matter? Evidence from the LSMS Panel Data." World Bank, Latin

American and Caribbean Region, Poverty Reduction and Economic Management Unit, Washington, D.C.

———. 1999b. "Gender and the Allocation of Adult Time: Evidence from the Peru LSMS Panel Data." Background paper for *Engendering Development*. Washington, D.C.: World Bank.

ILO (International Labour Organisation). 1982. "ILO (1982) Guidelines on Measuring Employment and Unemployment." Available online at http://www.hamburg.emb-japan.go.jp/infojp/wussten/dilo.html. Accessed November 24, 2003.

———. 1996. *Economically Active Population, 1950–2010* (4th ed.). Geneva.

———. 1998. *Breaking through the Glass Ceiling: Women in Management*. Geneva. Available online at http://www.ilo.org/public/english/bureau/inf/pkits/pdf/glassceiling.pdf. Accessed November 24, 2003.

———. 2002. *Women and Men in the Informal Economy: A Statistical Picture*. ILO Employment Sector Paper. Geneva.

———. 2003a. LABORSTA Database. Geneva.

———. 2003b. *Time for Equality at Work: Report of the Director General*. Available online at http://www.ilo.org/public/english/standards/decl/download/global4/toc.pdf. Accessed November 24, 2003.

———. 2003c. *Women Migrant Workers' Protection in Arab League States*. Geneva.

IMF (International Monetary Fund). 2000. "Behind the Dutch 'Miracle.'" *IMF Survey* 29(1): 4–6.

"INJAZ Students Discuss Achievements with Queen during Visit." *Jordan Times*, July 16, 2002.

INS (Institut National de la Statistique). 1997. Tunisian Annual Employment Survey (TAES). Tunis.

———. 2001.Tunisian Annual Employment Survey (TAES). Tunis.

International Center for Research on Women. 2002. "Gender Analysis of Budgets." ICRW Background Brief. International Center for

Research on Women, Washington, D.C. Available online at http://www.icrw.org/. Accessed November 24, 2003.

International Foundation for Election Systems. 2002. *Arab Election Law Compendium*. Washington, D.C. Available online at http://www.arabelectionlaw.net/. Accessed November 24, 2003.

Jabbra, Joseph G., and Nancy W. Jabbra. 1992. "Introduction: Women and Development in the Middle East and North Africa." *Journal of Developing Societies* 8(1): 1–10.

Jamal, Amal. 2001. "Engendering State Building: The Women's Movement and Gender Regime in Palestine." *Middle East Journal* 55(2): 274.

James, Estelle, Alejandra Cox Edwards, and Rebeca Wong. Forthcoming. *The Gender Impact of Pension Reform: A Cross-Country Analysis*. Washington, D.C.: World Bank.

Joekes, Susan. 1987. *Women in the World Economy*. Oxford, U.K.: Oxford University Press.

———. 1995. *Trade-Related Employment for Women in Industry and Services in Developing Countries*. Geneva: United Nations Research Institute for Social Development.

Joseph, Suad. 2002. "Gender and Citizenship in the Arab World." Concept paper presented at the Mediterranean Development Forum, United Nations Development Programme. Amman, April 8.

Joseph, Suad, and Susan Slyomovics. 2001. *Women and Power in the Middle East*. Philadelphia: University of Pennsylvania Press.

Kabeer, Naila. 1999. "The Conditions and Consequences of Choice: Reflections on the Measurement of Women's Empowerment." Discussion Paper 108. United Nations Research Institute for Social Development, Geneva.

Kandil, Amani. 2002. "Women in Egyptian Civil Society: A Critical Review." *Al-Raida* 19(97–98): 30–37.

Kandiyoti, Deniz. 1991a. "Islam and Patriarchy." In Nikki R. Keddie and Beth Baron, eds., *Women in Middle Eastern History*. New Haven, Conn., and London: Yale University Press.

———, ed. 1991b. *Women, Islam, and the State.* Philadelphia: Temple University Press.

Karam, Azza. 1999a. "Beijing+5: Review of Strategies and Trends." New York: United Nations Development Programme.

———. 1999b. "Strengthening the Role of Women Parliamentarians in the Arab Region: Challenges and Options." Paper written for the United Nations Development Programme POGAR (Programme on Governance in the Arab Region). Available online at http://www.undp-pogar.org/publications/gender/karam1/karama.pdf. Accessed November 24, 2003.

———. 2002. "Strengthening the Role of Women Parliamentarians in the Arab Region: Challenges and Options." Belfast: Queen's University.

Karshenas, Massoud. 1997. "Economic Liberalization, Competitiveness, and Women's Employment in the Middle East and North Africa." ERF Working Paper 9705. Department of Economics, School of Oriental and African Studies, University of London.

Karshenas, Massoud, and Valentine M. Moghadam. 2001. "Female Labor Force Participation and Economic Adjustment in the MENA Region." In E. Mine Cinar, ed., *The Economics of Women and Work in the Middle East and North Africa. Research in Middle East Economics.* Vol. 4. of *Research in Middle East Economies.* Amsterdam and London: Elsevier.

Keddie, Nikki R. 1981. *Roots of Revolution: An Interpretive History of Modern Iran.* New Haven, Conn.: Yale University Press.

———. 1991. "Introduction: Deciphering Middle Eastern Women's History." In Nikki R. Keddie and Beth Baron, eds., *Women in Middle Eastern History.* New Haven, Conn., and London: Yale University Press.

Khalaf, Mona. 2002. "Women in Post-War Lebanon." In Kail C. Ellis, ed., *Lebanon's Second Republic, Prospect for the Twenty-First Century.* Gainesville: University of Florida Press.

Kingdom of Morocco. 1999. *Morocco Living Standard Measurement Survey.* Rabat.

Kirchberger, Andre. 2002. "The Knowledge Economy and Education Reforms in MENA Countries: Selected Examples."

Available online at http://lnweb18.worldbank.org/MNA/mena.nsf/
Attachments/Education2/$File/Mena_Educ.pdf. Accessed November 24, 2003.

Klasen, Stephan. 1999. *Does Gender Inequality Reduce Growth and Development? Evidence from Cross-Country Regressions.* Policy Research Report on Gender and Development. World Bank, Washington D.C.

Klasen, Stephan, and Francesca Lamanna. 2003. "The Impact of Gender Inequality in Education and Employment on Economic Growth in the Middle East and North Africa." Paper prepared for the World Bank, Washington, D.C.

Lebanon Nongovernmental National Committee for the Follow-up of Women's Issues. 1999. "The Shadow Report on the Progress of Implementation of CEDAW in Lebanon" [in Arabic]. Beirut.

LeVine, Mark. 2002. "The U.N. Arab Human Development Report: A Critique." MERIP Press Information Note 101. Middle East Research Information Project, Washington, D.C. Available online at http://www.merip.org. Accessed November 24, 2003.

Lloyd, Cynthia B., Sahar El Tawila, Wesley H. Clark, and Barbara S. Mensch. 2001. "Determinants of Educational Attainment among Adolescents in Egypt: Does School Quality Make a Difference?" Policy Research Division Working Paper 150. Population Council, New York.

Lovenduski, Joni, and Azza Karam. 2002. "Women in Parliament: Making a Difference." In *Women in Parliament: Beyond Numbers.* Stockholm: International Institute for Democracy and Electoral Assistance. Available online at http://www.idea.int/women/parl/ch5a.htm. Accessed November 24, 2003.

Malhotra, Anju, Sidney Ruth Schuler, and Carol Boender. 2002. *Measuring Women's Empowerment as a Variable in International Development.* Washington, D.C.: Social Development Group, World Bank.

Mason, Karen. 2003. *Gender Equality and the Millennium Development Goals.* Washington, D.C.: World Bank.

Matland, Richard. 2002. "Enhancing Women's Political Participation: Legislative Recruitment and Electoral Systems." In *Women in Parliament: Beyond Numbers.* Stockholm: International Institute for

Democracy and Electoral Assistance. Available online at http://www.idea.int/women/parl/ch3a.htm. Accessed November 24, 2003.

Mehran, Golnar. 1992. "Social Implications of Illiteracy in Iran." *Comparative Education Review* 36(2): 194–211.

———. 1997. "A Study of Girls' Lack of Access to Primary Education in the Islamic Republic of Iran." *Compare* 27(3): 263–76.

———. 1999. "Lifelong Learning: New Opportunities for Women in a Muslim Country (Iran)." *Comparative Education* 35(2): 201–15.

Moghadam, Fatemeh Etemad. 2001. "Iran's New Islamic Home Economics." In E. Mine Cinar, ed., *The Economics of Women and Work in the Middle East and North Africa. Research in Middle East Economics.* Vol. 4. of *Research in Middle East Economies.* Amsterdam and London: Elsevier.

Moghadam, Valentine. 1992. "Women's Employment in the Middle East and North Africa: The Role of Gender, Class, and State Politics." Working Paper 229. East Lansing: Michigan State University.

———. 1993. *Modernizing Women: Gender and Social Change in the Middle East.* Boulder, Colo.: Lynne Rienner.

———. 1995. "The Political Economy of Women's Employment in the Arab Region." In Nabil Khoury and Valentine Moghadam, eds., *Gender and Development in the Arab Region.* London: Zed Books.

———. 1998. *Women, Work, and Economic Reform in the Middle East and North Africa.* New York and London: Lynne Rienner.

———. 2001. "Women, Work, and Economic Restructuring: A Regional Overview." In E. Mine Cinar, ed., *The Economics of Women and Work in the Middle East and North Africa. Research in Middle East Economics.* Vol. 4. of *Research in Middle East Economies.* Amsterdam and London: Elsevier.

———. 2002. "Citizenship, Civil Society, and Women in the Arab Region." *Al-Raida* 19(97–98): 12–21.

Moreno-Fontes, Chammartin Gloria. 2003. *Women Migrant Workers' Protection in Arab League States.* Geneva: International Labour Organisation.

Morocco, Government of. 1999. Morocco Living Standard Measurement Survey (MLSS). Rabat.

Mulama, Joyce. 2002. "Women Produce Most of the Tea Grown in Kenya." InterPress Service News Agency. Available online at http://ipsnews.net/africa/Focus/religion/note_34.shtml. Accessed November 24, 2003.

Naciri, Rabea. 1998. "The Women's Movement and Political Discourse in Morocco." Occasional Paper No. 8. U.N. Fourth World Conference on Women. Geneva.

Naik, Gautam. 2003. "Tunisia Wins Population Battle, and Others See a Policy Model." *Wall Street Journal*, August 8, 2003.

Najmabadi, Afseneh. 1991. "Hazards of Modernity and Morality: Women, State, and Ideology in Contemporary Iran." In Deniz Kandiyoti, ed., *Women, Islam, and the State*. Philadelphia: Temple University Press.

Narayan, Deepa, Raj Patel, Kai Schafft, Anne Rademacher, and Sarah Koch-Schulte. 2000. *Voices of the Poor: Can Anyone Hear Us?* Washington, D.C.: World Bank.

Nataraj, Sita, Yana van der Meulen Rodgers, and Joseph Zveglich Jr. 1998. "Protecting Female Workers in Industrializing Countries." *International Review of Comparative Public Policy* 10: 197–221.

National Council of Women. n.d. "Equal Opportunity Focal Points in Ministries." Available online at http://www.ncw.gov.eg/new-ncw/english/cons_equ.jsp. Accessed June 3, 2003.

Nickell, Steve, and Jan van Ours. 1999. "The Netherlands and the United Kingdom: A European Unemployment Miracle?" Discussion Paper 119. Center for Economic Research, Tilburg University, Tilburg, Netherlands.

———. 2000. "Falling Unemployment: The Dutch and British Cases." *Economic Policy* 30: 137–80.

O'Brien, Kevin J. 1996. "Rightful Resistance." *World Politics* 49: 31–55.

Ofek, Haim, and Yesook Merrill. 1997. "Labor Immobility and the Formation of Gender Wage Gaps in Local Markets." *Economic Inquiry* 35(1): 28–47.

"Oman Human Rights Record." 2001. *Arabic News*, March 12. Available online at http://www.arabicnews.com/ansub/Daily/Day/010312/2001031255.html. Accessed November 24, 2003.

Omar, Manal. 2001. "The Marriage Mystery: Exploring Late Marriage in MENA." *Al-Raida* 18–19(93–94): 12.

Ongile, Grace. 2002. "Gender and Agricultural Supply Response to Structural Adjustment Programs: A Case Study of Smallholder Tea Producers in Kericho, Kenya." Research Report 109. Nordic Africa Institute, Nairobi. Available online at http://www.fiuc.org/iaup/sap/. Accessed November 24, 2003.

Paidar, Parvin. 1995. *Women and the Political Process in Twentieth-Century Iran*. Cambridge, U.K.: Cambridge University Press.

Palestinian Center for Policy and Survey Research. 1994. "Palestinian Elections, Participation of Women, and Other Related Issues." Public Opinion Poll 8. Ramallah, West Bank and Gaza. Available online at http://www.pcpsr.org/survey/cprspolls/94/poll8.html. Accessed November 24, 2003.

Palestinian Central Bureau of Statistics. 1999. *West Bank and Gaza Labor Force Survey*. Ramallah, West Bank and Gaza.

Palestinian Working Women Society for Development. 2002. "Public Opinion Survey: Women's Perspectives on Political Reform." Ramallah, West Bank and Gaza. Available online at http://www.palpwwsd.org/reports/reforming.pdf. Accessed November 24, 2003.

Paluch, Marta. 2001. *Yemeni Voices: Women Tell Their Stories*. Sana'a: British Council.

People's Democratic Republic of Algeria. 1990. *Office National des Statistiques Situation de l'emploi*. Algiers.

Population and Housing Survey. 1996. Lebanon.

Population Reference Bureau. 2003. *2003 World Population Data Sheet of the Population Reference Bureau*. Available online at http://www.prb.org/pdf/WorldPopulationDS03_Eng.pdf. Accessed November 24, 2003.

Preston, Valerie, and Sara McLafferty. 1992. "Spatial Mismatch and Labor Market Segmentation for African-American and Latina Women." *Economic Geography* 68(4): 406–31.

Pritchett, Lant. 1994. "Desired Fertility and the Impact on Population Policies." *Population and Development Review* 20(1): 1–55.

———. 1999. "Has Education Had a Growth Payoff in the MENA Region?" Working Paper 18. Middle East and North Africa Region, World Bank, Washington, D.C.

Putnam, Robert. 1993. *Making Democracy Work: Civic Traditions in Modern Italy.* Princeton, N.J.: Princeton University Press.

Rao, Aruna, and David Kelleher. 2003. "Unravelling Institutionalized Gender Inequality" AWID Occasional Paper No. 8. Association for Women's Rights in Development, Toronto. Available online at http://www.awid.org/publications/OccasionalPapers/OccasionalPapers.html. Accessed November 24, 2003.

"Report on Women's Difficulties in Public Transportation [in Farsi]." 2001. *Zanan* 92(1381).

Republic of Yemen. 1992. *Third Periodic Report to the CEDAW Monitoring Committee.* Sana'a.

Republic of Yemen, Central Statistical Organization. 1999. *Yemen National Poverty Phenomenon Survey.* Sana'a.

Roudi-Fahimi, Farzaneh. 2003. *Women's Reproductive Health in the Middle East and North Africa.* Population Reference Bureau. Available online at http://www.prb.org. Accessed November 24, 2003.

Rubery, Jill, Colette Fagan, and Friederike Maier. 1996. "Occupational Segregation, Discrimination, and Equal Opportunity." In Gunther Schmid, Jacqueline O'Reilly, and Klaus Schomann, eds., *International Handbook of Labor Market Policy and Evaluation.* Cheltenham, U.K.: Edward Elgar.

Ruhm, Christopher J. 1998. "The Economic Consequences of Parental Leave Mandates: Lessons from Europe." *Quarterly Journal of Economics* 113(1): 285–317.

Safa, Helen I. 1999. "Free Markets and the Marriage Market: Structural Adjustment, Gender Relations, and Working Conditions among Dominican Women Workers." *Environment and Planning* 31(2): 291–304.

Said, Mona. 1995. "Public Sector Employment and Labor Markets in Arab Countries: Recent Developments and Policy Implications." *ERF* [Economic Research Forum] *Forum Newsletter* 2(2): Article 8.

———. 2001. "A Decade of Rising Wage Inequality? Gender, Occupation, and Public–Private Issues in the Egyptian Wage Structure, 1988–98." Final Report, Egypt Labor Market Project. Cairo: Economic Research Forum for the Arab Countries, Iran, and Turkey.

Saito, Katherine. 1994. "Raising the Productivity of Women Farmers in Sub-Saharan Africa." Discussion Paper. Africa Technical Department, World Bank, Washington, D.C. Processed.

Sanasarian, Eliz. 1982. *The Women's Rights Movements in Iran: Mutiny, Appeasement, and Repression from 1900 to Khomeini.* New York: Praeger.

"Saudi Women's Bank Accounts Waiting to Be Tapped." 2002. *Al-Madinah.* November 19.

Sayed, Haneen, and Zafiris Tzannatos. 1998. "Sex Segregation in the Labor Force." In Nelly Stromquist, ed., *Women in the Third World: An Encyclopedia of Contemporary Issues.* New York: Garland.

Scarpetta, Stephano. Forthcoming. "Female Participation in Aggregated Unemployment: Some Issues for Discussion." Middle East and North Africa Region, World Bank, Washington, D.C.

Scheindlin, Dahlia. 1998. "Palestinian Women's Model Parliament." *Women's International Net Magazine* 11(July). Available online at http://winmagazine.org/. Accessed November 24, 2003.

Seguino, Stephanie. 2000. "The Effects of Structural Change and Economic Liberalization on Gender Wage Differentials in South Korea and Taiwan." *Cambridge Journal of Economics* 24: 437–59.

Shafik, Nemat. 2001. "Closing the Gender Gap in the Middle East and North Africa." In E. Mine Cinar, ed., *The Economics of Women and Work in the Middle East and North Africa. Research in Middle East Economics.* Vol. 4. of *Research in Middle East Economies.* Amsterdam and London: Elsevier.

Sharaf-Eddin, Fahmia, and Aman Shaarani, eds. 2001. "In Support of Participation of Women in the Political Life in Lebanon: The

Municipal and Parliamentary Elections of 1998–2000 [in Arabic]." Beirut: Domestic Committee for the Follow-up of Women's Issues, in cooperation with Friedrich Ebert Stiftung Corporation.

Shvedova, Nadezdha. 2002. "Obstacles to Women's Participation in Parliament." In *Women in Parliament: Beyond Numbers*. Stockholm: International Institute for Democracy and Electoral Assistance. Available online at http://www.idea.int/women/parl/ch2a.htm. Accessed November 24, 2003.

Singerman, Diane. 1995. *Avenues of Participation: Family, Politics, and Networks in Urban Quarters of Cairo*. Princeton, N.J.: Princeton University Press.

————. Forthcoming. "Rewriting Divorce in Egypt: Reclaiming Islam, Legal Activism, and Coalition Politics."

Standing, Guy. 1989. "Global Feminization through Flexible Labor." *World Development* 17(7): 1077–96.

————. 1999. "Global Feminization through Flexible Labor: A Theme Revisited." *World Development* 27(3): 583–602.

Statistical Center of Iran. 2000. *Household Expenditure and Income Survey 2000*. Tehran.

Strickland, Richard, and Nata Duvvury. 2003. "Gender Equity and Peace-Building: From Rhetoric to Reality: Finding the Way." Washington, D.C.: International Center for Research on Women.

Strum, Philippa. 2002. "Women in the Barracks: The VMI Case and Equal Rights." Lawrence: University Press of Kansas.

Swamy, Anand, Steve Knack, Young Lee, and Omar Azfar. 2001. "Gender and Corruption," *Journal of Development Economics* 64(1): 25–55.

Thomas, Duncan. 1997. "Incomes, Expenditures, and Health Outcomes: Evidence on Intrahousehold Resource Allocation." In Lawrence Haddad, John Hoddinott, and Harold Alderman, eds., *Intra-household Resource Allocation in Developing Countries: Models, Methods and Policy*. Baltimore and London: Johns Hopkins University Press for the International Food Policy Research Institute.

Touimi-Benjelloun, Zineb. 2003. "Women and 2002 Parliamentary Elections in Morocco." Rabat, Morocco: United Nations

Development Fund for Women (UNIFEM). Available online at
http://www.hshr.org/politicaladvancementwomenmorocco.htm.
Accessed November 24, 2003.

Tzannatos, Zafiris. 1995. *Economic Growth and Equity in the Labor Market:
Evidence and Policies for Developing Countries.* Washington, D.C.:
World Bank.

———. 1998. "The Long-Run Effects of the Sex Integration of the
British Labour Market." *Journal of Economic Studies* 15(1): 1–18.

Udry, Christopher. 1996. "Gender, Agricultural Production, and the
Theory of the Household." *Journal of Political Economy* 104: 1010–46.

UNAIDS (United Nations Program on AIDS/HIV) and WHO (World
Health Organization). 2002. *AIDS Epidemic Update.* New York.
Available online at http://www.who.int/hiv/pub/epidemiology/
epi2002/en/. Accessed November 24, 2003.

UNAIDS (United Nations Program on AIDS/HIV), WHO (World
Health Organization), and World Bank. 2002. *Overview of the
HIV/AIDS Situation in the Middle East and North Africa and Eastern
Mediterranean.* New York.

UNDP (United Nations Development Programme). 1995. *Human
Development Report.* New York.

———. 2000. *Human Development Report.* New York.

———. 2002. *Human Development Report.* New York.

UNDP and Arab Fund for Economic and Social Development. 2002.
*Arab Human Development Report 2002: Creating Opportunities for
Future Generations.* Amman: UNDP.

UNESCO (United Nations Educational, Scientific, and Cultural
Organization). 2002. *Arab States Regional Report.* Paris.

UNICEF (United Nations Childrens' Fund). 1997. *The Situation of
Jordanian Children and Women.* New York.

UNIFEM (United Nations Development Fund for Women). 2001.
Paving the Road towards Empowerment: A Progress Report on Egypt,

Jordan, Lebanon, Palestine, Syria, the United Arab Emirates, and Yemen. Amman: UNIFEM Arab States Regional Office.

————. 2002. *Progress of the World's Women.* New York: United Nations.

UN-HABITAT (United Nations Human Settlements Program). 2001. "Women and Urban Governance." Policy Dialogue Series No. 1. Nairobi, Kenya: United Nations Centre for Human Settlements. Available online at http://www.unchs.org/campaigns/governance/documents/women_and_urban_governance_policy_paper.pdf. Accessed November 24, 2003.

United Nations. 2000a. Women's Indicators and Statistics Database (WINSTAT). Available online at http://unstats.um.org/unsd/demographic/social/default.htm.

————. 2000b. *The World's Women 2000: Trends and Statistics.* New York.

————. 2002. *Population Prospects: World Population Projection to 2050.* New York.

United Nations Division for the Advancement of Women. 1996. *Fact Sheet on Women in Government.* New York: United Nations.

United Nations Economic and Social Commission for Western Asia. 1999. Statistical Database. Beirut, Lebanon.

United Nations Economic and Social Council. 2002. *Prevention of Discrimination: The Concept and Practice of Affirmative Action.* Document E/CN.4/Sub.2/2002/21. New York: United Nations.

United Nations Population Fund. 2001. *The State of World Population, 1999.* New York: United Nations.

United Nations Statistical Division. n.d. Women's Indicators and Statistics (WISTAT) Database. New York.

United States Central Intelligence Agency. 2002. *World Factbook.* Available online at http://www.cia.gov/cia/publications/factbook/ Accessed November 24, 2003.

United States Social Security Administration and International Social Security Association. 1999. *Social Security Programs around the*

World. Washington, D.C.: Office of Policy, U.S. Social Security Administration.

————. 2002. *Social Security Programs around the World*. Washington, D.C.: Office of Policy, U.S. Social Security Administration.

USAID (United States Agency for International Development). 1999. "Women's Political Participation: The Missing Half of Democracy." *Gender Matters Information Bulletin* 3 (July). Available online at http://www.genderreach.com/pubs/ib3.htm. Accessed November 24, 2003.

Visser, Jelle, and Anton Hemerijck. 1997. *A Dutch Miracle: Job Growth, Welfare Reform, and Corporatism in the Netherlands*. Amsterdam: Amsterdam University Press.

Wahba, Jackline. 2000. "Labor Mobility in Egypt: Are the 1990s Any Different from the 1980s?" Minneapolis: Minnesota Population Center, University of Minnesota.

WIDTECH (Women in Development Technical Assistance). 1998. "Women and Development in Jordan: A Review of Current Activities and Future Opportunities." Washington, D.C. Available online at http://www.widtech.org/Publications/Jordan_WID.pdf. Accessed November 24, 2003.

Woolcock, Michael. 2000. "Managing Risk, Shocks, and Opportunity in Developing Economies: The Role of Social Capital." In Gustav Ranis, ed., *The Dimensions of Development*. New Haven, Conn.: Yale University Center for International and Area Studies.

World Bank. 1995. *Will Arab Workers Prosper or Be Left Out in the Twenty-First Century?* Washington, D.C.

————. 1999. "Education in the Middle East and North Africa: A Strategy towards Learning for Development." Working Paper 21589, Middle East and North Africa Region, Washington, D.C.

————. 2001. *Engendering Development through Gender Equality in Rights, Resources, and Voice*. Washington, D.C.

————. 2002. *Legal and Judicial Reform: Observations, Experiences, and Approach of the Legal Vice Presidency*. Available online at http://www4.worldbank.org/legal/publications/ljrobservations-final.pdf. Accessed November 24, 2003.

———. 2003a. *Better Governance for Development in the Middle East and North Africa.* Washington, D.C.

———. 2003b. *Doing Business in 2004: Understanding Regulations.* Washington, D.C.

———. 2003c. "Egypt Country Gender Assessment." Middle East and North Africa Region, Washington, D.C. Processed.

———. 2003d. *Global Development Finance.* Available online at www.worldbank.org/prospects/gdf2003/index.htm. Accessed November 24, 2003.

———. 2003e. *Governing Development and Developing Governance in the Middle East and North Africa.* Washington, D.C.

———. 2003f. "Increasing Girls' Enrollment in the Arab Republic of Egypt." Human Development Group, Middle East and North Africa Region, World Bank, Washington, D.C. Processed.

———. 2003g. *MENA's Employment Challenge in the 21st Century: From Labor Force Growth to Job Creation.* Washington, D.C.

———. 2003h. Statistical Information Management of Analysis (SIMA) Database.

———. 2003i. *Trade, Investment, and Development in the Middle East and North Africa: Engaging with the World.* Washington D.C.

———. 2003j. *World Development Indicators.* Washington, D.C. Available online at http://www.worldbank.org/data/wdi2001/index.htm. Accessed November 24, 2003.

———. 2003k. "Yemen Country Gender Assessment." Middle East and North Africa Region, World Bank. Processed.

———. 2004. *Unlocking the Employment Potential in the Middle East and North Africa: Toward a New Social Contract.* MENA Development Report. Washington, D.C.

Wyly, Elvin K. 1998. "Containment and Mismatch: Gender Differences in Commuting in Metropolitan Labor Markets." *Urban Geography* 19(5): 395–430.

Yaccato, Joanne Thomas. 2003. *The 80% Minority: Reaching the Real World of Women Consumers.* Toronto: Viking Canada.

Yacoubian, Mona. 2001. "Promoting Women's Participation: A 'Roadmap' to Women's Empowerment in the Middle East and North Africa." Paper prepared for the World Bank. Processed.

Youssef, Nadia. 1978. "The Status and Fertility Patterns of Muslim Women." In Lois Beck and Nikki R. Keddie, eds., *Women in the Muslim World.* Cambridge, Mass.: Harvard University Press.

Zveglich, Joseph, and Yana Rodgers. Forthcoming. "Occupational Segregation and the Gender Wage Gap in a Dynamic East Asian Economy." *Southern Economic Journal*, April 2004.

Web Sites

Al-Ahram Weekly: http://weekly.ahram.org.eg/. Accessed November 24, 2003.

Arab Regional Resource Center on Violence against Women: http://www.amanjordan.org/english/. Accessed November 24, 2003.

Arab Women: http://www.arabwomen.org/main.html. Accessed November 24, 2003.

Arab Women Connect: http://www.arabwomenconnect.org/. Accessed November 24, 2003.

Arab Women Solidarity Association: http://www.awsa.net/. Accessed November 24, 2003.

Association des Femmes Chefs d'Entreprises du Maroc: http://www.afem.ma/. Accessed November 24, 2003.

Association for the Support and Training of Women Candidates (KADER), Turkey: http://www.ada.net.tr/kader/. Accessed November 24, 2003.

Center for International Development: http://www.cid.harvard.edu/ciddata/ciddata.html. Accessed November 24, 2003.

Human Strategies for Human Rights: http://www.hshr.org/. Accessed November 24, 2003.

INJAZ (Economic Opportunities for Jordanian Youth): http://www.injaz.org.jo/. Accessed November 24, 2003.

International Budget Project: http://www.internationalbudget.org/. Accessed November 24, 2003.

International Constitutional Law: http://www.oefre.unibe.ch/law/icl/home.html. Accessed November 24, 2003.

International Institute for Democracy and Electoral Assistance: http://www.idea.int/women/. Accessed November 24, 2003.

Inter-Parliamentary Union: http://www.ipu.org/. Accessed November 24, 2003.

Islamic Family Law: http://www.law.emory.edu/IFL/. Accessed November 24, 2003.

Jordan Times: http://www.jordantimes.com/. Accessed November 24, 2003.

Lebanese Center for Policy Studies: http://www.lcps-lebanon.org/. Accessed November 24, 2003.

Machreq/Maghreb Gender Linking Information Project (MACMGAG-GLIP): http://www.macmag-glip.org/. Accessed November 24, 2003.

National Democratic Institute for International Affairs: http://www.ndi.org/. Accessed November 24, 2003.

Population Council Web site: at http://www.popcouncil.org/. Accessed November 24, 2003.

Population Reference Bureau: http://www.prb.org/. Accessed November 24, 2003.

Royal Tropical Institute (KIT): http://www.kit.nl/. Accessed November 24, 2003.

United Nations Development Programme POGAR (Programme on Governance in the Arab Region): http://www.undp-pogar.org/resources/. Accessed November 24, 2003.

United Nations Development Fund for Women: http://www.unifem.org. Accessed November 24, 2003.

United States Agency for International Development: http:// www.usaid.gov/. Accessed November 24, 2003.

University of Michigan Documents Center, Foreign Governments, Middle East and Africa: http://www.lib.umich.edu/govdocs/forme.html. Accessed November 24, 2003.

Web site of King Hussein: http://www.kinghussein.gov.jo. Accessed November 24, 2003.

Women for Women's Human Rights: http://www.undp.uz/GID/eng/TURKEY/NGO/wwhr_tr.html. Accessed November 24, 2003.

Women in Business in the Arab World: http://www. forwomeninbusiness.com/. Accessed November 24, 2003.

Women in Development Technical Assistance (WIDTECH): http://www.widtech.org/. Accessed November 24, 2003.

WomensNet: http://www2.womensnet.org.za/govbbs/. Accessed November 24, 2003.

WomenWatch: http://www.un.org/womenwatch/. Accessed November 24, 2003.

World Bank: http://worldbank.org. Accessed November 24, 2003.

Index

accountability, 12, 131
 state leadership, 141–145
added worker effect, 77
advocacy groups and activism, 14, 140–141, 146*n*.8
affirmative action, 53*n*.5
age
 economic dependency ratio, 66
 expectations and, 21
 labor force participation and, 59, 60, 90*n*.6
 marriage, 130
agenda for change
 definition, 131–135
 framework, 129–130
agriculture, 83–84
Algeria
 judiciary, 143
 labor participation, 63
assets, control, 18
attitude, Moroccan men's to working women, 111–112

Bahrain
 labor participation, 63, 64
 parliament, 145*n*.3
balance of power, 10
banking, new businesses, 117
bargaining power, 73
barriers, 11
benefits, 11, 134, 150, 151
 family, 104–107, 125*n*.12
 maternity, 120
breadwinner, male, 10, 21, 95, 95, 124*n*.4, 130

cabinet ministers, 139
capacity building, 141
casual workers, 88
change agents, 135–145
childcare, 121, 126–127*nn*.21, 22
civil society, 140–141, 146*n*.7
coalitions for change, 142
code of modesty, 10, 95–96, 111–116
compensation, 11
 nonwage, 104–107
competition and competitiveness, 18, 73
constitutional rights, 133, 152, 153–154
consumers, 141, 146*n*.9
contraception, 47–49
 rates, 164
corruption, 73
Côte d'Ivoire, earnings and expenditure patterns, 74
court decisions, 146–147*n*.11
current generation, 12–15
curricula, 41

daftar, 126*n*.19
data used in this book, 22, 23*n*.7, 56
decisionmaking, 4
 resource allocation, 3
demand factors, 7–9
demographics, 12, 130
development model, 18
development policies, 57

discrimination, 3, 18, 23*n*.3
 policies, 116, 118
 see also wage discrimination
divorce, 69, 130
Djibouti judiciary, 143

earnings, expenditure patterns
 and, 74
economic dependency
 costs, 65–67
 ratio, 55, 57, 65–66, 89*n*.3
economics, 2, 4–5, 21–22, 55–91
 contribution at the household
 level, 18
 factors, 10–12
 growth, 8
 policy, new model, 12–14
 regional, 130–131
education, 3, 5, 5–6, 13, 21,
 25–54, 90*nn*.10, 12,
 90–91*n*.13, 125*nn*.9, 10, 145
 budgets, 37
 childcare and, 121
 demand for, 38–42
 early-childhood, 42
 empowerment and, 35–43
 fertility and, 55, 57
 health and, 28
 income and expenditures,
 74*n*.1
 labor force, 103
 labor force participation and,
 59, 60, 62–63, 67–69, 89*n*.1
 material inputs, 40–41
 primary, 157–158
 quality, 39–41
 rates of return on, 68–69
 remote and poor families, 43
 right of citizenship, 27–28
 secondary, 157–158
 spending, 26, 27
 tertiary, 157–158
 wages and, 68–69
 see also school enrollment
efficiency, 131
Egypt
 empowerment, 97
 income, 71
 judiciary, 143
 labor participation, 63

parliament, 145*n*.3
 primary school enrollment, 38
 return on education, 68
 unemployment, 76
 wage differentials, 105
empowerment, 2, 4–6, 22–23*n*.1
 education and, 35–43
 public vs. private, 97
engendered environment, 124*n*.6
entitlements, 134
equal rights, 133
equity, 131
examination scores, 34–35
expenditure patterns, 74

family
 bargaining power, 73
 book, 126*n*.19
 centrality of, 10, 94–95
 responsibilities, 118–124,
 126*n*.20
family law, 11, 20, 96, 98, 111
 see also legislation
family planning programs, 48
fertility
 economic dependency, 66
 education and, 28–29, 55
 labor force participation and,
 57–58, 59, 60, 62–63, 89*n*.1
 unemployment and, 91*n*.16
fertility rates, 18–19, 25, 50, 43,
 46–49, 54*n*.14, 162
 education and, 46–47
 Germany, 122
flexibility, restrictions to,
 111–118
foreign workers, 64
framework for change, 129–130
 agenda, definition, 131–135

garment workers, 85, 112
gender budgeting, 26–27
gender discrimination, effects, 46
gender equality, 14
 history, 19–21
gender inequality, 17–54, 109
 costs, 1–4
 defined, 17
gender paradigm, 10
 traditional, 94–100, 124*n*.2

gender paradox, 1
gender policy, 12–14
gender research, 142–143
Germany, working mothers, 122
governance, 73
government, decentralization,
 139
gross domestic product, 57
 per capita, 72–73, 90–91n.13
guidance, 41
Gulf Cooperation council, 64

health, 5, 6, 21, 43–54, 145
 education and, 28
 second-generation issues,
 49–52
 social, 49–52
 spending, 26, 27
 see also fertility; life
 expectancy
health services and information
 access to, 51–52
 gender-specific, 52
HIV/AIDS, 52
honor, 95–96
household
 female-headed, 69, 90nn.7, 8
 head of, 124n.3

inclusiveness, 12, 131
income
 control, 18
 earned, 70–71
 growth of aggregate, 72–74
 household, 70–72
 low participation and, 69–74
 per capita, 4
 per family, 57
 potential increases, 71
 sources, 70
infant mortality, 43, 44–45
 rates, 161
informal employment sector,
 81–82
information, gender-
 disaggregated, 142–143
infrastructure, 13
 supportive, 134
International Labour
 Organisation, data, 86–89

Iran, Islamic Republic of
 family planning, 48
 labor participation, 63
 labor participation, 63
 literacy training, 31
 night taxis, 114
 school enrollment, 53n.

jobs, 13–14
 creation, 86
 restrictions, 113–114
job segregation, 93, 108–110,
 126n.15
 inefficiency, 109
Jordan
 education, 40
 family laws, 126n.19
 labor participation, 63
 return on education, 68
judiciary, 143

Kuwait
 labor participation, 63, 64
 parliament, 145n.3

labor-abundant, resource-poor
 countries, labor force
 participation, 7, 63, 64
labor-abundant, resource-rich
 countries, labor force
 participation, 7, 63
labor force
 categories, 88
 constraints, 22
 defined (ILO), 88
 exclusions, 88
 growth, 84
 participants, 88–89
labor force participation, 6, 7–12,
 19, 23n.4, 55, 56
 actual and projected, 58,
 61, 62
 benefits, potential, 72
 changes, 60
 defined, 56growth, 57–60,
 89n.2
 economic dependency ratio
 and, 66
 economic impact, 64–74
 education and, 67–69

growth and, 79–84
income and, 69–74
low-level, 55, 57, 61–64, 93
male vs. female, 91*n*.14
marriage and, 99–100
men, 89*n*.4
rates, 9, 10, 86–89, 125*n*.8
trends, 59
unemployment and, 74–78
labor importing, resource-rich
 countries, labor force
 participation, 63, 64
labor laws and regulations, 10,
 13–14, 20, 81, 86, 94,
 99–100, 112–113, 119
 see also legislation
labor market, 4
 discrimination, 9
leadership training, 141
Lebanon
 judiciary, 143
 labor participation, 63
 parliament, 145*n*.3
legal equality, 150
legislation, 12–13, 153–154
 childcare, 120, 121
 family benefits, 104–105
 interpretation of the law and
 legal institutions, 142,
 146–147*n*.11
 family law
 maternity leave, 119
 pensions, 106
 reform, 132–134
 restrictions to women's work
 and mobility, 113
 see also family laws; labor laws
Libya, labor participation, 63
life expectancy, 6, 25–26, 43–44,
 54*n*.11, 69, 163
lifelong learning, 53*n*.8
literacy, 26, 29–30, 136,
 159–160
 Iran, 31
 rural, 43
 training, 31
 Yemen, 31

mahram, 95–96, 124*n*.5
maids, 126–127*n*.21

male breadwinner model, 10,
 21, 95
manufacturing, 85–86
marginal product of labor,
 125*n*.14
marriage, 118, 130, 152
 early, 51
 labor force participation and,
 99–100
maternal mortality, 43, 44–45,
 54*n*.12
 rates, 161
maternity benefits, models, 120
maternity leave policies and laws,
 118–120
the media, 141
men
 interaction with, 95–96
 preferences, 130
Millennium Declaration, 19
mobility
 freedom of, 152
 restrictions, 115–116
Morocco
 education, 53*n*.6, 85
 garment workers, 112
 gender budgeting, 27
 labor participation, 63, 85
 school enrollment, 53*n*.3,
 53*n*.10
mothers, 120–124
Muhammad, heirs, 145*n*.1

national machinery, 147*n*.12
national women's machinery,
 143–145, 147*n*.13
nationbuilding, 19–20
Netherlands, reform, 123
new agenda, 12–14
new business licensing,
 Saudi Arabia, 117
nonwage workers, 88

obedience, to husband, 11
occupational segregation, 93,
 108–110
 trends, 110–111
oil, 20
Oman
 fertility, 50

labor participation, 63
opportunity, access to, 129, 150

Palestine, parliament, 145n.4
parking, safety, 116
parliament, 136–139, 145nn.3, 4
participation, enhanced, 4
part-time work, 121–122, 124, 127n.24
pensions, 106, 108, 150, 151
planning framework, 22
policy, 129–147
 framework, 12, 13
 gender-sensitive, 141–142
 implementation, 130
 labor market, 135
political reservations, parliament, 146nn.5, 6, 10
politics, 14, 18, 73
 inclusion, 136–141, 145n.2
 local, 139–140
poverty, education, 43
power, unequal, 96, 98
pregnancy, reduction of early pregnancies, 50–51
private sector, 8–9, 84–86, 88, 102, 104, 124–125n.7, 129
 wage discrimination, 103
public sector, 8, 14, 37, 129, 135
 labor force participation, 79–81
 laws, 132
 wage discrimination, 103

Qatar
 labor participation, 63, 64
 parliament, 145n.3
quota systems, parliament, 138, 145–146nn.5, 6, 10

reform, gender-related, 20
regulations, gender-based, 11
reproductive health knowledge, 51
resource allocation, 3
resource-based income, labor force participation and, 63–64
resource-poor countries, labor force participation, 7, 63

resource-rich countries, labor force participation, 7, 63
retirement, 90n.6, 108, 118, 125n.13
right to work, 153–154
role models, 41
roles, 10
rural families, education, 43, 53n.1

safety, 116
Saudi Arabia
 labor participation, 63
 new business licensing, 117
 parliament, 145n.3
school completion, 32–33, 35, 36, 37
school enrollment, 25–26, 28, 29, 32, 53nn.3, 6, 7, 90n.10, 157–158
 costs, 34
 gender gaps, reducing, 30–32
 primary education, 28, 30, 33, 35, 37, 38, 42, 53n.10
 secondary education, 30–31, 33, 36, 37, 67
 tertiary education, 31–32, 34, 36, 37
services, family-provided, 56n.1
sexuality, male vs. female, 54n.15
skills, 134–135
social factors, 10–12
social health, 49–52
Social Security Laws, U.S., 107
socialization, boys vs. girls, 39
standard of living, 65
state feminism, 19
state leadership, 14–15
survival rate, girls vs. boys, 46
Syria
 judiciary, 143
 labor participation, 63

talent pool, 109
taxis, night, Iran, 114
textile and garment manufacturing, 85, 112
Tunisia
 family planning, 48
 judiciary, 143

labor participation, 63
parliament, 145*n*.3
school enrollment, 53*n*.10

U.N. Convention on the
 Elimination of All Forms
 of Discrimination against
 Women (CEDAW),
 19, 23*n*.5, 137–138, 144,
 155–156
U.N. Millennium Goal, 35, 37
U.S. Air Force, benefits, 107–108
unearned income, 7
unemployment, 2–3, 7–8, 20–21,
 66, 67, 88, 89*n*.5
 defined, 56
 education and, 41
 female participation and, 57
 fertility and, 91*n*.16
 labor force participation and,
 74–78
 women's, 75–77
United Arab Emirates, labor
 participation, 63, 64
 parliament, 145*n*.3

virtual classrooms, 53*n*.9
vocational training, 42
voting, 136
voting rights, 20

wages, 2, 20, 71, 90–91*n*.13, 72
 discrimination, 9, 72, 90*nn*.11,
 12, 91*n*.17, 93, 100–104,
 125*nn*.9, 10

gaps, 93
 education and, 68
West Bank and Gaza, labor
 participation, 63
the woman question, 21, 23*n*.6
women's interests, promotion,
 143–145, 147*n*.13
work, 150
 constraints on, 93–127
 defined, 56
 experience, 125*nn*.9, 10
 hours, restrictions, 114–115,
 126*n*.16
 informal and unregulated,
 81–82
work force ability, 73, 90–91*n*.13
workers, ratio to nonworkers,
 65–66
workplace purification, 118

Yemen, Republic of
 education, 53*n*.4
 empowerment, 97
 fertility, 50
 income, 71–72
 labor participation, 63
 literacy training, 31
 parliament, 145*n*.3
 return on education, 68
youth, expectations, 21